AFRICAN KINGS

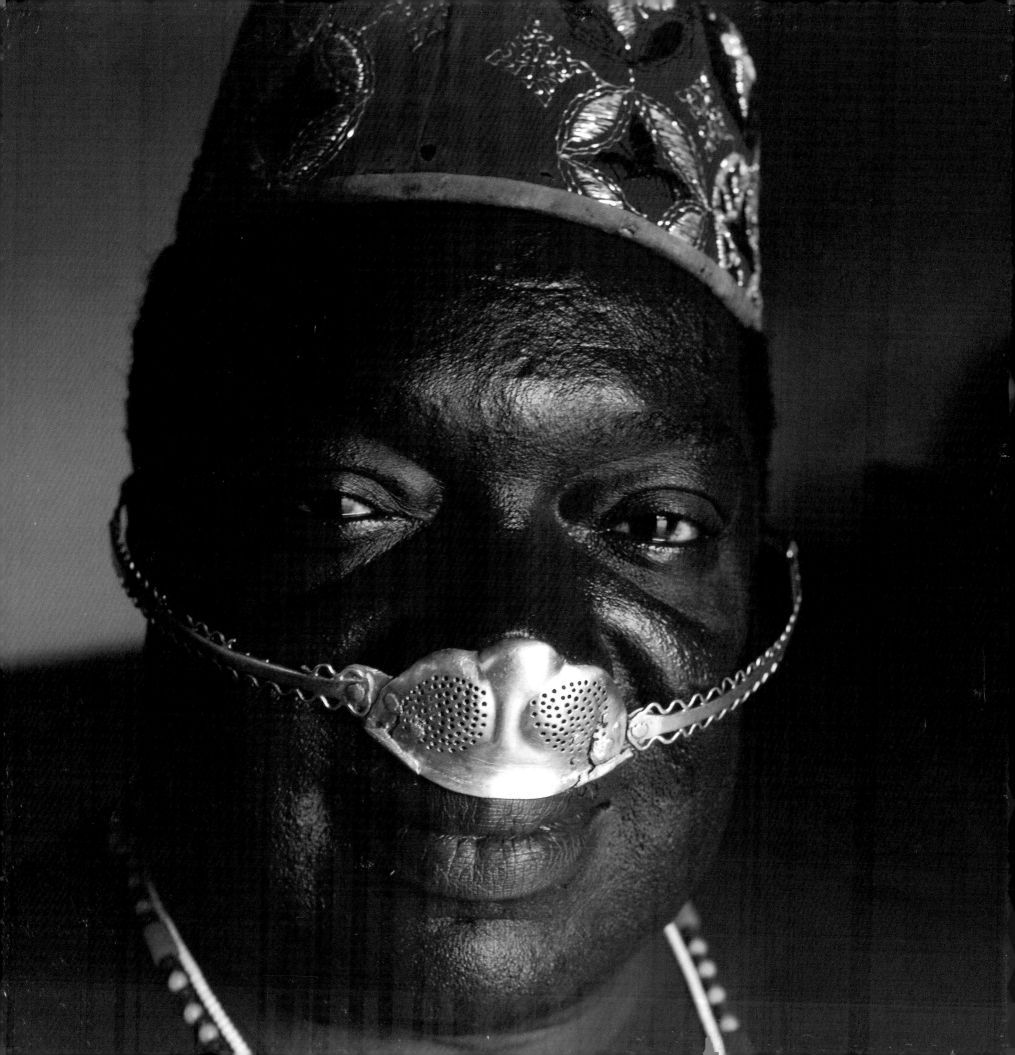

AFRICAN KINGS

Daniel Lainé

TEN SPEED PRESS

BERKELEY ◎ TORONTO

Previous page:
Agboli-Agbo Dedjlani,
King of Abomey, Benin

FOREWORD

THERE ARE HUNDREDS OF KINGS IN AFRICA. In 1988, I decided to photograph seventy important monarchs whose dynasties marked the history of Africa until the middle of the twentieth century. I have included a few of the minor ones because I found their "regalia" particularly interesting. They no longer hold absolute power, but they retain a traditional and spiritual authority that is difficult for the Western mind to comprehend. People prostrate themselves at their feet. Judging by the size of their palaces, their numerous residences abroad, and their vast parking lots, most of these kings are rich. Few of them live modestly.

Owing to the scarcity of data and ethnological works on present-day monarchies, I first had to carry out my investigations haphazardly and then go and meet the kings outside the large cities, often at the end of tortuous trails. To photograph them, I almost always had to comply with an elaborate protocol; it took time, perseverance, and occasionally money. Intermediaries, who were well connected at the royal courts, were of considerable help. Without them, negotiations proved impossible. By May 1988, in Cameroon, the work had barely gotten underway. And then I had to make a detour on some trail, and it happened—the car accident in Africa that everyone dreads. I saw my friend Grégoire, taken unconscious to what passed for a hospital, but which was in fact a filthy dilapidated building, where you had to pay for everything: nurses, doctors, blankets—you had to pay just to be treated like a human being. For three or four days, I thought my friend was going to die. The police intervened. They found it strange the white man was unscathed while the black man lay dying in the hospital; there must have been some witchcraft at work. People had "to be paid off"! Fortunately, the director of the Bafoussam breweries generously rescued me from the dangerous impasse and took care of my injured friend. But fate can be cruel at times; a little while later, he lost his job.

In three years, from 1988 to 1991, I made about a dozen trips, which allowed me to stay in Africa, all told, for almost twelve months. Yet I didn't get to see the king of the Shiluk, a descendant of the Black dynasties that ruled Egypt, because the Sudanese civil war made the journey too difficult. During the same time, I made five trips to Oyo without meeting the Alafin. His ancestors of the Yoruba kingdom had dominated southern Nigeria for centuries. When I rang up his entourage, they made it perfectly clear that a sovereign doesn't speak to strangers over the phone. The process might have taken several months, so I didn't bother to insist. I regret that this great king is not part of this book. The king of Swaziland is the only king who refused to meet me. Almost a year went by while his secretary didn't even bother to answer my requests for an audience with the monarch. Finally, exasperated by my insistence, he advised me in no uncertain terms to stop pestering him!

In Uganda, I managed to locate the princess of Toro. She had been a minister in Idi Amin's government, a top fashion model, an ambassador to the United States, and wrote an autobiography. Since her husband died in an accident, she was said to have fallen into a state of depression and her whereabouts were unknown. In her day, a lot of ink had been written about her escapades. After traveling for two days over a rough and exhausting trail, I met up with her at the home of her brother, the deposed king of Toro. Frail and nervous-looking, she was shocked that I had come to see her without informing her agent in New York. She refused to let me photograph her and showed me the door.

I returned to Kampala drained by fever and fatigue, only to collapse in the middle of a photo shoot in the residence of the royal family of Buganda. I had a temperature of over 104°F and had come down with a bout of extremely resistant malaria. Nevertheless it was a momentous occasion. It marked Prince Mutebi's first traditional appearance in public since the collapse of the Buganda monarchy. In my travels, I had coped with telephones that never worked when you needed them and transportation that was often slow and dangerous, but I never really got used to the African concept of time. "Time is a white person's concern," they say in Africa. That's why in the former Zaire, what with the time spent getting the obligatory authorization, the traveling and the ritual that had to be followed before the King of the Kuba could put on the royal ceremonial costume, it took me three weeks to photograph him.

In Cameroon, I also had to negotiate for three weeks before photographing the Sultan of Njoya. The Baba of Rey Bouba made me cool my heels for eight days in a cabin. In Nigeria, I trailed the Oni of Ife for two weeks on his seemingly endless trips back and forth across the country. I succeeded in photographing one of the most prestigious African monarchs—the Oba of Benin—on the double quick, by infiltrating the throne room with the entourage of the king of Ogba, who had come to pay him a visit. In South Africa, Nzunza, the heir to the usurper king described in the Ndebele legend, had me spend half a day in front of his royal council, then sent me to seek authorization from the Kwa-Ndebele government to photograph him. Working my way through various departments and offices, I finally found myself facing a white senior bureaucrat, who threatened to have me expelled for violating the homeland's state of emergency. No photos, but ten days of wrangling to discover that the Ndebele had yet to gain control of their own destiny.

But to compensate for those inevitable inconveniences of officialdom, there was the hospitality and courtesy shown by all the kings, who obviously attached little importance to a picture they might never see. They agreed to pose in their magnificent apparel, with no chance of gain, simply as a favor to a foreigner. Of course there were all the other things you run into when you travel in Africa: bush taxis; chance encounters; "good guys," (be they ambassadors or peasants); "bad guys," (more of them in government departments than on the street); unforgettable moments shared with their royal majesties and their subjects, in the silent communion of a ritual; the rhythms and the incredible laughter in Africa, which is all too often interrupted by fate . . .

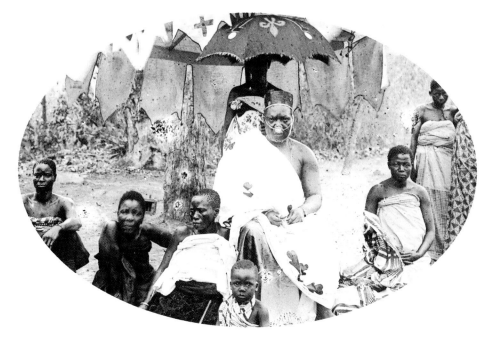

The king of Abomey, wearing his silver dust-protector

ORIGINS OF THE AFRICAN KINGDOMS

BY PIERRE ALEXANDRE

THE STEREOTYPE OF THE NEGRO KING, today associated with that of the banana republic is, to say the least, derogatory (not to mention a paradox), connoting primitive savagery, inhuman brutality, and irreparable backwardness. Since the late nineteenth century, the popular adventure novel, later aided and abetted by comic strips, has imprinted on the Western mind images of a grotesque but dangerous figure in a fireman's helmet and scholar's gown without pants, fricasseeing missionaries and explorers in giant caldrons. In more recent times, the appalling deeds of General Idi Amin and Emperor Bokassa have been cited to reinforce this perception. In fact these two figures make the opposite case. They received their military training with colonial troops; Amin with the British, Bokassa with the French. They were little more than glorified junior officers without the least claim to traditional legitimacy or the least link with the historical reality of traditional political systems. Indeed, they were the mere incarnation of a European racist myth.

The ideological justification of colonial conquest rested on the obliteration of past knowledge and understanding. To appreciate this, we needn't go as far back as the legendary King Balthasar, one of the three visitors to Bethlehem during the Nativity, or to the queen of Sheba, who seduced Solomon. It suffices to recall that medieval mapmakers depicted African monarchs in much the same costumes and regalia as their European counterparts. From an ethnological perspective, their portrayal was undoubtedly inaccurate, but understandable given Arab voyagers' accounts at the time. Philippe I of France and William the Conqueror of England were, in fact, petty nobles compared with the great King Tunka Menin of Ghana, who could deploy forty thousand archers in battle. And three centuries later, what European monarch could match the economic clout of the Mansa of Mali, Kankan Musa, who flooded the market with enough gold to cause a twenty percent devaluation in the Egyptian dinar?

Truth be told, the mere mention of the word "king," (not to mention "emperor") is enough to create a certain confusion with institutions that are familiar to us. Thus it is important to put the word in an African context, beginning by subsuming it under the neutral generic notion of chief, which comprises all recognized holders of political (but not uniquely political, as we shall see later) authority. Indeed, it would be a mistake to attempt to compartmentalize traditional African cultures, to try to find in them a separation of powers that would distinguish, for example, politics from religion, or rite from technique. There is every evidence of a division of labor (even in the simplest of the societies, where it was based on gender and age), but the social ideology is all-encompassing, however complex and diverse the institutions.

According to a theory, propounded by French ethnologists among

others, African political formations derive historically from an extension (a "concentric" extension according to Léopold Senghor of Senegal) of the extended family. These fundamental groups can be found, we are led to believe, throughout the continent, in numerous variations depending on lifestyle (farming, herding, hunting and gathering, fishing . . .) and, consequently, ecology, which determines size. They vary from a hundred members among some farmers and shepherds to about twenty among hunter-gatherers such as the Mbuti peoples (Pygmies) of the equatorial forest or the San peoples (Bushmen) of the Kalahari. Living members (elders, adults, children) of the group have a genealogical depth of three generations to which is added (in varying numbers depending on the peoples concerned), a line of from three to thirty, even forty, real or mythical ancestral generations. The extended family tends to be a largely self-sufficient production and consumption unit, but it is open to other groups in order to accommodate matrimonial networks, an openness that is necessary because of the exogamic imperative, related to a very broad and constraining concept of incest.

Politically (if the term is applicable here), what was involved was not so much a patriarchy as a gerontocracy. In fact, the elder generation had to reach a consensus before any important group decision could be taken. The family head (or supposed head), elder (social as much as or more than biological) of this generation was no more than the *primus inter pares*, first among equals, vested with an essential function, that of attending to ancestor worship. The ancestors were consulted in times of crisis because they constituted the principal element in the group's collective identity.

The extended family frequently underwent a process of fragmentation and dispersion, especially when the rate of demographic growth outstripped the subsistence potential of its economic territory (agricultural region, transhumant routes, and hunting ground . . .). Proponents of the above theory would argue that this social and geographical scissiparity was at the origin of the clan clusters of extended families with a common ancestry. Through a similar mechanism, clans formed ethnic groups, and at this stage, it is argued, royalty develops. Unfortunately, the weakness of this view is that it is a gross oversimplification. First, there were many cases in which dispersion resulted not in the formation of clans (which required a deep genealogical memory), but in the proliferation of nonhierarchical, autonomous groups. In these groups, the original community's memory was obliterated in two or three generations, even though the members spoke the same language and observed very similar religious rituals derived from the same mythology. Second, the existence of diversified clans (erroneously referred to as a "tribe" in past terminology), which traced their descent from a single Great Ancestor or Founding Hero, did not necessarily mean that a common chief managed shared interests or mediated internal disputes. In many societies, these were corporate responsibilities, devolved upon associations whose members were very selectively recruited from among the lineage elders. To a certain extent, it involved transposing the system of birthright prerogatives from the family level to the whole society, but with a substantial qualitative leap, since this type of ancestry was mythical, rather than biological, in nature—a legal fiction. It is then that we see a senior clan chief emerge from a major lineage, which is reputed to be in the most direct line of descent from a common, real or mythical, ancestor.

The relationships between the major lineage and the minor, or junior, lineage replicate the family model. For the clan chief to be more (or other) than the elder of a group of equals, there would have to be an internal rupture, a sort of revolution, or an intervention from the outside. In the former case, often in exceptional circumstances (an external threat, food shortage, economic transformation), an individual (or a group) challenged the rules of birthright and collegiality, even if he returned to them afterward, giving historical reality a nudge in the right direction. An illustration of this is the classic myth of the elder who is lost, then found. The elder disappears or is kidnapped at birth and comes back as an adult to restore social order, which has been compromised by his disappearance. In historical fact, there have been several instances in which a valorous warrior resorted to force of arms to impose his personal domination, then passed it on to his descendants according to the traditional family model, revised and corrected, of course.

The latter case (to which the term "royalty" could be applied) closely resembled the one that resulted from intervention by a foreign group. It might have been a peaceful intervention; the foreigners, having been authorized to settle, may have formed a social stratum that was subordinate, at least for a time, to the original group's descendants. It might also have involved a successful military invasion in which the victors imposed their authority on the vanquished. In passing, it is interesting to note that cultural assimilation could go both ways. Either the immigrants adopted (and sometimes adapted) the original members' language and customs, or, conversely, the newcomers may have absorbed the original members. In either event, the result was an ethnically homogeneous situation, the formation of a society, which I prefer to call a "kingdom," reserving the term "empire" for ethnically heterogeneous political entities.

Thus we have a theoretical classification in which we can distinguish: first, acephalous, noncentralized societies, without a chief, in which political authority is diffuse, *familial anarchies* (Mbuti, San, highlanders of the Sudan); second, non-centralized acephalous societies, without a chief, in which authority rested with secret *initiation societies* (Fang of Gabon, Igbo or Ibidio in Nigeria); third, non-centralized

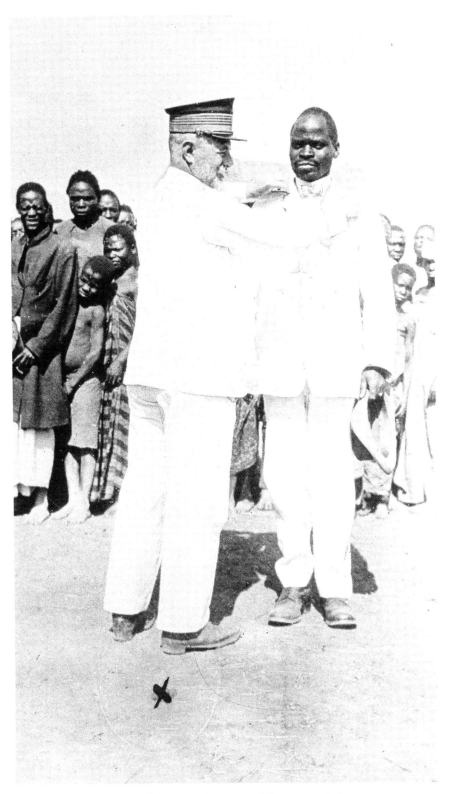

The Msiri's grandson receiving a medal

homogeneous societies, bringing together *chiefdoms* with clearly defined territories, in which the authority was embodied by barely hierarchized clan chiefs with equal rights (Xhosa in South Africa, Ewe city-states in Togo and Ghana); fourth, centralized *kingdoms* with a clearly defined territorial foundation, in which the authority was based either on the domination of the original clan (Zulu) or on conquest followed by cultural assimilation (Rwanda, Burundi); and fifth, centralized, ethnically heterogeneous *empires*, territorially defined, in which the authority rested on the hegemony of a conquering kingdom (Sokoto, medieval Mali).

However schematic this attempt at classification, it permits us to foresee a great variety of concrete situations, in which common factors were not always apparent. One common factor, however, does stand out: the nature of power and its exercise. Earlier, I questioned the advisability of automatically linking the notions of tyranny and absolute despotism with the notion of African kingships. It is true that history has given us a few monarchs who fit the image, but typically, they were founders of kingdoms (Shaka, the founder of the Zulu nation in the nineteenth century) or of new dynasties (Muhammad Turé, the first Askia of Songhai in the fifteenth century) or the last representative of an ancient dynasty, eliminated because of their abuses (the Fia Agokoli of Nuatja at the close of the fifteenth century). In fact, the royal function, like that of the family head, according to the same ancestry principle, remained sacred or rested on divine right. In an ethnically homogeneous kingdom, in which the sovereign was of the same blood, of the same lineage as his subjects, he played the role of a bridge builder between them and the group's ancestors, he was a priest-king. In ethnically heterogeneous kingdoms, in which the sovereign was a descendant of the conquerors and did not belong to the same line as his subjects, he was the incarnation of the god or the demiurge of his ancestors *and* theirs, he was a god-king. In both instances, he was more than a mere human being. He symbolized, embodied in his person, not only the principle of royalty, but the kingdom itself as an experienced reality, of which he was as much the captive as the master. The case of the celebrated Sudanese empires, which melded many ethnic groups, was more complex, but not fundamentally different. Islam was, of course, the common social factor, but it served as a link only in the upper hierarchy. The constituent ethnic groups preserved their own ancestry, and the emperor himself, commander of the faithful at the imperial level, remained sacred in the African cult of his own ethnic group.

Thus, if the king *was* the kingdom, it follows that nothing that concerned him was trivial. The elaborate and omnipresent etiquette surrounding him was, in fact, an essentially religious ritual, the details of which varied widely from one society to the other since they were the identifying criteria for a society. Nevertheless, a certain number of

traits recurred. For example, a kingdom's well-being was often considered to be intimately linked to the sovereign's health. His vigor (particularly his virility) was tested before his enthronement and monitored afterward. In case of illness or senility, steps were taken to send him discreetly but directly to meet his ancestors. The Jukun people of what is now Nigeria offered a rather extreme illustration. After their monarch had reigned for seven years, his head was placed alongside his predecessors' in the dynastic pantheon. On another, but related, level, there were rites marking the king's distance from common mortals, his exceptional status. At times, there was an intentional break with strict social prohibitions, for example, royal incest with a mother or sister among the Bantu of the Central African Republic, or homo-

sexual relations with the pages at the royal courts in the Great Lakes region. Other prohibitions set the monarch apart from mere mortals. Only certain domestic officials (those who monitored his physical well-being), had the right to see the sovereign eating or sleeping; outside the palace the monarch spoke through an intermediary (a "royal mouth"), his feet never touched the ground outside the palace, he was carried everywhere, and he wore a veil. When his subjects approached him, they were obliged to be barefoot or bare-chested, to prostrate themselves on the ground or kneel before him, and they could never address him directly, or utter his name. Items of regalia (jewels, weapons, ceremonial staffs of office, seats, etc.) were preciously preserved from reign to reign by an elite palace guard, who might also be

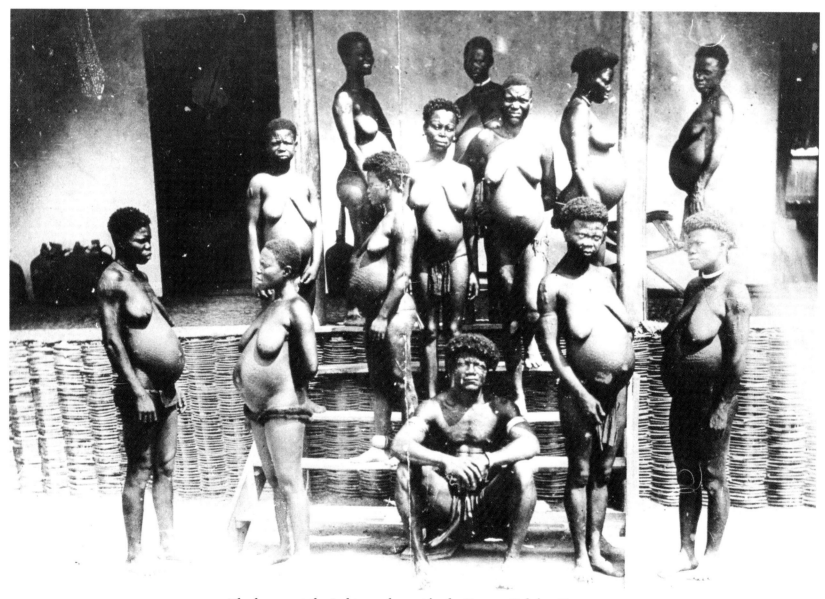

The harem at the Luba royal court in the Former Belgian Congo

charged with keeping the royal history. On the other hand, the royal paraphernalia might be liquidated when the ruler died, along with his personal servants and some of his wives.

The corps of officials responsible for the royal rituals limited the sovereign's power by preventing him from violating accepted ancestral custom and thereby committing a kind of sacrilege. Generally, there were a number of groups with distinct attributions, who checked and balanced one another. They were recruited from various strata in the population (nobles, free men, slaves, tradesmen, etc.) that they represented, legitimately and effectively, before the king. Frequently, especially in states born of conquest, a "land chief" represented the vanquished people. Since he alone had the authority to celebrate agrarian rites, he could effectively contest a sovereign's abuse of authority by refusing to perform them.

In short, without attempting even a cursory analysis of the day-to-day administration of traditional kingdoms (courts, taxes, army, etc.), it must be pointed out that, compared with their European counterparts, African kings possessed power that was undoubtedly less political, strictly speaking, than religious (or, at any rate, sacred). Although certainly based on divine right, their power was not absolute but subject to more or less representative collegial control by the subjects.

COLONIAL OCCUPATION, A DRASTIC UPHEAVAL OF TRADITIONAL INSTITUTIONS

The preceding outline refers to a past, dating back to colonial penetration (1850–1900) and, particularly to colonial occupation (1900–1960)—in all, a period of a little over a century, brief from an historical perspective, but which saw a drastic upheaval of African institutions—an upheaval whose effects lasted a generation after independence was attained. The independent states, incidentally, are not so much specifically African historical entities as territories defined by colonial intervention, within borders that often bear little relation to the actual distribution of ethnic groups, languages and cultures. Fewer than half a dozen states (Lesotho, Botswana, Swaziland, Rwanda, and Burundi) more or less correspond to pre-colonial kingdoms.

The initial penetration phase paradoxically resulted (simultaneously with the genesis of the above myth) in the proliferation of so-called kingdoms, mainly on the coast. In fact, they were nothing of the sort. Naval officers and early explorers of the interior drew up all manner of protectorate treaties with people who were little more than village chiefs, heads of families, vassals, abusive subordinates, or incompetent ministers of legitimate sovereigns. In short, with individuals, or at most with subjects lacking regalian attributions, who were dubbed "kings" to lend legal weight to acts of extortion. At best,

these documents constituted a de facto investiture of a pretender soliciting outside assistance to support him in his attempt to overthrow the ruler in place. As a result, the French signed a "protectorate" agreement with one king and the English with another for the same place—Petit Popo, in present-day Aného in Togo, and the Germans and the English did the same in Douala in present-day Cameroon.

The penetration and pacification of the interior unfolded in slightly different circumstances. Since the coast had been closed by companies plying the slave trade in the late sixteenth century, the hinterland was *terra ignota*; the earliest explorations in the early nineteenth century had resulted in the emergence of only a few trails along the major traditional trade routes. There was only superficial knowledge about the social organization of the people of the interior, bereft of true understanding, riddled with errors of interpretation due to abusive Eurocentric assimilation. Paradoxically, military conquest (generally called "pacification") proved easier in large chiefdoms and centralized kingdoms than in acephalous societies. In the former case, the conquerors could exploit historic rivalries between states, or capitalize on the resentment of recently subjugated peoples to overcome resistance by organized states. Once the head fell (the king was killed, or worse), the body was easy to dismember. In acephalous societies, on the other hand, the conqueror had to proceed canton by canton, if not hamlet by hamlet, the resistance proving to be more polycephalous than the nine-headed Lernan hydra. One such example occurred in northern Cameroon. There the submission of the great emirates was brought about by 1905, while that of the acephalous highlanders did not occur for another thirty years.

Before conquest and partition was complete (symbolized by the Franco-Anglo-Germanic agreements between 1890 and 1905), the colonizers were obliged to devise an indigenous policy, that is, a body of legal and administrative measures, based on an ideology or declarations of intent that were more or less sincere. This allowed a small band of European bureaucrats to govern without too much opposition or friction from the indigenous masses. It was common practice, in this regard, to contrast direct French administration with *indirect British rule*. The contrast was less stark, in actual practice—in the African bush, for example—than would appear in colonial administrative law books, but the contrast was real nevertheless, and the consequences have survived de-colonization.

First, there was one consideration that sprang from the very nature of the problem. It would have been impossible for Europeans to govern Africa without the cooperation of African intermediaries. Given this premise, different solutions were chosen. The French colonizer, a republican of the Jacobin-Napoleonic persuasion, tried to unify the intermediate structures, turn the officially recognized chiefs into

bureaucrats and make them submit to authority. From Dakar to Bangui, the "indigenous command" was structured as the tripartite hierarchy: the village chief, the district chief, and the senior chief. They possessed only the authority and the powers delegated them by the Republic, which, when annexed, legally confiscated and incorporated those once possessed by the sovereigns. The long-term objectives of the system (they would never be realized) were to set up a municipal and prefectural system identical to that of *France d'Outremer* ("Overseas France," a rather revealing term . . .) extending well beyond the borders of continental France.

Her British Majesty's representatives were guided by a very different fundamental concept: minimal involvement in the everyday life of the natives, leaving the administration to the upper class and the traditional gentry, restoring their rights once they acknowledged the sovereignty of the Crown. Typically, the French administrator was the "commandant"; the British administrator, the "commissioner"; where his French neighbor and counterpart commanded, he was supposed to guide and give counsel.

At least, so went the theory. For the French, setback followed setback while they tried to impose chiefs they had recruited according to nontraditional criteria: junior infantry officers, detached or retired office clerks, who were often foreign to the group, or members of a servile or despised class or caste. Sometimes, a straw chief, a leader in name only and powerless, coexisted with a secret chief designated according to custom and the only one accepted by the population. Soon, the practice was to recruit a member of the dynasty, who was considered acceptable, frequently after laborious, discreet negotiations with legitimate chief-makers. Using tolerance and compromise, the French encountered situations like the one in which the man designated by them as the Chef Supérieur de Première Classe de Ouagadougou was in fact the *mogho naba* (king) of the Mossi (in addition to being a retired captain in the French Army).

The British, on the other hand, ran into a case in which a chief, out of a sense of commitment to traditional institutions, showed an attachment to sacred customs like human sacrifice or ordeal by poison or fire—a predilection difficult to accept in the twentieth century. There again, they often had to resort to discreet pressure or negotiated compromise to bring about a change in practice or a change in chief. Finally, after two generations of European domination, colonizers found themselves (on either side of the frontier), in a comparable situation: chiefs who could, by and large, claim dynastic or traditional legitimacy, but whose attributions and powers had been largely disrupted by the actions, by the incomprehension, of the colonizers. In fact, the English and the Belgians, like the French and the Portuguese, initially saw the chief as a political figure who embodied the three powers enunciated by Montesquieu (the legislative, executive, and judicial powers of government). Seeing the chief in this light, the colonial authorities tried by fair means or foul to manipulate him, all the while remaining completely oblivious of the sacred character of the institution until relatively recently (see, in general, ethnological works in the '40s and '50s). For example, the English literally imposed the exercise of political authority on the *oba* (rulers) of the Yoruba, and the French did the same with the *Fia* (rulers) of the Ewe, even though these monarchs were completely without political power—this did not prevent some of them from acquiring a taste for it.

AFTER INDEPENDENCE THE GOVERNMENTS FACED THE TRADITIONAL ARISTOCRACY

The chiefs' fate after independence has been, to a large degree, but not entirely, a function of the role they played and the attitude they had during the colonial era, *grosso modo*. So-called progressive regimes proved to be hostile to traditional chiefdoms, even when their leaders claimed to have (Sékou Touré in Guinea) or did in fact have (Julius Nyerere in Tanzania) royal blood. For some the political consequences would prove their undoing—the revolutionary Ghanaian and Burkinabe soldiers, who, like their colonial predecessors, underestimated the symbolic importance of the *Asantehene* of Kumasi or of the *Mogho Naba* of Ouagadougou, had to deal with them. By contrast, the kings of Rwanda, Burundi, Lesotho, and Buganda, like the Sultan of Zanzibar, were overthrown by popular uprisings, which were sometimes supported by the army. In the former Zaire, in the southern Sudan, the chiefdoms, at least some of them, survived as well as they could and found themselves with little power amid widespread disorder. In calmer, more heavily policed nations the traditional aristocracy had a fate similar to that of its French counterpart, enjoying social prestige that sometimes amounted to little more than snobbishness, its members adapted to the new system, carrying out local, even national responsibilities within the framework of elective institutions. Ultimately, some chiefs were little more than quaint relics of folklore, drawing on the meager resources of tourism.

It is worth taking a brief look at the cultural and historical contexts to which the leaders in this book belong. Indeed, there are just as many resemblances and differences among them as there are between European nations. A Zulu *Nduna*, for instance, has as much, or as little, in common with an *Akan Hene* as a Prussian Freiherr with a Spanish Grandee. These cultural zones coincided, *grosso modo*, with the major geographic, or more precisely climatic, regions, which conditioned overall lifestyles and ease of travel, elements that affect the political

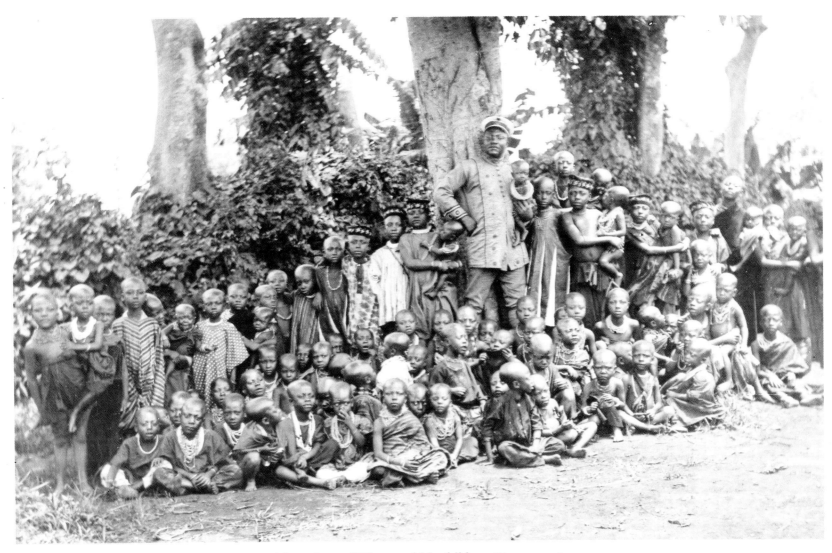

The sultan of Njoya and his children (Cameroon)

institutions. It is a fact that the development of complex specialized structures requires the availability of resources that exceed the immediate needs of subsistence; not only must the king and his court be fed, but he must be given a surplus that he can redistribute. Second, great political formations did not develop in difficult terrains, so a chief's authority could not extend to a point at which it was longer possible or it took too long to communicate his orders and respond to them. But that is not all. The existence of vast empires or kingdoms was linked to the existence of major trade routes, long-distance economic circuits. On the other hand, acephalous societies were nearly always modest in size, often occupying relatively inaccessible refuge zones (desert steppes, rugged mountains or cliffs, dense forests), quite closed to the outside world.

THE SAVANNA: CHOSEN LAND OF THE KINGDOMS OF THE WESTERN SUDAN

It is hardly surprising, therefore, that the great historic empires took root in the large strip of the Sudanese savanna, which extends from the dense forest to the Sahara, from Cape Verde to the Nile Valley. It is an open, virtually flat country, drained from east to west by great, partially navigable rivers, linked by ancient caravan routes to the Maghreb and the Levant, and by forest trails and coastal rivers on the Guinean coast.

Between the eighth and seventeenth centuries, the western Sudan (in Arabic, *bilad as-sudan*, "land of the black peoples") fell under the successive domination of three structurally similar empires. Up to the

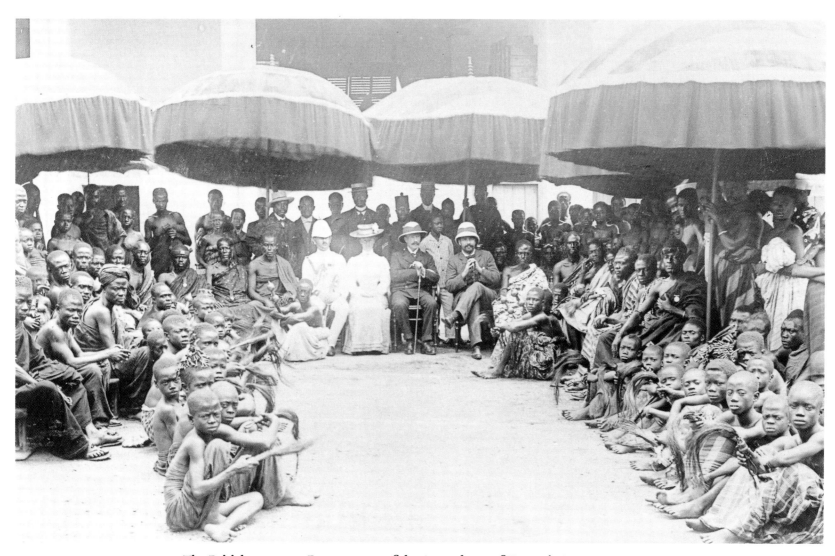

The British governor Byron, guest of the Asantehene of Kumasi (August 7, 1905)

twelfth century, the Soninke Empire of Ghana; from the twelfth to the fifteenth, the Manding Empire of Mali; and finally from the fifteenth to the seventeenth, the Songhai Empire of Gao, destroyed by the Moroccan invasion after their victory at Tondibi (1591). Further east, beyond Lake Chad, in the central Sudan, the Kanem-Bornu Empire, which arose in the eighth century, survived until the end of the nineteenth century (and, though somewhat diminished, even persists in the present time). These states showed marked resemblances to one another; they brought together diverse peoples under the command of an emperor, whose authority rested on his commitment to Islam. This commitment was shared with his principal vassals and senior bureaucrats, while the masses (and the ruler himself in the domestic and private spheres) continued to practice the traditional ethnic cults. Among his subjects, the emperor, the *Amir al-Muslimin* (Commander of the Faithful), was still considered a priest-king, often reputed to be a great magician. He maintained a professional army with the cavalry as its nucleus—a formidable arm in the flatlands—and an administration that did its writing in Arabic, more or less adapted to local languages. He raised revenues from tribute, direct taxes, customs duties and trade monopolies on such commodities as rock salt from the Sahara and gold nuggets from the mines on the forest edge.

When war, famine, pestilence, or a decadent ruling elite brought an empire to its knees, its constituent peoples regained their autonomy and formed or re-formed traditional kingdoms, even though at times their ruler, if he was a descendant of a former imperial governor kept up at least the outward appearances of practicing Islam.

The *Mogho Naba* of Ouagadougou was an exception to the rule. Tourist guides' claims aside, he was not really an emperor. He reigned

over only a segment of an ethnically homogeneous people—he was a divine king, the supposed descendant of a union between a local princess and a foreign hunter, whose daring romance was believed to have produced the founder of the dynasty. In fact, reasonably reliable historical sources seem to indicate that in the fourteenth century, Voltaic- (or Gur-) speaking warrior clans took advantage of the struggle between a declining Mali Empire and a rising Songhai Empire to consolidate themselves into small kingdoms. Acephalous agricultural groups in these kingdoms willingly or unwillingly accepted protection from the heads of bands of horsemen. Among the Mossi and their Dagomba, Mamprusi, and Gurma neighbors and related peoples, we still see traces of the distinction between a hierarchy of "commoners," including village headsmen, provincial governors, and servant-ministers (equerries, gatekeepers, palace guards, head eunuchs, etc.) and an aristocratic hierarchy, the *Nakomse*, who were hereditary heads of districts (or fiefs) and, as such, military leaders. To sum up the situation, the *mogho naba* "rules, but custom governs."

Indeed, custom was the concern of the priestly council, which designated the new monarch from among his predecessor's eldest sons, after a kind of symbolic regency with one of his virgin daughters and one of his grandsons. Throughout his reign the *mogho naba*'s power, though theoretically absolute, was constantly balanced by a whole range of ritual prohibitions, overseen by a joint council of representatives of the *Nakomse* and the commoners, which could prevent his orders from being carried out. This is symbolized by the daily "going-off-to-war" ceremony, in which the ruler does not actually go off to war. What is more, the kingdom of Ouagadougou was quite pacifistic, while the other great Mossi state, Yatenga, with a similar political structure, carried out an expansionist strategy against neighbors and related peoples. This warlike policy did not produce a Mossi Empire, but it did transform the ethnic landscape by driving the Akan into the forest around the fourteenth century.

East of the Mossi nation, the Hausa states took a different path. They had been welded into an empire in the early nineteenth century by a foreign minority whose power had been both dislocated and confirmed by colonial occupation. The Hausa, the largest ethnic group in northwestern Nigeria and southern Niger, formed a complex of peoples, united by a common language. The most widely spoken language in the western Sudan, Hausa seems to be related to the Hamito-Semitic family (it is relatively close to Berber and ancient Egyptian) rather than to the Niger-Congo family, and has been written in Arabic characters since the end of the Middle Ages. The population consisted of a rural industrial mass, the *talaka*, who practiced intense agriculture, and an urban population, residing in large fortified cities, who plied highly developed crafts, and worked in exports and in commercial warehouses at the junction of the Saharan and Sudanese trade routes.

The seven "legitimate" Hausa states (*Hausa Bakwai*)—Daura, Gobir, Katsina, Biram, Kano, Rano, and Zaria—emerged between the tenth and twelfth centuries. According to legend, they were founded by the children from a union between the queen of Daura and a white warrior reputed to have delivered the country from a dragon terrorizing the land.

The legend, which was common to several kingdoms in the region, had special currency in Songhai and Ghana. Interestingly enough, the Hausa founding hero had a dual name (African *Bayajida* and Arabic *Abu Yazid*) although the monarchs did not officially convert to Islam until the fourteenth century. And long before that, the economic impact of the *Hausa Bakwai* brought about a partial assimilation of the seven "illegitimate" states (*Banza Bakwai*)—Kebbi, Zamfara, Yauri, Gwari, Nupe, Ilorin, and Kororofa (Jukun)—in the middle belt of modern Nigeria. None of these states were very active in external warfare, but their frequent internal clashes left them vulnerable to partial subjugation by Mali and Songhai, and in the east by Bornu from whom they borrowed a great deal culturally. At any rate, no Hausa Empire or unified Hausa kingdom ever emerged; instead there were periods when one or other of the states was predominant.

THE FULANI: A PEOPLE OF OBSCURE ORIGINS

In 1804, the situation began to change dramatically. But the principal motor of change was not the Hausa but the Fulani. The Fulani's origins have been the subject of much fanciful speculation. There have been claims that the Fulani were descendants of Jews, Palestinians, Persians, Indians, or even extraterrestrials. More prosaically, the earliest Fulani, in the Neolithic Age, were probably shepherds who started out in the plateaus of East Africa. They worked their way to West Africa through the Sahara (moist at the time) and present-day Mauritania and eventually spread out in small, isolated groups, reaching the Nile Valley in the early twentieth century. With the passage of time, they split into two main groups: the "Red Fulani," who remained nomadic and were hardly Islamized, if at all, and the "Black Fulani," who intermarried with sedentary farmers, all the while preserving their identity as a cultural and linguistic minority. Soon converted to Islam, the "Black Fulani" often served as *Modibbo* (scribes) or worked in urban commercial centers and at the courts of kings, some of whom were animists.

In the western Sudan, the political disintegration triggered by Morocco's attempt at colonization in the seventeenth century and the reaction it provoked, combined with the terrible drought that killed half the population of the Sahel between 1738 and 1756 to set the stage

for a sort of Islamic political revolution. This resulted in the foundation of a series of theocratic states ruled by the Fulani. Originating in present-day Senegal around 1760, the movement rapidly spread east, reaching Hausaland in 1804. That year, the great jurist and theologian Modibbo Usman dan Fodio, the private tutor of the crown prince of Gobir, was outraged at his pupil's attitude and that of other Hausa Sarki toward Islamic law and publicly accused them of hypocrisy, apostasy and heresy. He declared a *jihad*, a holy war, to overthrow them. In addition to strict Muslims (the Fulani and others), many *talaka* (pagan peasants), dismayed at their treatment by city dwellers, joined the movement. By 1809, the total subjugation of the seven "legitimate" Hausa states had been accomplished, symbolized by the construction of a common capital, Sokoto, which gave its name to the empire. Usman dan Fodio set up his eldest son and heir apparent, Muhammad Bello, in the city, entrusting the conquest of the West to his second son, Abdullahi. He ordered his disciple, Modibbo Adama, to conquer the South (Fumbina). Adama would give his name to the vanquished region (Adamawa). By the time Adama died in 1847, the Sokoto Empire embraced the North and the middle belt of present-day Nigeria, the territory of the present Republic of Niger, the northern portion of the Republic of Benin, the Cameroonian plateau and the Benue Basin reaching all the way to Chad. He had conquered the border provinces of the Bornu Empire and the threat he had posed to the Yoruba had prompted them to shift their political capital, Oyo, to the south. Only the pagan Kirdi highlanders and a handful of small, orthodox Muslim states such as Rey Bouba and Wandala, in what is now Cameroon, avoided coming directly under his sway.

Structurally, the empire was more Islamic than African. Former kingdoms became emirates (erroneously labeled sultanates), which were divided into provinces, and in turn subdivided into districts, respectively entrusted to Fulani *lamido* and *lawan*. Their judicial hierarchy of Malekite jurisprudence (*qadis*) consisted of tax collectors responsible for gathering Koranic tithes from Muslims as well as taxes non-Muslims paid in return for security and protection (*dhimmi*). The court and the reigning aristocracy were essentially Fulani, but their minority status meant that there were many mid-level and low-level posts available to qualified Muslims, whatever their origin. Fulbe was the language of the courts; Arabic, the language of the mosques and higher courts; Hausa, the language of the bureaucracy. But soon the sheer size of the empire caused *de facto* decentralization as Fulani nobles and officials formed matrimonial alliances for diplomatic purposes with the families of compliant chiefs. At the time of the conquest in 1905, the emirates were practically autonomous—whatever preeminence Sokoto retained was more a matter of prestige than authority. The English encouraged this tendency by consolidating and even expanding the emirs' political and

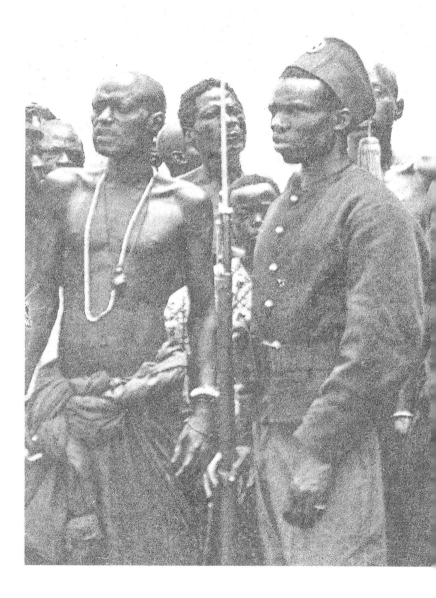

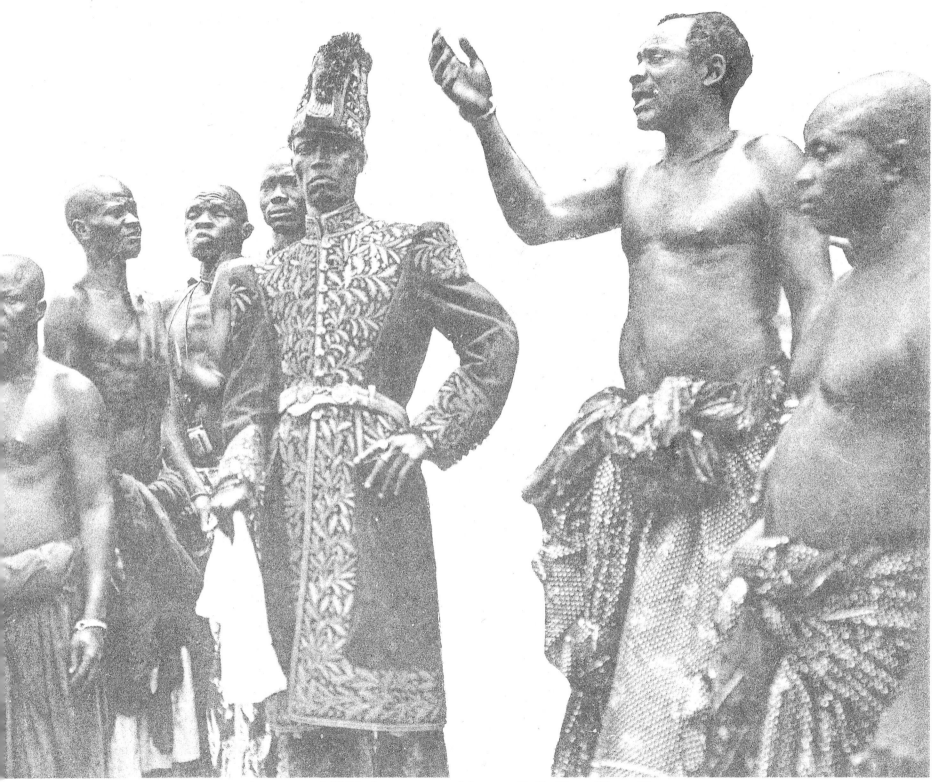

Adji-Ki, the successor of the great Toffa, King of Porto-Novo

administrative power. Colonial partition placed the fringes of the empire in French territory, severing the Cameroon *lamido*'s subordinate relationship with the emir of Yola and incorporating the (sometimes not very traditional) chiefs of the conquered peoples into the colonial hierarchy. Kanem-Bornu, also divided between Chad and Nigeria, suffered a comparable fate: the *mai* of Bornu remained a great ruler in Nigeria, but his vassals and governors in Chad were reduced to the uncertain status of minor local functionaries.

THE YORUBA DRUMS REVERBERATE FROM GUINEA TO BRAZIL

South of the western Sudan's cultural zone, along the coast, from eastern Nigeria to the Ivory Coast forest belt, stretches the area of Lower Guinea, which correlates with the Kwa linguistic group (not to be confused with the Khoi group of the Khalahari). The hinterland is dominated by a dense forest, hollowed out in the middle by the great "Benin" clearing, the result of ancient deforestation. In this rather homogeneous geographical zone the Yoruba is the dominant culture. They influence their coastal neighbors (Edo-Bini, Itsekiri, Igala, Aja, Ewe . . .) and those in the "middle belt" (Nupe, Jukun) and spread beyond the Atlantic to Cuba (Lukumi), to Brazil (Candomblé), and to Jamaica. The major ethnic group in western Nigeria, the Yoruba also inhabit Togo and the present-day Republic of Benin. Their cultural relatives—the Aja, Fon and Ewe residents of Benin—serve as a bridge between them and the dominant culture to the west of the zone, the Akan people of Ghana and Ivory Coast (Ashanti, Baule, Fanti, Anyi . . .).

There never was a Yoruba kingdom, still less a Yoruba empire. But a common pattern emerged in the region involving the Fanti, Ewe,

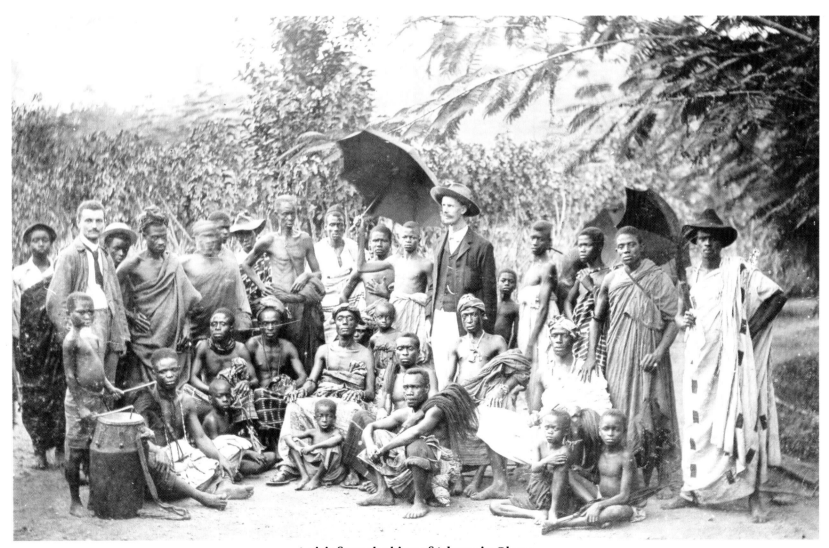

A visit from the king of Adanse in Ghana

18

Ashanti, and other societies, a kind of confederacy of kingdoms grouped around a sort of sanctuary—Ife, the birthplace of the founding hero, not Oyo, the political center and oldest city. This was yet another example of the myth of the white adventurer with a dual African and Arabic name—Olodumare/Lamurudu, whose son, Oduduwa, became the first *oni* of Ife and whose grandsons were the earliest ancestors of the seven crown-bearing kings, including Oranyan, the first *Alafin* of Oyo and genitor of Shango, the *Orisha* (god) of thunder and lightning, who still looms large in the Caribbean and Brazilian pantheon.

This highly decentralized political and economic system was characterized by the size of its cities, the largest and most densely populated in pre-colonial Africa. Each was the nucleus of a kingdom, a sort of city-state entertaining essentially religious ties with Oyo, and particularly Ife. Every *oba* was regarded as a descendant of Oduduwa, the originator of the royal principle rather than the founder of the kingdom as a territorial entity. The *oba* was a sacred figure vested with such cosmic energy that it was dangerous to see or hear him. So he lived as a virtual recluse in his own palace, spoke through an intermediary and wore a mask in public. For his enthronement, he bathed in the blood of his predecessor's eldest son and ate his heart. For British colonizers, however, the *oba* had no political power; his task was limited to performing the rites essential to the state's material and moral well-being. If he proved ineffective, the *Bahorun*, the dean of the council of commoners who designated the monarch and monitored his acts, politely suggested suicide as a solution, failing which he was walled in his palace along with his entire immediate retinue. Real political power rested with the corporate bodies: on one hand, family head and hereditary elders, and the village or district chiefs designated by them; on the other, the representatives of urban craft guilds, and the members of various initiation societies, which bestowed hierarchical titles through initiation or sold them. The women's association, the *Egbe Iyalode*, a ministry for the rights of women, was ahead of its time. But the most important association was the Ogboni Society, on whose counsel the *oba's* life or death depended.

The Edo kingdom of Benin (not to be confused with the modern republic of the same name) was, to some extent, the grandson of Ife and the half-brother of the Yoruba kingdoms. In fact, it is said that around the late twelfth century, the Edo, having overthrown the local Ogiso dynasty, asked Oranyan, the *Alafin* of Oyo, to send them one of his sons, who would father a child with Erinwide, a local princess. Their offspring, Eweka, was the first in a dynasty of thirty-five *obas*. The dynastic seat, Benin City, was an arts capital whose magnificence astonished the British when they sacked the town in 1897.

The *oba* was a divine king similar to the Yoruba monarch, but Benin's political structure was quite different. A distinction was made between the capital, and the rural villages were organized quite differently. The villages, functioning with a highly stratified system of classes distinguished by age, enjoyed considerable autonomy; the *Odiowere*, the eldest member of the senior class, managed internal affairs, while the *Onogie*, selected according to primogeniture from a specialized lineage, represented a cluster of villages at court. A wide central street divided the capital into two distinct entities—the palace and the city—that exercised reciprocal control over each other. The city consisted of four districts, each governed by a guild resembling a palace association. Urban organization was based on a system of titles, some hereditary, others conferred or purchased. The *oba* was considered the incarnation of one of his predecessors; the various parts of his body were magically entrusted to a ritual society, responsible for one of the state cults. Besides the *oba*, there were three orders of chiefs: the seven hereditary Uzama, who designated and crowned the ruler; nineteen nonhereditary town chiefs, who conferred titles on behalf of the *oba* and performed most of the political and administrative tasks; twenty-nine nonhereditary palace chiefs, who were members of three major associations; and finally, one feminine and three masculine junior orders, each with its hierarchical system of titles. The system afforded the opportunity for social mobility (by acquiring titles) and guaranteed a possibility for exercising control that often culminated in Byzantine intrigues, which some *obas* adeptly exploited to consolidate their personal power.

In the sixteenth century, Benin extended its trading supremacy all the way to present-day Togo through a network of coastal lagoons. When the kingdom was allied with Portugal, it converted for a time to Christianity, but in the eighteenth century, a pagan revolt, marked by a growing number of human sacrifices, served as a pretext for an English expedition in 1897.

On the other side of the Niger Delta, in the Bight of Biafra and in the hinterland, the Igbo kingdom of Onitsha was the only state to replicate the Yoruba model; the other Igbo states rested their organization on initiation societies, without an individualized organ of authority. The Efik and Ibibio societies of the Delta and the coast were organized into "houses," built on external trade (slaves before the nineteenth century, oil after that) with initiation societies to adjudicate disputes and manage common interests.

The Yoruba saw their direct influence wane in the western region of the Kwa linguistic zone, where they were supplanted by the Akan peoples, who were dominant in Ghana and in lower Ivory Coast. The Ewe and Fon occupied a sort of cultural transition zone. Until the eighteenth century, all these peoples had functioned in large chiefdoms or small kingdoms, with ritual ancestral traditions rather than political

ties in common. The coast was controlled by groups specializing in the export of slaves bought from the people of the interior in return for European imports. The *coutumes*, taxes paid by the slaving companies to rent the sites where they set up forts and trading posts, complemented the revenues of the coastal city-states, which paid a pittance to their suppliers in the interior. To challenge this monopoly and open up direct sea access, two mighty kingdoms began to arise in the late seventeenth century. They were more secular than the Yoruba and Bini systems: Dahomey, or the kingdom of Abomey of the Aja-Fon peoples, and the Ashanti Confederacy, or the kingdom of Kumasi of the Akan.

The Aja were dissident Yoruba, who revolted against the *oba* of Ketu in the sixteenth century. From then on, they challenged the ritual and political eminence of Ife and Oyo. In the early seventeenth century, Do-Aklin, an Aja chief in the interior, imposed his authority over the Fon inhabitants of the Abomey plateau, who bore linguistic and cultural resemblances to the Ewe, who in turn had distant ties with the Yoruba of Tado. His grandson Wegbaja (late seventeenth century) instituted Dahomey's organization and initiated the push to the sea. The fifth *Daada* captured the coastal kingdom of Allada in 1724; his successor took Ouidah in 1747. These towns played a central role in the slave trade, and Dahomey overcame Yoruba opposition to maintain its ascendancy along the Slave Coast until it was conquered in 1894 by French colonial troops led by General Dodds of Senegal.

Though the *Daada* of Dahomey ruled by divine right, he was neither a god-king nor a priest-king. The cult of kingship, symbolized by the scepters and thrones of deceased kings, was the purview of a commoner/minister, on whose shoulders rested prohibitions similar to those of the Yoruba kings. The king was assisted by a council of ministers, but they were commoners who could be removed *ad nutum*. There can be no doubt that it was the king who exercised royal power; practice was divorced from principle. He designated his successor, the Vidaxo (whose mother must not be of royal blood) early enough so that his successor would be closely linked to kingly authority to avoid succession disputes. Though village headsmen were selected from among the local elders, they owed their power to the king and were restrained by a kind of minister of police. The army, with its celebrated cadre of Amazons, the core of the royal guard, was partially composed of permanent units, mainly consisting of mercenaries and foreign slaves. A *Yovogan* (minister of whites) oversaw the slave trade and European imports, both of which were heavily taxed. The whole system seems comprehensible to the Western mind, but it is important not to make too much of its seeming secularity. The *Festival of Grandes Coutumes*, an annual celebration of the kingship cult, involved dozens, even hundreds of human sacrifices over the royal tombs.

The Akan were located further west. Though linguistic evidence indicates they probably shared a distant origin with the Yoruba, they were not part of the same migratory wave. The Akan had trade links to the great Empires of the western Sudan and must have reached the ocean by making the long trek across the forest, beginning sometime during the thirteenth or fourteenth century. Portuguese accounts from the late fifteenth century attest to the presence, on the coast, of Manding trade centers targeting the hinterland. Diverting this caravan traffic in favor of Portuguese maritime traffic (the Elmina–Saint-Georges de la Mine trading post, 1581) made it possible to consolidate the Akan slave-trading kingdoms on the Gold Coast and the Ivory Coast at the expense of the Ga-Adangme and Ewe lagoon network, which had formerly been under the thumb of Benin. The situation was similar to that of the Slave Coast; the Anyi of Indénié, the Fanti of Denkyera, the Akwapim of Akwamu monopolized the slave trade, refused to let Europeans penetrate the interior, and denied the people of the interior direct access to the coast. Hence, once again at the close of the seventeenth century, the Ashanti response paralleled that of the Aja of Dahomey, though it took a different form.

The Akan's system was matrilineal. In other words, social membership and personal status were acquired in the womb, through maternal ancestry. The men still wielded political authority, but for every male chief there was a female chief primarily concerned with issues of genealogy and ancestry. Each *oman* (state) was subdivided into *abusua* (lineage territories) occupied by a matrilineage dating back some ten generations, in one or more villages. The chiefs, at all levels, were elected. The *abusua* chiefs were elected by the free adults of both sexes; village chiefs by the lineage elders (men and women); the paramount chief, the *omanhene*, by the council of representatives of the *abusua* in the capital, on a proposition by the queen mother and subject to the assent of the *asafo*, the general assembly of citizens. Chiefs could be deposed at any time through the same process that elected them. Before the establishment of the confederation, the states were bound not only by common culture, but by temporary alliances directed against the coastal states in particular, especially Denkyera. It is said that following one of these campaigns in 1701, after a defeat of Denkyera at Feyiase, the divine priest Okomfo Anokye brought the Golden Throne and Sacred Sword down from the sky and gave them to Osei Tutu, the *Omanhene* of Kumasi. They served as a symbol to the Confederacy, and from then on, the chief of Kumasi and his descendants bore the title of *asantehene*.

It is important to remember that, unlike Dahomey, Ashante was

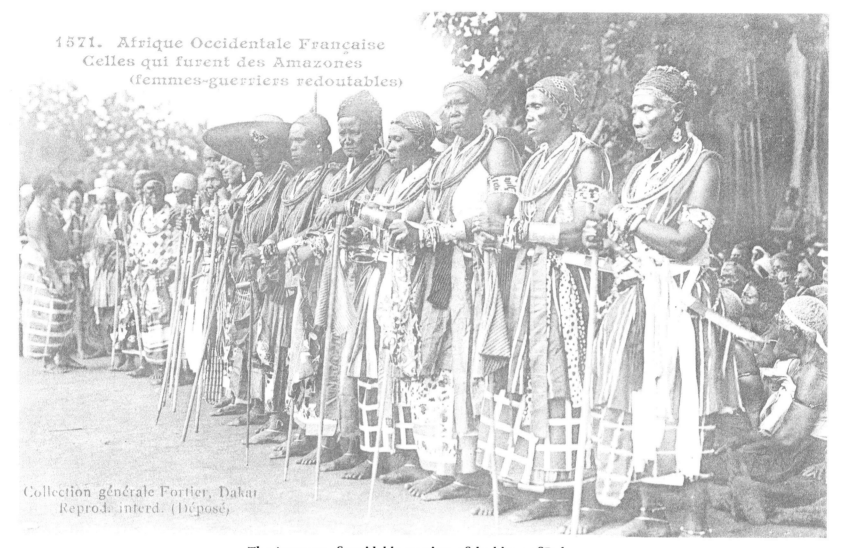

The Amazons, formidable warriors of the kings of Dahomey

not a centralized state, but a confederacy, replicating on a larger scale the model of its member states. Whereas the *Daada* of Abomey appointed provincial governors, the *asantehene* recognized the elected junior chiefs, who, in their turn, paid him homage. But beside his guard which served as a standing army, the king maintained an officer corps in each of his states. The officers were charged with organizing the peacetime levies and training of warriors mobilized in case of war, in addition to keeping an eye on local chiefs on the *asantehene*'s behalf. In terms of fiscal and economic organization, Ashante resembled Dahomey with royal monopolies on slaves and gold exports, and on gunpowder and firearms imports and customs duties, in addition to the granting and taxing of markets. The system was very effective indeed. It took British colonizers eight campaigns, from 1811 to 1896, to defeat it. The British governor's attempt to sit on the Golden Throne (no one had the right to sit

on the throne because it *was* the kingdom), provoked a violent revolt in 1900. As a result, the *Asantehene* Prempeh was deposed and the Confederacy dissolved. This turned out to be a temporary situation, however; bowing to public pressure, the colonial administration restored the confederacy and reinstalled Prempeh in 1935. After independence, President Nkrumah, a coastal Akan of Denkyera, was scarcely more successful in subduing the Ashanti. There was one consolation—unlike Dahomey, the kingdom never succeeded in opening an outlet to the sea.

As it turned out, the coastal states (Fanti, Ga-Adangme, or Ewe), feeling threatened, wasted little time in calling on European military support, as early as the nineteenth century. Organized into small trading towns, (the Fanti formed a federation on the initiative of the British resident consul), their government could best be described as corporate. Their chiefs often had European surnames inherited from

passing sailors (Mantse and Konor with the Ga, Fia with the Ewe) and played a role that was more symbolic than political or military.

THE GREAT BANTU KINGDOMS
ALONG THE COPPER AND LIVESTOCK ROUTES

The vast Bantu domain combined great linguistic homogeneity with cultural diversity rivaling that of West Africa. Researchers place the original ancestral home of the Bantu (or rather pre-Bantu) languages on the plateau shared by Nigeria and Cameroon in the Benue Basin. Divergences in these languages must have begun to appear in the early Iron Age (about 300 B.C.), when early metalworkers developed technical superiority over Neolithic cultivators. This explains the relatively rapid Bantu migration. Bantu-speakers reached the Upper Congo and the interlacustrine zone around the seventh or eighth century A.D. and the shores of the Indian Ocean around the tenth century, before being brought to a halt by Dutch colonists at the cape on the Fish River as the eighteenth century came to a close. Present-day Bantu speakers display a diversity of social institutions and physical types that can undoubtedly be traced to the absorption of previous populations and to adaptation to various biotypes.

In northwestern Cameroon, near the prehistoric starting-point for the migration, the tiny Bamiléké-Bamum states showed marked resemblances to their Nigerian neighbors. These resemblances include lost-wax bronze casting reminiscent of Benin; rich men's initiation societies, recalling similar associations among the Igbo and Efik peoples; and masked judicial societies, to cite only a few. The region was divided into autonomous groups, each perched on its own mountain, operating as competitors and partners in the trade network that led to the Bight of Biafra. Organization into chiefdoms was not a very ancient practice (seventeenth century). Ritual societies still restrained royal power, however real, particularly with regard to military and judicial matters. They also checked and balanced one another. In the overall scheme of things, the Bamum kingdom of Foumban was something of an exception. Situated on the doorstep of the Sokoto empire, it converted to Islam in the late nineteenth century. Like its Fulani neighbors and enemies, it retained every aspect of its previous politico-ritual system that could possibly buttress royal power. Njoya, the last of the precolonial rulers, earned enduring fame for inventing one of the rare writing systems of African origin, rejecting any use of Arabic and Latin alphabets.

The Bamiléké-Bamum group belonged culturally and economically to West Africa, opening onto the Sudan through Adamawa and onto Lower Guinea through Calabar and the Oil Rivers region. There was

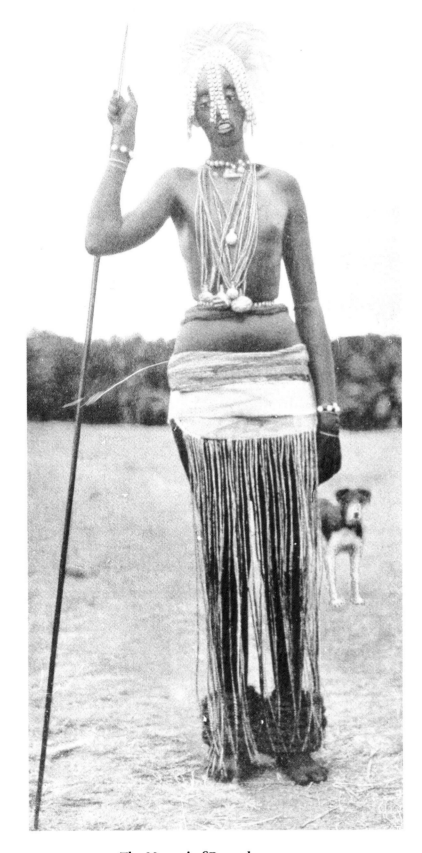

The Mwami of Rwanda

no need for long-distance caravans and voyages; merchandise traveled from one chiefdom to another, from one border market to another. But a genuine integration into an exchange network did take place over the long haul. The link between the network and systems farther south and east in the Bantu expansion zone was weak or nonexistent.

This area is partially covered in the Congo Basin by the dense equatorial forest, hardly a favorable environment for travel (except on the navigable waterways) or the development of large human settlements. It was only on the margin of the savanna or cleared forest that the necessary conditions were likely to be present. The states under consideration could be situated more or less along two areas. One, subequatorial, going east-west, on the southern border of the forest; the other, going north-south, from one tropic to the other, on the high plateaus along the eastern Great Rift Valley. Their intersection was located approximately at the former Zaire-Zambia frontier, where the great Scottish linguist Malcolm Guthrie situated the dispersion point of the proto-Bantu migration from the plateau that joined Nigeria and Cameroon.

HUNTER-MAGICIAN KALULA ILUNGA FOUNDS THE LUBA EMPIRE

The dispersion point coincides with the prehistoric home of the Luba kingdoms. Indeed, there is archeological evidence to suggest the presence, in about the eighth century, of a population of agriculturalist/metalworkers (iron and copper). The differentiation in burial places, where copper was used as a precious metal, indicates social stratification. Oral traditions chronicle legendary kingdoms dating back to this distant period, but it was only around the fifteenth century that their existence was actually confirmed. On the other hand, the roots of present-day African political organization reach no further back than the sixteenth century. Legend says that the first Mulopwe, the founder of the empire somewhere between 1500 and 1550, was the hunter-magician Kalula Ilunga. He usurped power by killing King Nkongolo, his maternal uncle and *pater familias* in the matrilineal society. This founding myth in all probability reflects a political transformation initiated by external intervention. Indeed, the political system was based on patrilineal descent groups, not familial organization. In addition to (and perhaps in contrast to) the royal cult, the religion essentially involved ancestor worship associated with the land, invoked by spirit mediums, with a highly elaborate feminine initiation, the *cisunga*. The territory was divided on one hand between chiefdoms whose origins antedated Kalula Ilunga, with hereditary vassal chiefs directly responsible to the Mulopwe, and on the other, conquered provinces, administered by governors appointed with his consent. When he died, his court was dissolved, and there ensued a period of ritualized anarchy until the new king was crowned and his half-brothers executed or sent into exile.

The Luba Empire was not really an empire until the seventeenth century when it reduced a number of neighboring peoples (Songye, Kanyok, Lulua . . .) to vassals, while preserving pre-existing structures and "Lubanized" them by setting up Luba garrisons and colonists. Since the end of that century, the *mulopwe's* political authority has been contested in a rivalry, lasting to this day, between the Kasai-Luba and the Katanga-Luba. The Mulopwe's ritual preeminence has endured. Thus, the supposed empire was, above all, a cultural community that influenced the entire Zambezi-Congo axis, along the copper export routes, beginning at least in the late thirteenth century, at any rate before Kalula Ilunga's supposed reign.

Kalula's son (or nephew) Cibinda Ilunga, a hunter and blacksmith, is said to have founded the Lunda dynasty (in fact the Aruund), by seducing Rweej, the daughter of Chief Yala Mwaku, who was in illegal possession of the *lukano*, a bracelet made of human tendons, incarnating the kingship. Again, Lunda's political structures had been established before the reported event, which may correspond to a dynastic change in favor of a Luba lineage. The political structure of the Aruund was one of the polities that most closely resembles an absolute monarchy. Possession of the lukano bracelet invested the Mwaant Yaav with a quasi-divinity, with an authority from which all chiefs and minor dignitaries derived their powers. Their relationships adhered to the rules of a fictitious legal family relationship so that people who assumed a responsibility or rank were automatically vested with their predecessor's status and relationships ("child" becomes "father," "nephew" becomes "uncle," "brother" becomes "brother," etc.), without reference to their biological relationships. The system guaranteed political stability, enabling the Lunda to expand their sphere of influence as far as the Atlantic and the Indian oceans. It was the basis of Chokwe and Imbangala kingdoms of Angola and what was then Zaire; of the Lwena, Bemba, Bisa and Lula of Zambia; and particularly, in the eighteenth century, of Kazembe, "son" of the *Mwaant Yaav*, the junction point of the transcontinental trade routes, which dominated the region's economy until 1870.

The relatively pacifistic Kuba kingdom of the Bushong people stood in sharp contrast to the often fiercely expansionist Luba kingdom and, above all, of the Aruund. The Kuba kingdom was, in fact, a confederacy of chiefdoms, whose ruler, Nyimi was the chief of the Bushong clan. He held essentially judicial and ritualistic authority; his political power was confined to nominating some of the chief's advisers in each chiefdom. The Kuba's dynastic historiography was particularly elaborate, both in terms of oral tradition (some facts could be pre-

cisely dated by referring to solar eclipses preserved in oral memory), and plastic arts (somewhat like Dahomey, where every reign was represented in sculpture that symbolized major events).

If the dominant commodity of the east-west was copper, that of the north-south axis was large livestock. The north-south migration route necessarily traversed an open biotype (savanna or clear forest), at an altitude (above 1,500 feet) beyond the reach of the tsetse fly, the carrier of the bovine trypanosomiasis. Pure pastoralism, typical of nomadic life, was limited to the northern and southern portions of the zone. It was practiced by non-Bantu groups who organized into classes by age rather than chiefdoms or kingdoms. The primary economic activity was sedentary agropastoralism; cattle-raising remained the preserve of men of the aristocracy. These sedentary agropastoralists were indeed the Bantu, but their genesis indicates a fusion between agriculturalist/metal-workers from the west and Hamito-Semitic (more specifically Cushitic) or Nilotic, linguistically assimilated pastoralists from the north. The process is historically well-documented with respect to the Great Lakes kingdoms. Buganda, the northernmost of these communities, succeeded Kitara, a more ancient state, whose existence was considered the stuff of myth until the discovery of the ruins of its capital, Bigo, after the World War II. The reigning Chwezi dynasty, established in the eighth century, came down from the northeast—from what is now Ethiopia—and consequently was Cushitic-speaking. At its apogee in the fifteenth century, Kitara encompassed the southern portion of present-day Uganda and northern Rwanda. But at the close of the century, a new pastoral influx, Nilotic this time, caused the kingdom to explode and the Chwezi dynasty to decline, though it has survived to this day in the dominant Hima and Tutsi castes. The Nilotic invaders were at the origin of the Bito dynasty, to which the current rulers of Bunyoro and Buganda belong.

Founded in the sixteenth century, Buganda had a somewhat different political and economic structure than its neighbors to the south. No doubt a climate less favorable for cattle-raising gave the Bataka, cultivators of Bantu origin, a more privileged social position than the Hutu of Rwanda and Burundi. They had representation on the *Lukiko*, the royal council presided over by the *Katikoro* (the principal minister). His ritual functions included the arrangement of royal marriages, an important task, since the *Kabaka's* children belonged to their maternal clan, and thus the size and variety of the royal harem made the court representative of the whole country. From the seventeenth century on, the provincial chiefs were no longer hereditary, but chosen by the *Kabaka* from the pages who also made up the royal guard. The monarch's political authority was real, but limited by a system of rites and etiquette, controlled by the *Lukiko*.

A ZULU "NAPOLEON" MAKES SOUTH AFRICA TREMBLE

The great cluster of Nguni groups, that included, from south to north, the Xhosa, Zulu, Swazi, and Ndebele (or Matabele) occupied the southeastern portion of the agropastoral zone. Until the beginning of the nineteenth century, the Nguni were unaware of the great kingdoms. Much like the Xhosa, the Nguni had formed autonomous clans, which were sometimes enemies, sometimes allies. The links between clans were largely cultural and linguistic. Instead of the classic pastoralist-agriculturalist dichotomy of the northern kingdoms, gender division characterized Nguni social and economic organization; the men tended the livestock and the women cultivated the fields. In the early nineteenth century, Shaka, the (illegitimate) chief of the small Zulu clan (in the future Transvaal), displayed such military and political genius that the English colonists on the Cape dubbed him the "Bantu Napoleon." In a few short years, he subjugated, by iron and fire, the Nguni in the North in a series of battles. As a result, he incorporated vanquished survivors into the Zulu fold and forged a nation that was the dread of all South Africa. His unbridled power (he ordered the execution of the divines who were supposed to keep him in check) led to his assassination in 1828. His successors may have lacked his skills, but they were a constant headache to the Boers and the English; the Zulu were not conquered until 1906. To this day, their keen sense of nation brings them into conflict with the Bantu peoples of South Africa, particularly the Xhosa and the Sotho.

A consequence of Shaka's adventures was that some of his generals, who had fallen into disgrace, deserted with their troops and headed north (almost to Lake Victoria), subjugating the populations and building kingdoms, somewhat similar to the Zulu model. The most famous of these leaders was Mzilikazi. He and his forces migrated to the land of the Shona in the southern part of present-day Zimbabwe, where he founded the Ndebele kingdom. The state had three strata, or castes—an aristocracy consisting of Nguni warriors and their descendants; an intermediate level with the Sotho auxiliary corps of his army as the nucleus; and an enslaved peasantry of Shona origin. In the same period, Sebetwane, a chief of the Sotho (the Nguni's western neighbors), fled from the Zulu and seized the Lozi (or Rotse) kingdom of the upper Zambezi. His policy of peaceful assimilation was shunned by his successors, the Kololo. In 1868, their tyranny sparked a Lozi uprising and led to the restoration of the original Luba-Lunda dynasty.

It is interesting to note that like the Lozi, the Shona belonged to the copper axis rather than the livestock one. Farther north in present-day Tanzania, the Sukuma and the Nyamwezi did not found large kingdoms, but, like the Zulu and the Ganda, they built an agropastoral

economy with cattle-raising as the prestigious activity. In the nineteenth century, their organization revealed the military influence of the Nguni groups heading north, and, above all, the economic impact of their insertion into the trade network of Swahili merchant adventurers, who blazed caravan trails from the continental coast of the Zanzibar Sultanate to the middle of the Congo Valley. In return for slaves and ivory, the Swahili bartered firearms to the subcontractors, who operated in bands, much like Nguni *impi* (regiments). Some mercenaries freelanced, setting themselves up more or less permanently, as local chiefs.

Msiri, a Nyamwezi, was one of these. In 1858, he transformed his troop of *bayéké* (elephant hunters) into an independent company of soldiers. At the expense of the Luba and Lunda chiefdoms, he carved out his personal kingdom of Garengazé, and used military force to divert trade to it from Kazembe in 1870. He gave his conquered lands institutions that were largely inspired by local societies: titles, which could be procured in exchange for slaves; a royal monopoly on salt, copper, and ivory; an administration that echoed the Nguni tradition of militarism within the state based on the royal guard—its *bayéké* and their rifles. The brutality with which the system was put in place eventually touched off a popular uprising and paved the way for the Belgian intervention of 1891. During that operation, Msiri killed Captain Dobson, who had wounded him mortally.

The ephemeral kingdom of Garengazé has survived Msiri in the form of a chiefdom in Katanga province, the present-day Shaba.

The French governor and the king of Abomey, Agboli-Agbo, riding in a Berliet

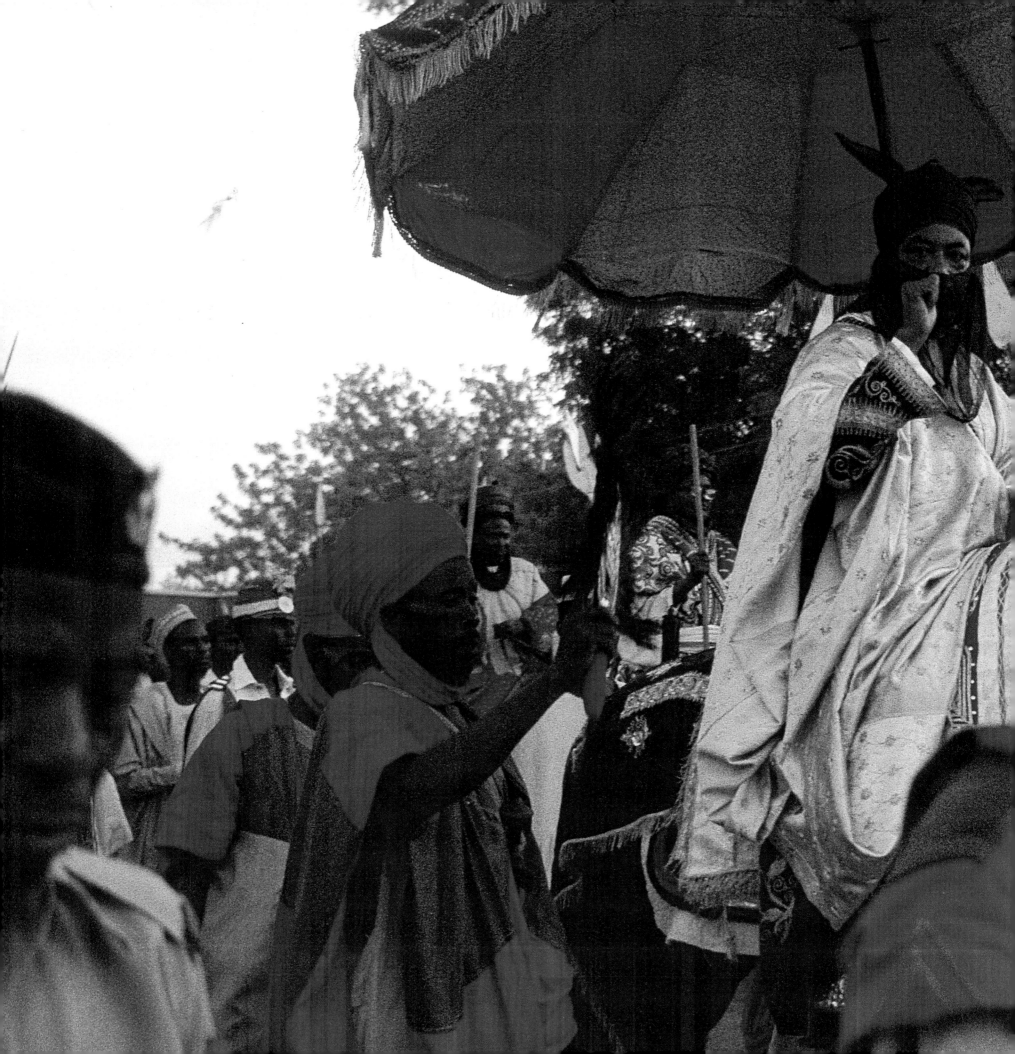

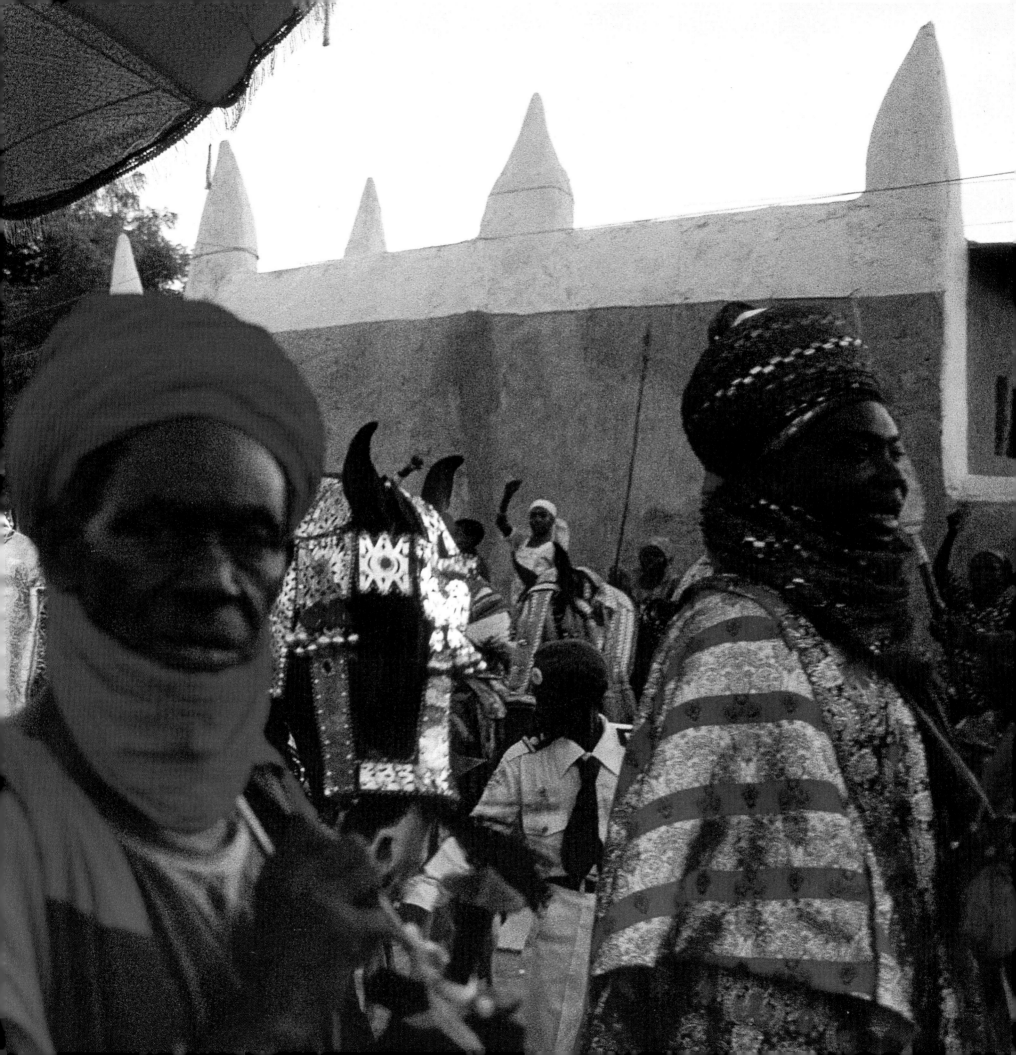

IGWE KENNETH NNAJI ONYEMAEKE ORIZU III, the Obi of

Nnewi. When ex-farmer Kenneth Nnaji ascended the throne of Nnewi in 1963, he and his ten wives already had thirty children. Located to the east of the Niger River in Igboland, the wealthy town boasts a number of millionaires. The kingdom, founded in the fourteenth century, is comprised of four large villages. The Portuguese arrived in the region around the sixteenth century, and many city-states arose. Like Nnewi, they were built on the slave trade. Trade had brought them into existence; they lived for it and took a dim view of the creation of a state that brought together the Igbo, Yoruba, and Hausa under the Nigerian banner. The three ethnic groups were as different from one another as the Swedes, the French, and the Italians are from one another. It did not take long for ethnic strife to erupt. In 1966, some Hausa, Muslims from the North, massacred thousands of Igbo in the region to the slogan "Attack the pagans." On May 26, 1967, the Eastern Region Consultative Assembly, of which Nnewi was a member, voted to secede from Nigeria and proclaimed Biafra an independent republic. The government was determined to crush the rebellion. During the two-year war, the federal government employed a strategy of starving the Biafrans by barring access to the ports. Half a million Biafrans, mostly children, perished from hunger and malnutrition. By January 1970, resistance had become futile and Biafra rejoined the Federal Republic of Nigeria.

Previous pages:
El Hadj Ado Bayero,
the Emir of Kano, parading
during Durbar in Sala, Nigeria

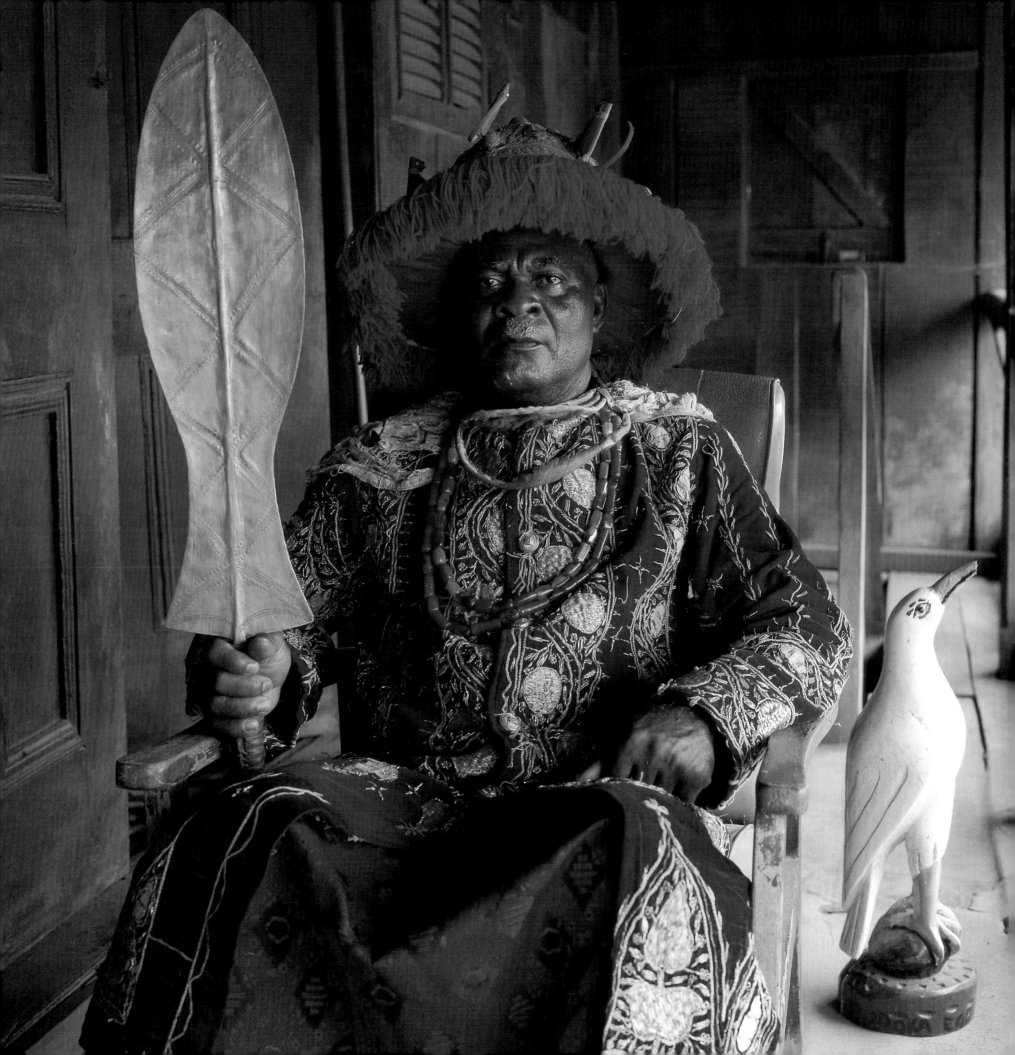

EL HADJ MAMADOU KABIR USMAN, Emir of Katsina. The Emir of Katsina is a polo devotee whose

family has given Nigeria several champions. In the twelfth century, Katsina was only a village in Hausaland governed by the Durbawa, a royal dynasty that had emigrated from a region whose name has been forgotten over the years. One of its kings, Janzawa, married Katsina, a princess from Daura, another Hausa state. She gave her name to the village, which became the terminus of the trans-Saharan trade route from Tripoli. Before the jihad, the inhabitants of Katsina depended for their prosperity and security on the Sarki's strength and good health. If the god king showed any sign of mental or physical weakness, the palace nobles chose his successor, whom they would put under a black ox whose throat had been slit. The new Sarki was then bathed and purified in the blood of the ox while one of the lords strangled the deposed sovereign. The late ruler was then wrapped in the hide of the ox and buried standing up!

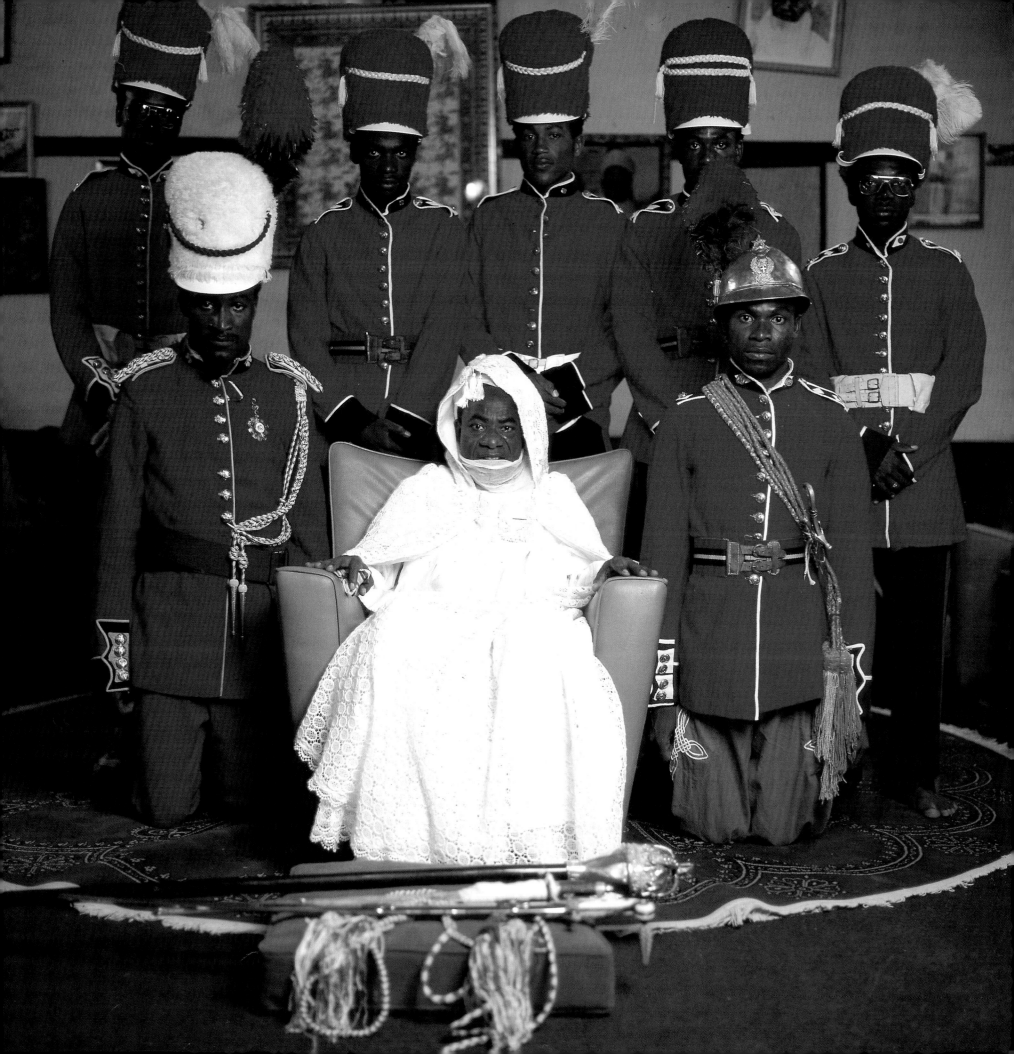

OBA OLANES OWOSOFO, Timi of Ede.

The Timi of Ede is one of sixteen Yoruba kings permitted to wear the beaded crown. In the past, the people revered the *oba* (king) as a god. He wore clothes forbidden to common mortals and he alone took shelter under a state umbrella. He appeared in public three times a year, his face veiled by beaded strands hanging from his crown because it was strictly forbidden for anyone to see his face. It was said that the unbearable intensity of his regard would strike anyone blind who chanced looked at him. Day and night, a corps of *emese-odi* (page-slaves) attended the sovereign. They tasted his meals, rolled around in his bed and if it passed the test, they declared, "there are no scorpions." Some of his slaves became ambassadors or spies. The senior *Odi* was the power behind the throne, a fomenter of palace intrigue. In fact, in Yoruba the same word denotes "servant" and "noble." The *oba* was a prisoner of his station; he had no real power. He belonged to the kingdom. Every year, the priests consulted the *Ifa* (oracle) to determine the king's fate. If it was decided he should die, the chiefs

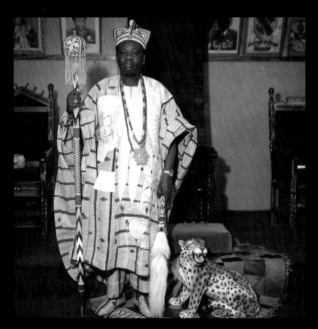

Oba Iyiola Oyewale, the Ataoja of Oshogbo

sent him a parrot egg. Then the sovereign had no alternative but to commit suicide. When the new king was enthroned, he performed a complex ritual. To unite his soul with the late monarch's, he ate his predecessor's heart or kept his head at home. The myth says that at the dawn of time, the world was nothing but a swamp. Oduduwa, son of Olorun, the unique god of the Yoruba, came down to Earth with the help of a chain. He held a handful of earth, a young rooster, and a palm kernel. Oduduwa tossed the earth into the water, and Ife, the first Yoruba kingdom, emerged from the waves. Oduduwa planted the palm kernel in a hole dug by the young rooster and it produced a powerful tree with sixteen branches—the sixteen dynasties of the Yoruba kingdoms.

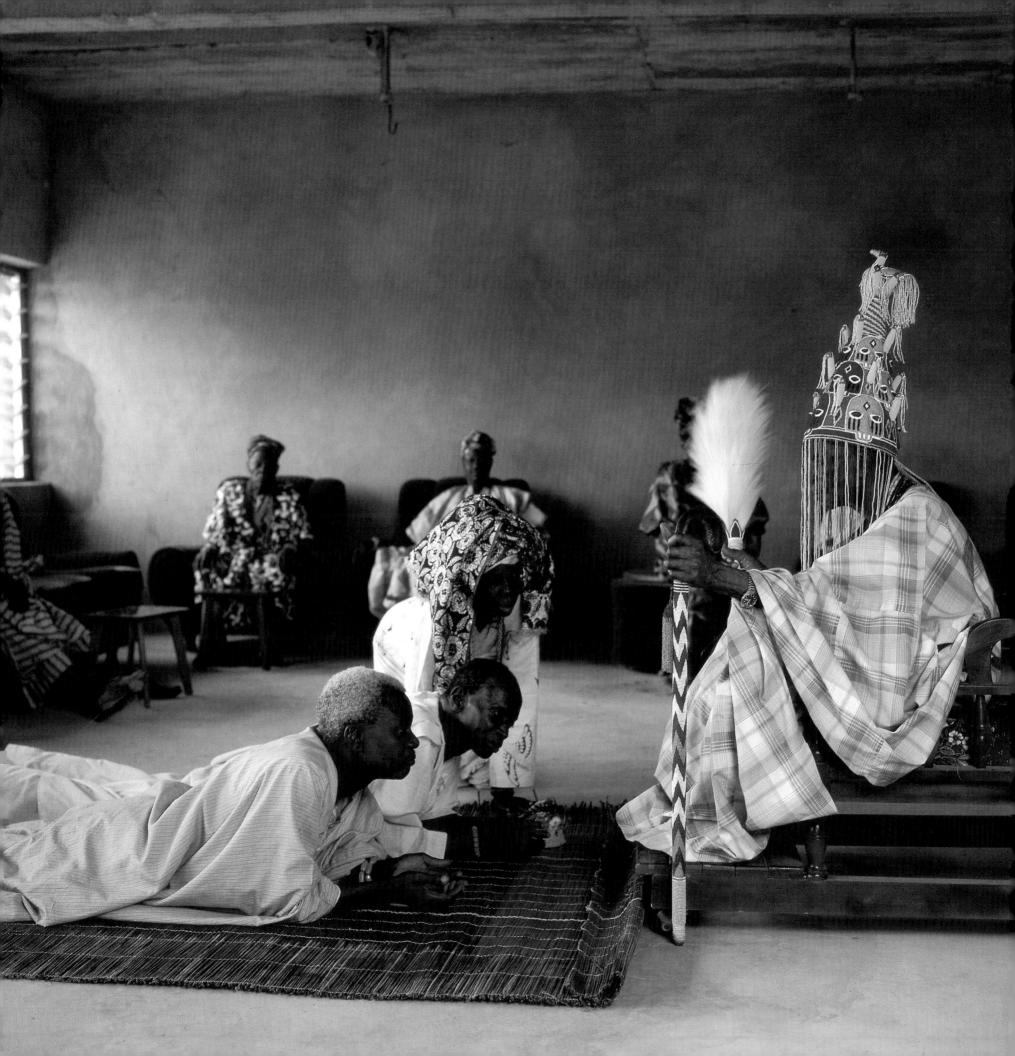

OBA JOSEPH ADEKOLA OGUNOYE, Olowo of Owo. Six hundred years ago, the *Olowo* (king) fell in love with the very beautiful goddess Orensen. Unfortunately for the king, she could not live with a man because she was not allowed to witness a woman grinding spices, drawing water from a well, or throwing firewood on the ground. The king loved the goddess and wanted to marry her, so he assured her that his other wives would observe these injunctions in front of her. Several years went by and the king's wives grew jealous of the goddess and rebelled. They performed the forbidden acts in front of her. Out of revenge, she cast a spell on the entire kingdom, vowing to make the people of Owo die of famine or disease unless the king and his chiefs held a ceremony in her honor every year and the drums begged her forgiveness and sang her praises for seventeen years. She also demanded that a man and a woman be offered to her in sacrifice. The ceremony, known as *Igogo*, is performed to this day, but since English colonization, a sheep and a goat have been sacrificed instead of humans.

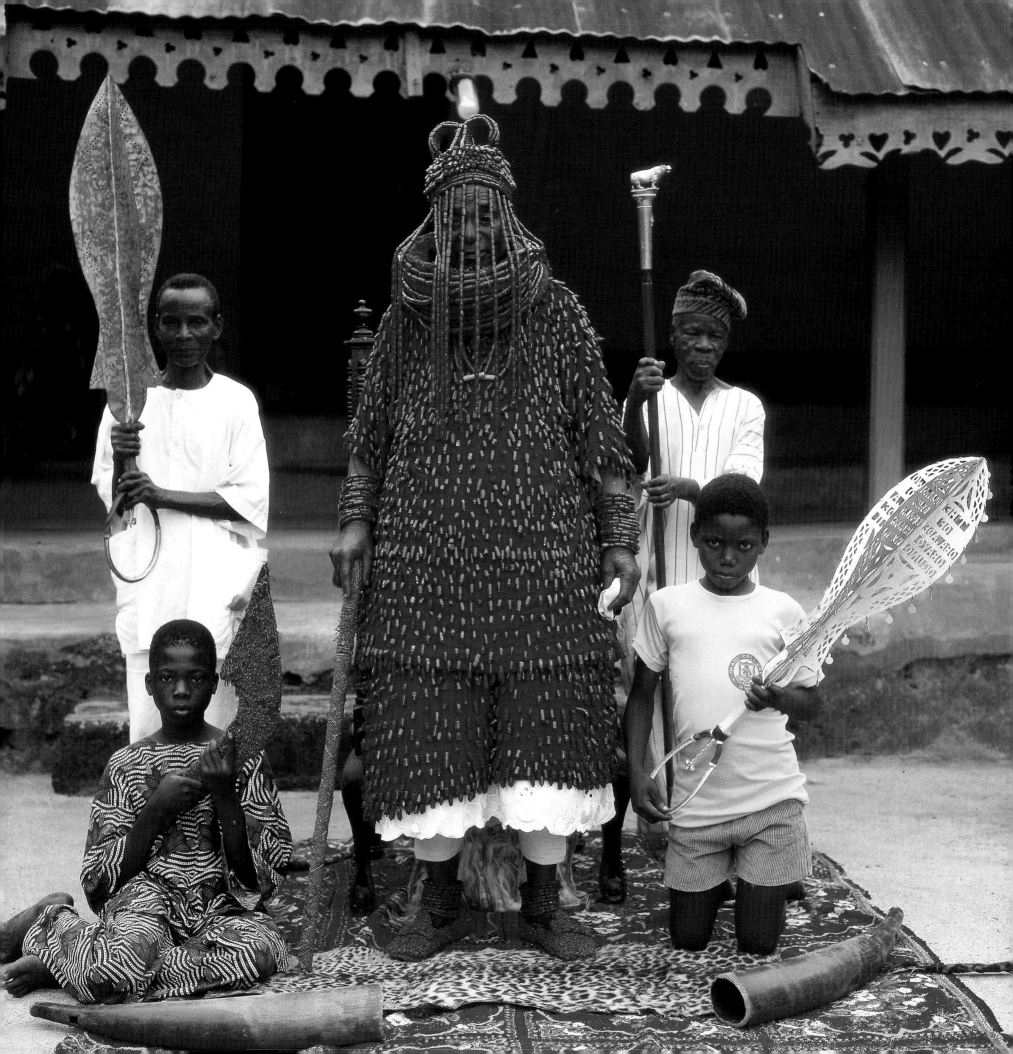

NNANI ISHIODU I OGBUAGU, Obi Agwara Onye Okwe, Eze Igwe of Oguta. Oguta is a
small village in Imo State in southern Nigeria. At the time of this photograph, the king was seventy-seven years old. He
worked as a policeman and a photographer before his enthronement in 1973. Four hundred and fifty years ago, the
kingdom of Benin was at its apogee. Thirsting for conquest, the *Oba* (king) of Benin waged fratricidal war, exhausting
many of his chiefs. Among them were the chiefs of Lagos, Ahoda, Owo and Oguta, whose people wandered across
Igboland before founding a kingdom, modeled after Benin. Like the latter, Oguta was a constitutional monarchy similar
to present-day European monarchies. The affairs of the realm were administered by a bicameral legislature with one
house for the king and the aristocracy and the other for the people's representatives. Since colonization, the king has no
longer had the power of life and death over his subjects. He holds traditional powers; he renders justice, adjudicates
property disputes, keeps the civil registry up to date, and makes sure his people vote regularly during elections.

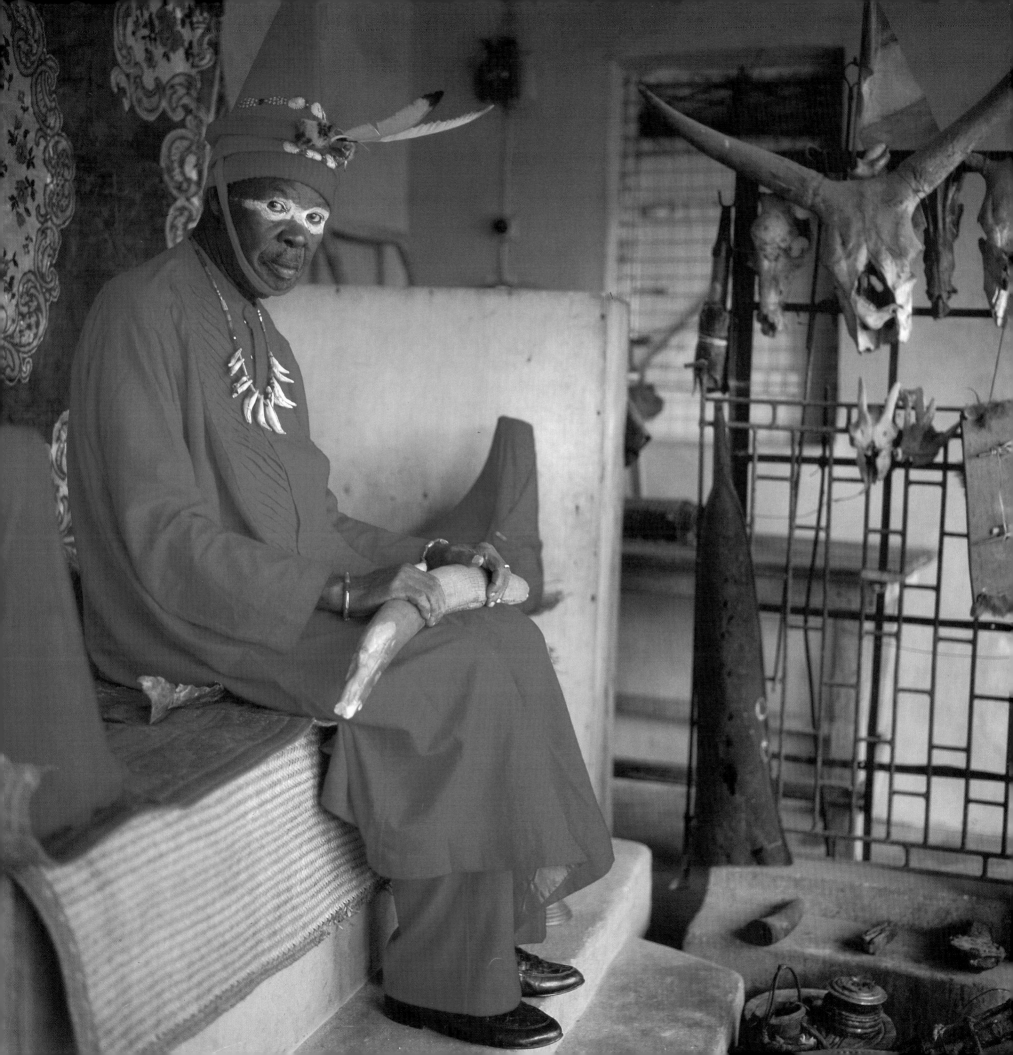

ALIYU MUSTAPHA, Lamido of Adamawa. One day Adama, who was known as *Modibo* ("the Well-Read"), learned that the great cleric Usman dan Fodio had declared a *jihad* (holy war) in Gobir and the Hausa states. He invited representatives from every Fulani state to come to Sokoto to receive his guidance and instructions so that they could prepare for the *jihad* when they returned home. Adama was one of the Fulani delegates from Fumbina (south) who attended, and he was chosen by *Shehu* Usman to receive the symbol of the *jihad*, the Muslim standard of power. The *Shehu* told them, "Those who obey him, will be obeying me. Those who oppose him will be opposing me and the commands of the Almighty." Adama became the *Lamido* of Fumbina, or ruler of the South. He converted the pagan peoples to Islam and erected mosques in conquered nations. The *Lamido* chose Yola as his capital and inducted forty-two Fulani chiefs, each of whom was ordered to found a kingdom. Every year, Adama sent Usman dan Fodio a number of slaves and a herd of oxen. When he died, his vast territory became Adamawa, which now covers part of southwestern Nigeria and the whole of northern Cameroon. Today, the *Lamido* has sixty children and is the chancellor of Ahmadu Bello University in Zaria, one of the most prestigious universities in Africa.

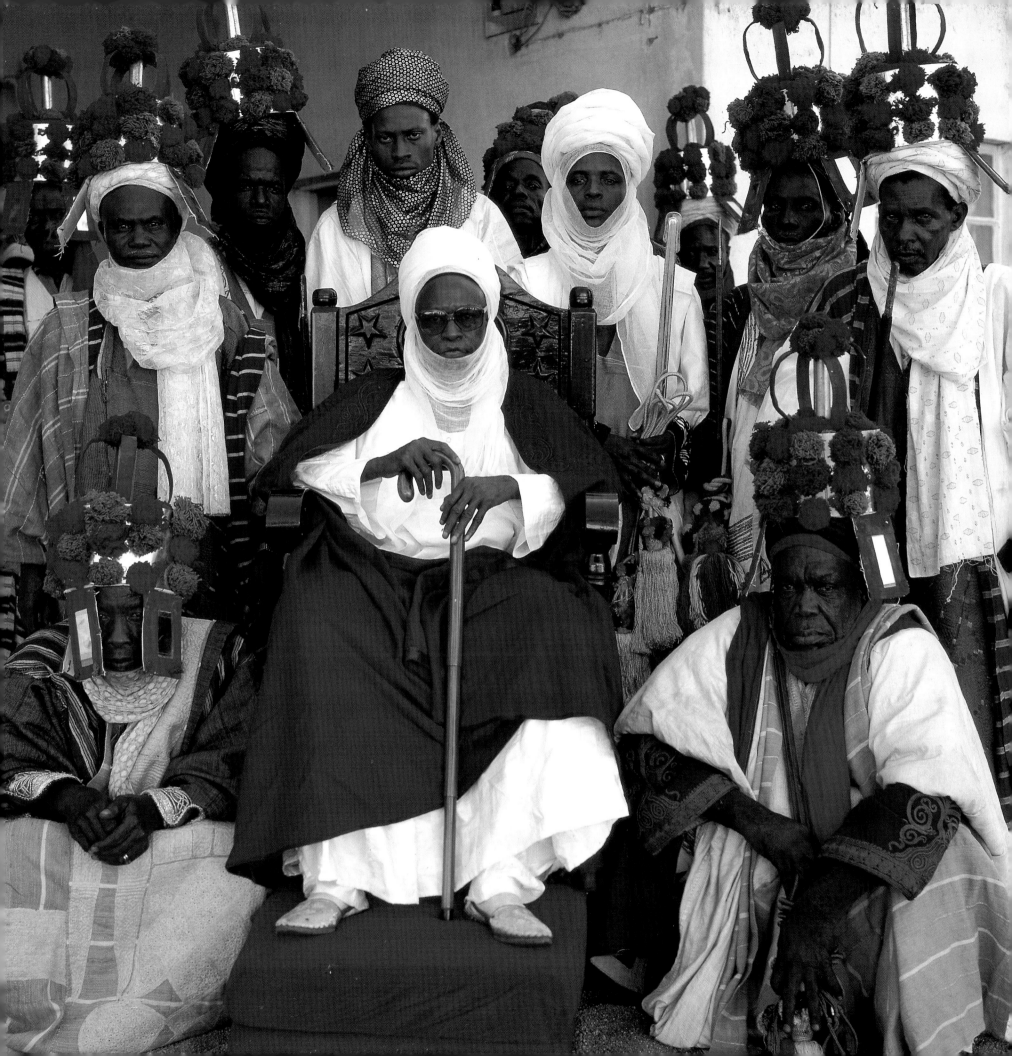

AL HADJ NIMAR EL KANEMI, Shehu of Bornu. El-Kanemi is the heir to the most ancient kingdom in Africa.

At its zenith, Kanem-Bornu was bigger than France, stretching from Nigeria to present-day Sudan. Positioned in the middle of Africa, on the shores of Lake Chad, it has been protected from the invasions that toppled the great Empires of Mali and Ghana. Kanem-Bornu controlled the Nile route that linked the Atlantic Ocean to the Red Sea, from Dakar to Mecca. All the important trade in the region passed through Kanem-Bornu, making the empire a major cultural crossroads, under the influence of the Arabs. The Kanuri people soon learned erotic sophistication and love techniques from the Arabs. They gained the reputation throughout Africa and the Arab nations for having the best eunuch harem guards. Kanuri women were the *nec plus ultra* of royal harems. According to oral tradition, little red Stone Age men lived on the shores of Lake Chad in the beginning of the eighth century. When Sayf, the first *mai* (king) of Kanem settled there, they were assimilated or massacred. The Sefawa dynasty, which ruled Kanem-Bornu for more than ten centuries, was one of the longest in history. The dynasty owed its longevity to an impeccable line of rulers and remarkably supple government. Whenever the Tuareg, Jukun, or Bulala threatened their borders, they would shift their capital from one end of the empire to the other. They guaranteed their nobles' loyalty by giving them enough autonomy so they would not be tempted to challenge royal authority. The *mai*, a god-king and cult object, held the destiny of his subjects in his hands. A virtual recluse in his palace, he rarely appeared in public and attended his ministers' council meetings in a cage, masked by a veil. The few people who could approach him, such as the queen mother or his eldest sister, sometimes appropriated his immense powers. Their political influence was considerable. All the ministers and senior bureaucrats were slaves. Kanem-Bornu was the first African state to equip its soldiers with firearms. In the early thirteenth century, the famous *Mai Dunawa II* could send into battle more than thirty thousand men on horseback or on camels and the same number of foot soldiers.

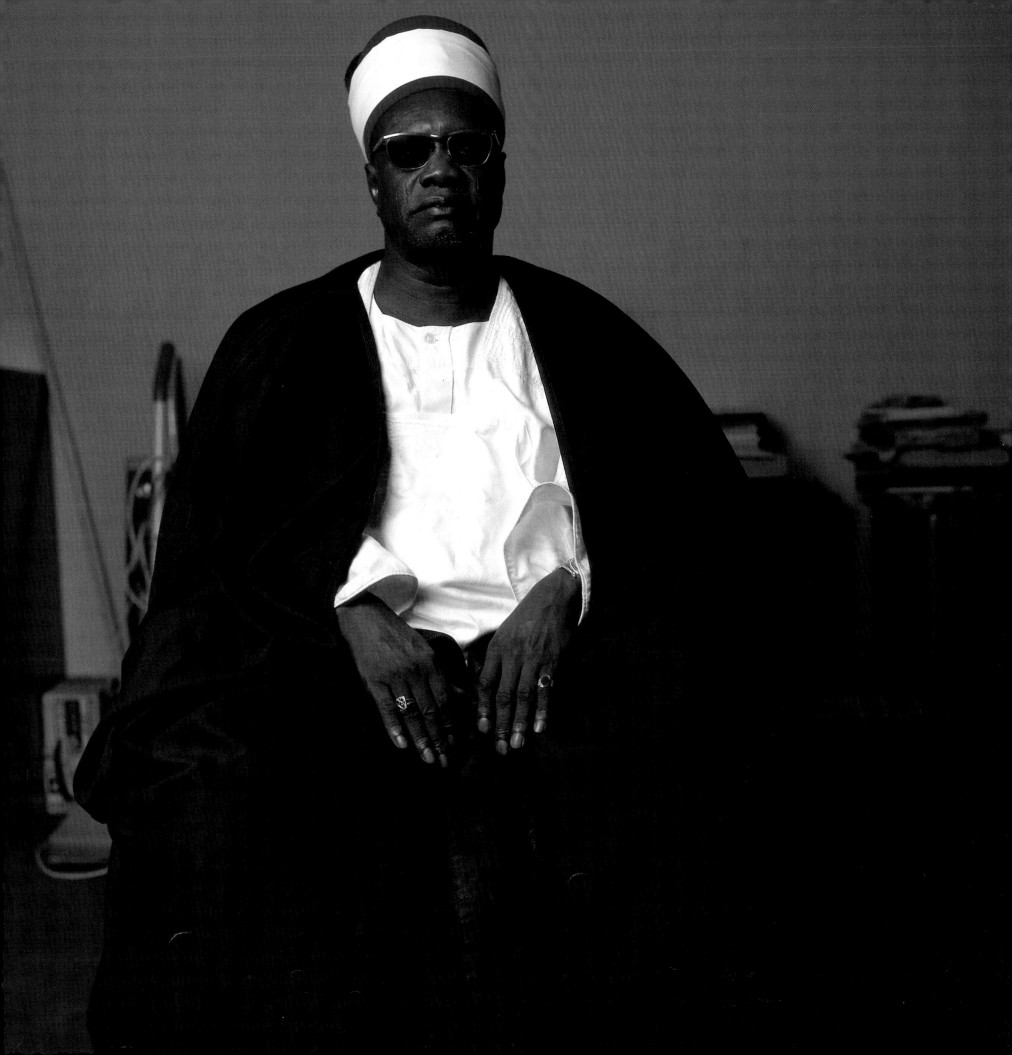

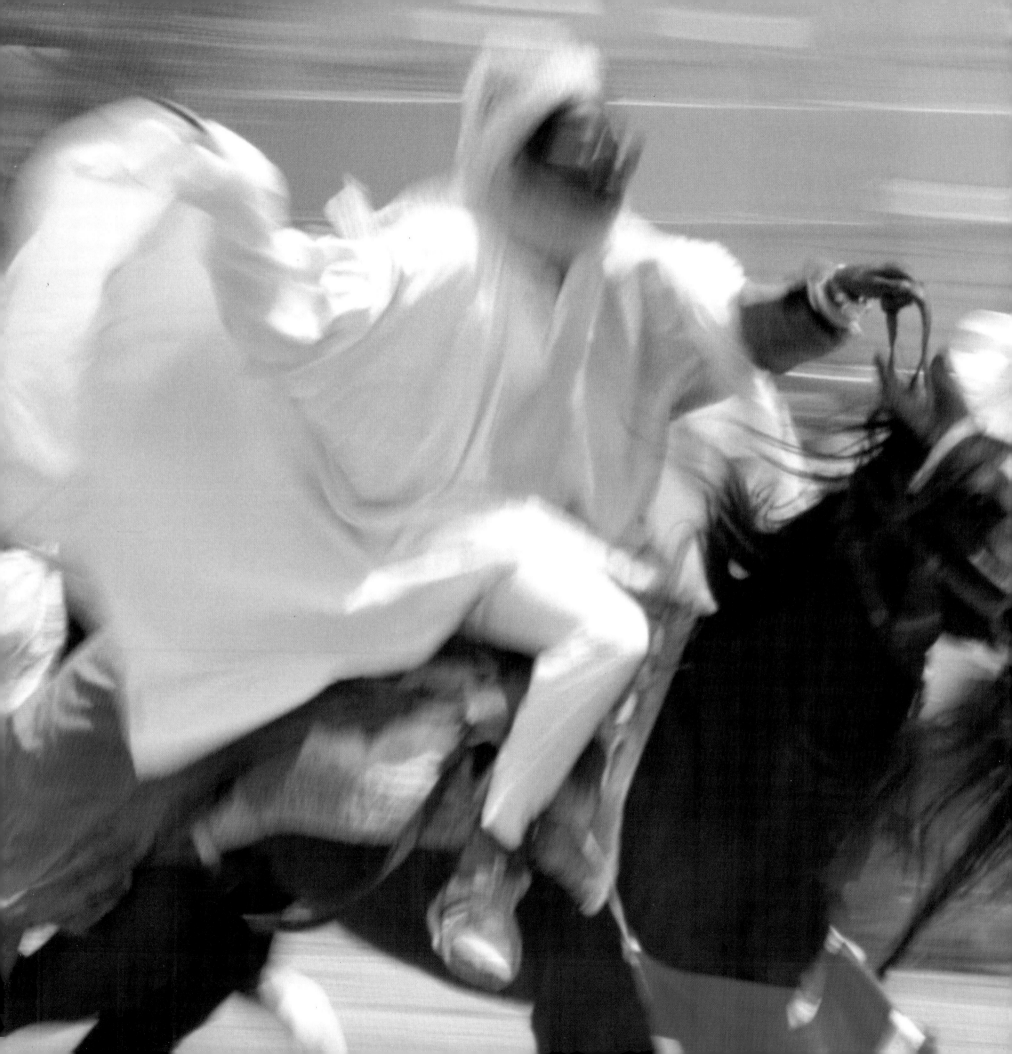

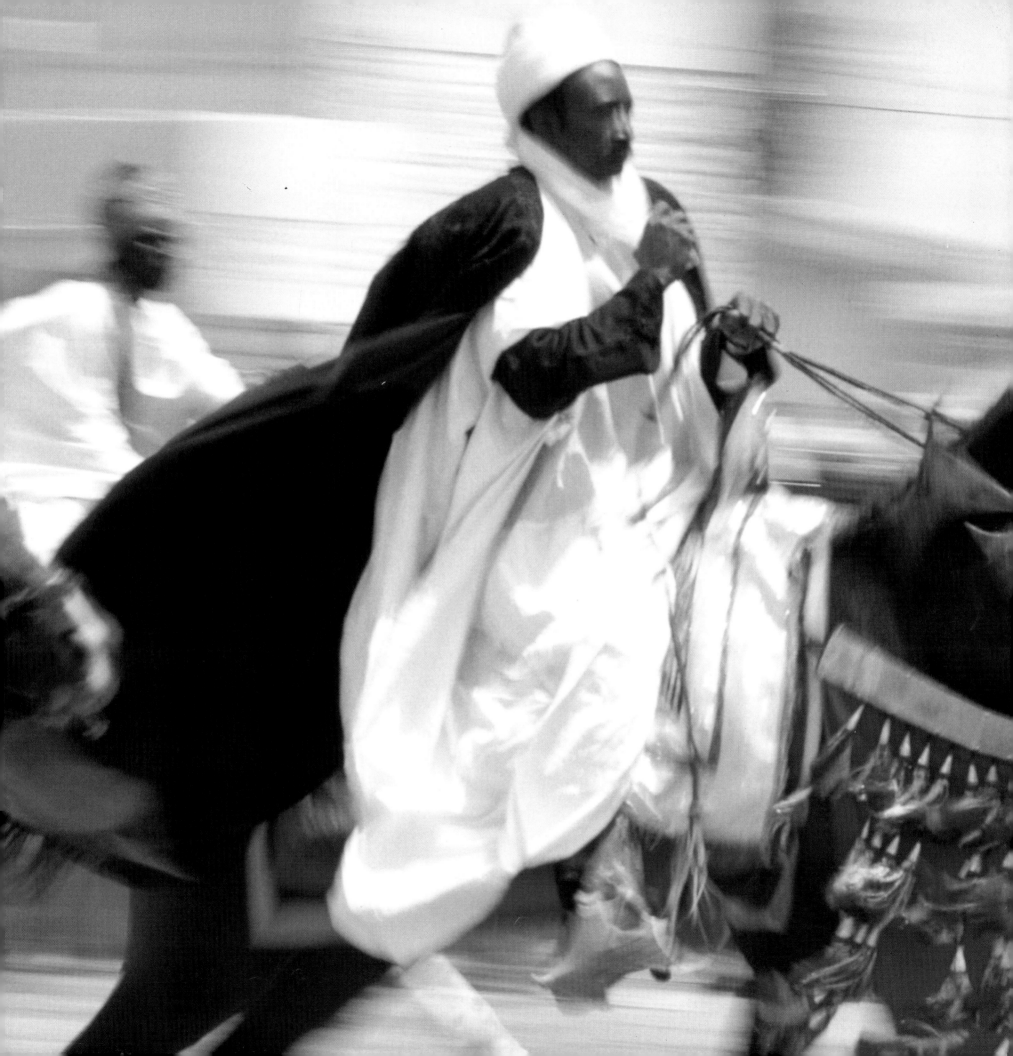

EL HADJ SHEHU IDRIS, Emir of Zaria.

Two women marked the history of the Hausa city of Zaria, even though it converted to Islam around the beginning of the sixteenth century. The first, Queen Bakwa Turunka was authoritarian but wise. She succeeded in repelling an invasion by the Jukun, whose soldiers had the reputation of not leaving behind any survivors. In 1670, coming from the south, the Jukun invaded Katsina, another Hausa city, massacring part of the population. Some survived because the Jukun general died after being kicked by a horse. In 1576 Princess Amina, Queen Bakwa's eldest daughter, succeeded her. Preferring the battlefield to the salon, Princess Amina had no wish to get married. For thirty-five years, she scored one victory after another, opening up trade routes from the north and the south. She was the first person in Hausaland to have eunuchs and the first to have kola nuts. At the time of her death, Zaria was the greatest slave market in Hausaland.

The Emir of Zaria's guards

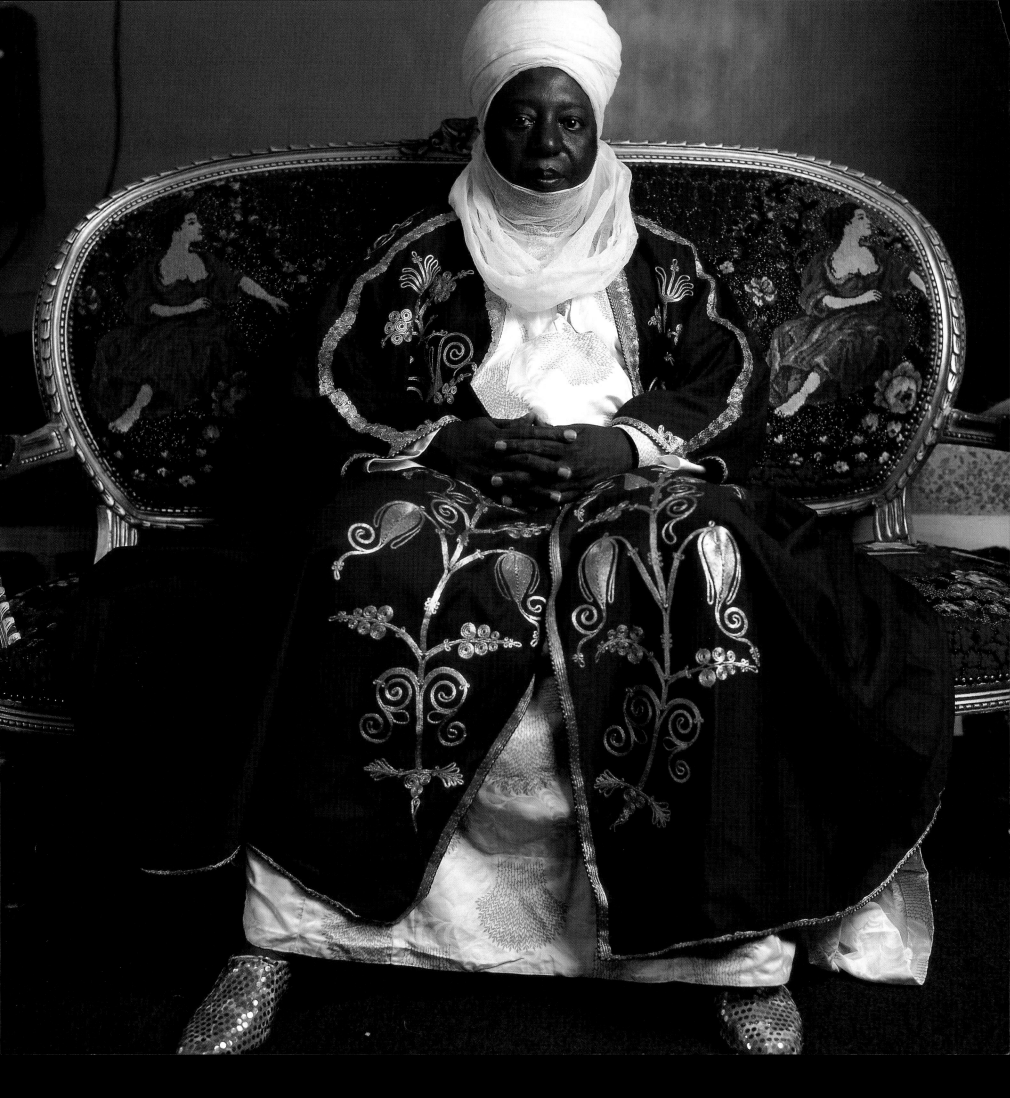

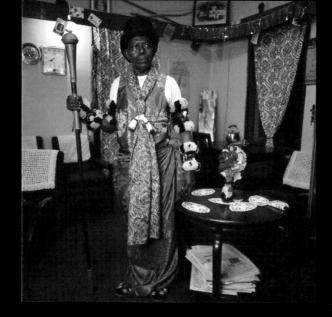

An Efik chief from Cross River, Calabar

EDIDEM OTU EKPE NYONG, Effa IX, Obong of Calabar, King of the Efik. Otu became *Obong* of Calabar, king of

the Efik of Cross River, in 1987. At seventeen years of age, he saw combat with the West African Frontier Force. After demobilization, he worked in an office, and then in a hospital in Port Harcourt. In 1948, like many young Nigerians, he studied law at Holborn College in London. When the Biafran War erupted, he founded an Old Calabar popular movement to oppose Biafran secession, claiming that Biafra was part of one nation, Nigeria. Nigerian president General Gowon was impressed with the *Obong*'s federalist views and helped him open a law office, which he directed until his enthronement. The *Obong* of Calabar belongs to the Atai dynasty, which ruled Ibom in the tenth century. Through various marriages and alliances between clans, he founded the kingdom of Old Calabar, which was described in the accounts of navigator Fernando Po, who visited the state in 1472. The Obong is also a sacred priest, who increases his powers through occult rituals. The Efik are jointly governed by the king and two secret societies, the Noem and the Ekpe. This trinity was all-powerful before colonization. Its members donned masks and went out into the night to execute their victims.

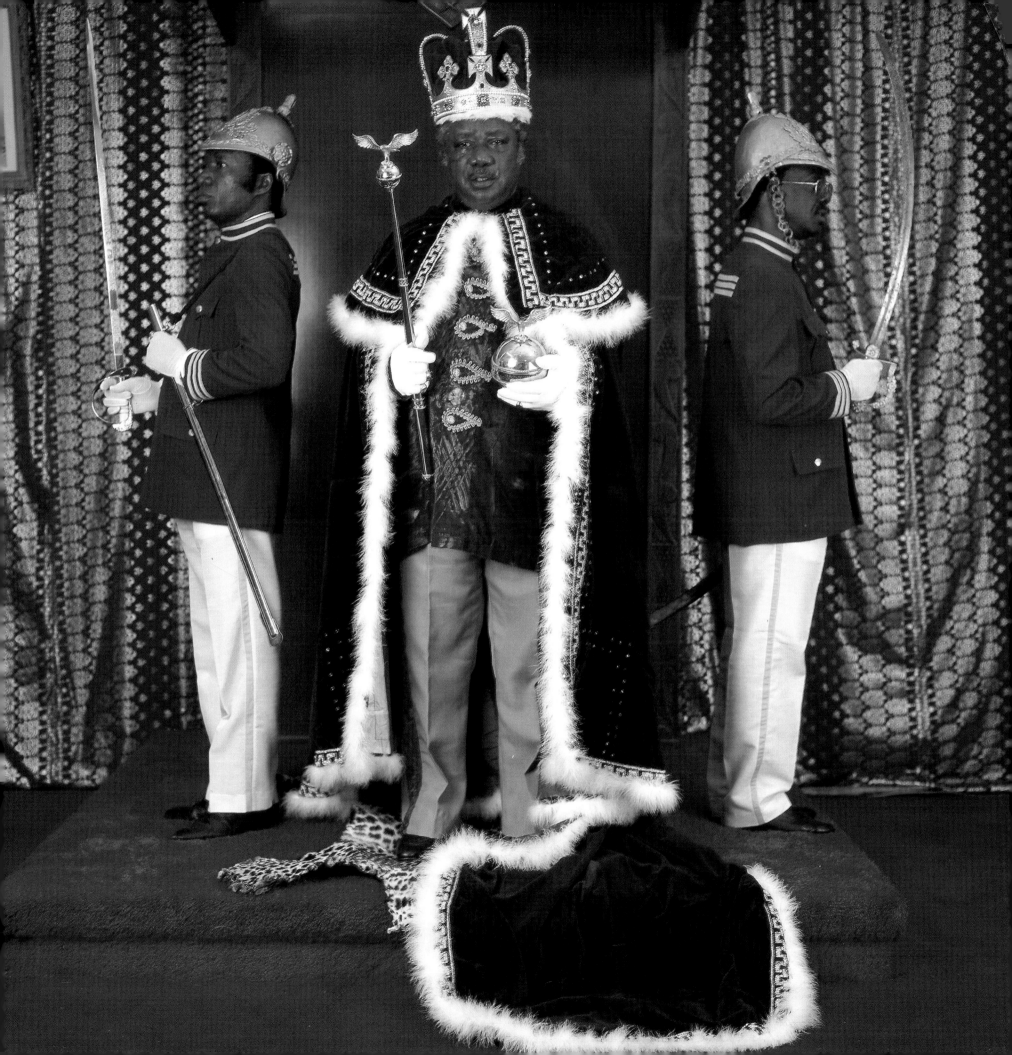

ABUBAKAR SIDIQ, Sultan of Sokoto, Commander of the Faithful. This photograph was taken two weeks before the

Sultan's death. His reign had lasted over fifty years. A council of kingmakers chose his successor. At the time of the coronation, a dispute broke out. Two royal families contested the choice. A hundred people were killed as a result of the struggle. A poll by the major Nigerian weekly, *News Watch*, attested to the Sultan's power. Most of the people surveyed said they would rather be the sultan than the president of the country. Abubakar Sidiq was not as wealthy as other Nigerian monarchs. He needed his annual income of almost a million naira ($200,000) to support his suite of 86 people and feed his 350 grandchildren. He was the successor of *Shehu* Usman dan Fodio, the founder of the Fulani Empire of Sokoto and a legendary figure throughout West Africa. A devout Muslim, Usman dan Fodio preached the return of strict Islam from town to town in every Hausa kingdom in northern Nigeria. His religious conviction and faith fascinated people. He denounced oppression by the great princes, corruption, and debauchery. He made enemies. The powerful ruler of Gobir even tried to assassinate him. Usman and his supporters managed to escape and he declared a holy war on infidels. At the time he was fifty years of age and he was suffering from leprosy. With a handful of determined mujahedin, Usman routed Hausa troops, ten times more numerous. He pursued his *jihad* throughout northern Nigeria, subjugating the Hausa states one after the other. When he died, his empire stretched from the northern part of the Republic of Benin to Cameroon.

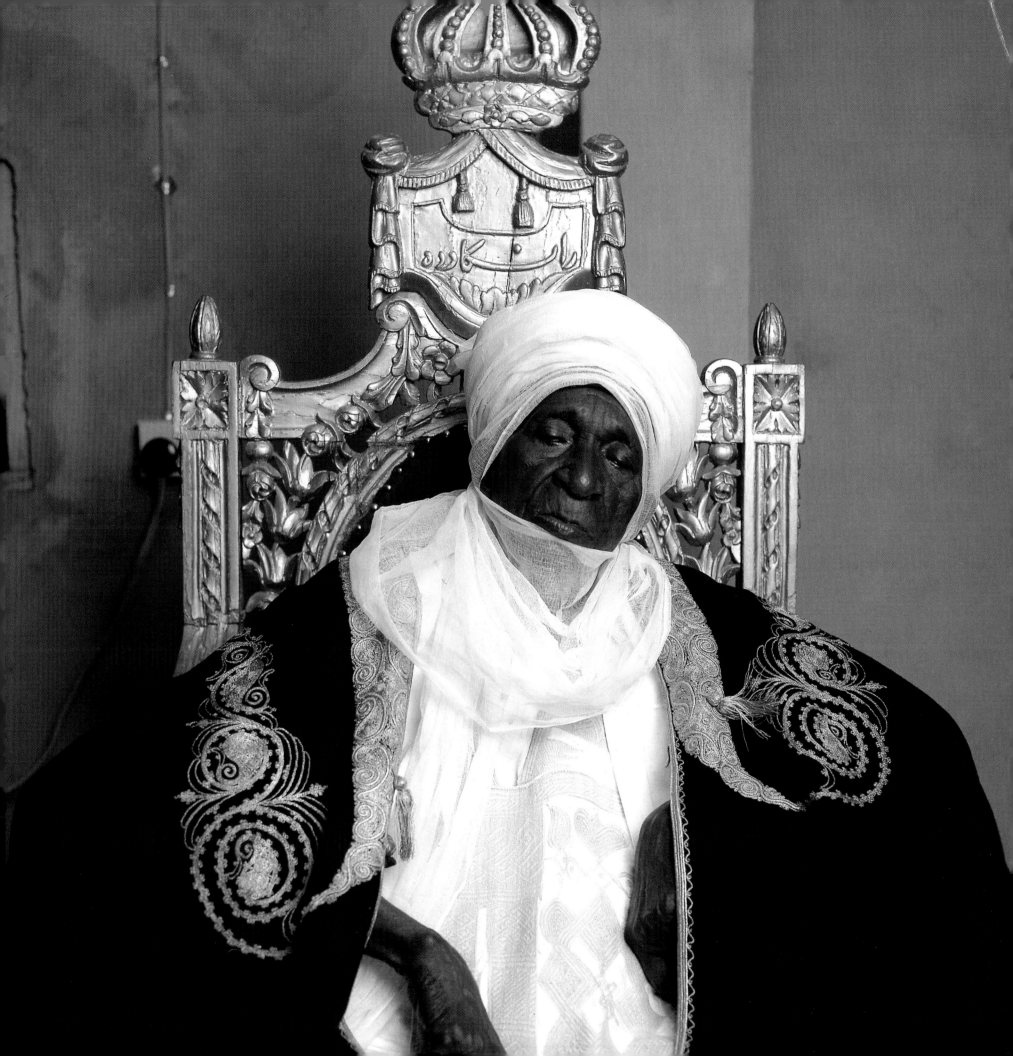

THE PRINCE OF KATSINA.

Bayajida was the ancestor of the Prince of Katsina and of the royal family of the fourteen Hausa kingdoms. He was a white man expelled from his country by his father, the King of Baghdad. Bayajida was received at the court of the Mai (king) of Kanem where he was imprudent enough to court the mai's daughter, who became pregnant. Furious, the ruler of Kanem tried to assassinate him. Bayajida fled to Bira-Ta-Gabas, a town farther west, where he was obliged to abandon the princess. While escaping, he encountered a highly skilled community of blacksmiths who made him a special sword so that he could fight Sarki, the evil serpent. The beast was terrorizing the inhabitants of the village of Daura by preventing them from fetching water from the river. Bayajida slew the monster. As a reward, he was given the queen of Daura's hand in marriage and he became the monarch of the village. The relation produced seven descendants, and each of them had a son who founded a kingdom. These states were called the "seven legitimate Hausa states." The grandsons from the illicit union founded seven other Hausa towns, known as the "seven illegitimate states."

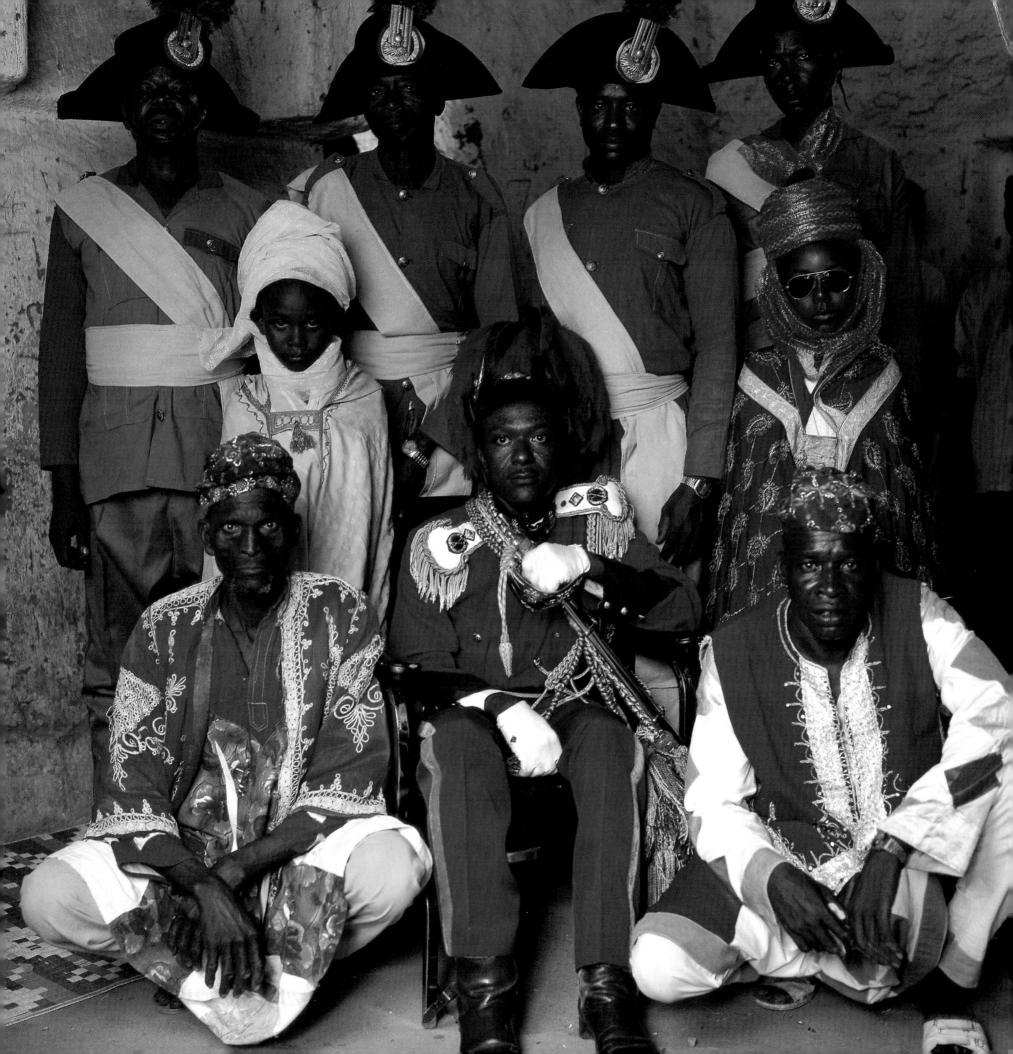

CHIEF IZE IYAMU OF BENIN. The oldest chief in the kingdom of Benin, he is an advisor to the *oba*.

He keeps a close watch on the city's witches and sorcerers to learn more about the powers they possess and to make sure their evil forces benefit the *oba*. Every year during a special ritual in the temple of the god Olorun, where we see him sitting, it is his duty to exorcise the realm of all demons and protect the inhabitants from disasters, epidemics, disease, and sundry misfortunes.

SALOMON IGBINOGHODUA, Oba Erediauwa of Benin. On March 23, 1979, Prince Salomon, a graduate of

Cambridge University, was crowned *Oba* (king) of Benin. In succeeding his father, Akenzua II, he became the thirty-eighth *Oba* of a dynasty dating back to the thirteenth century. "The great stick of chalk has been broken" was the metaphor that officially announced the death of Akenzua II, the *Oba* of Benin. Upon hearing the news, the Edo people in Nigeria, England, and the United States shaved their heads. A new growth of hair would signal the rebirth of the kingdom and the restoration of harmony between human beings and the elements, a harmony that had been temporarily disrupted by Akenzua II's death. When the Portuguese and the Dutch arrived, the palace of Benin was the size of a large town. Sometimes, the *oba* would venture forth, surrounded by leopards, leading an impressive procession of warriors. But in the nineteenth century, these victorious kings, captives of their rank, were transformed into deified monarchs. The empire was crumbling. To save it, the sovereigns ordered hundreds of human sacrifices. Invested in 1888, Ovonramwen was the last *oba* to exercise the power of life and death over his subjects. In 1897 England sent a punitive expedition that put an end to this great kingdom's supremacy. The *oba* was exiled, his palace pillaged, and England wound up with one of the most magnificent collections of African bronzes and art.

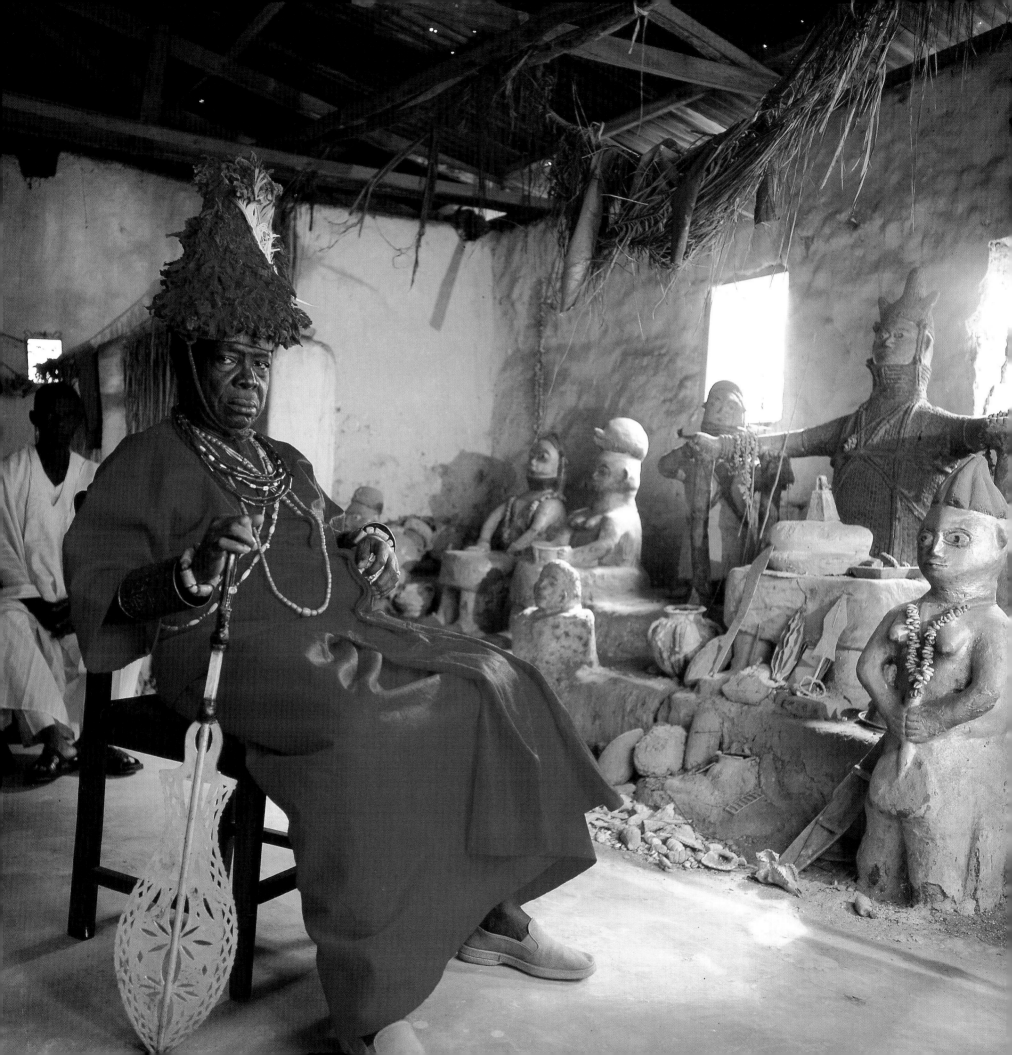

ADEYINKA OYEKAN II, King of Lagos. Oyekan II is the twenty-second King of Lagos. An adventurer named Ashipa

founded the monarchy. In 1600, Ashipa headed an army of mercenaries from Bendel state in southern Nigeria and seized control of the city of Lagos, then a protectorate of the *Oba* (king) of Benin. After a failed attempt to recapture the town, the *oba* recognized Ashipa's right to the throne, and thus an adventurer became the first king of Lagos. His son, King Ado, fell in love with a woman who sold fish, and she gave him a daughter of rare beauty, Erela Kuti. To pay a debt of honor, the king married her off to the chief herbalist of Lagos, who was poor, ugly, and old. Ologuntere was born of this marriage. He became the sixth king of Lagos and the founder of the second royal dynasty.

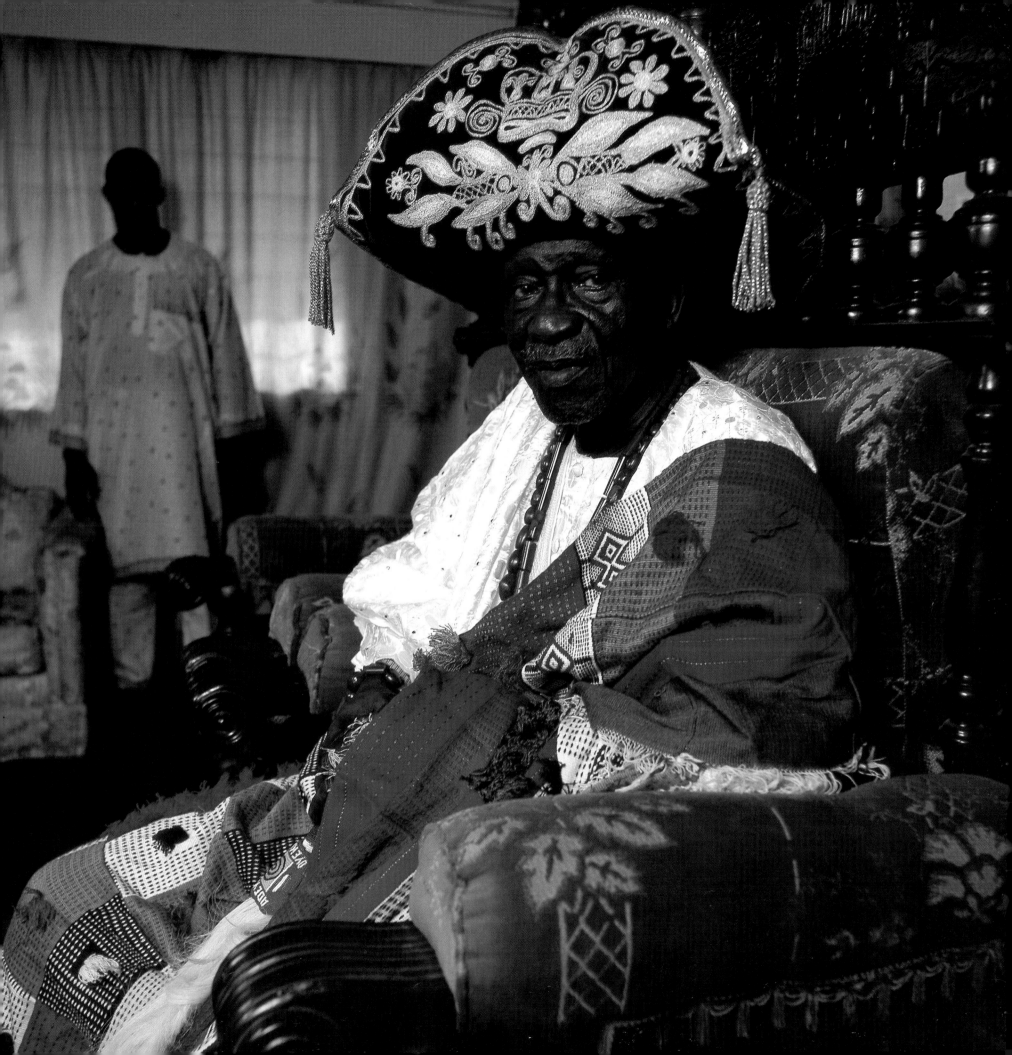

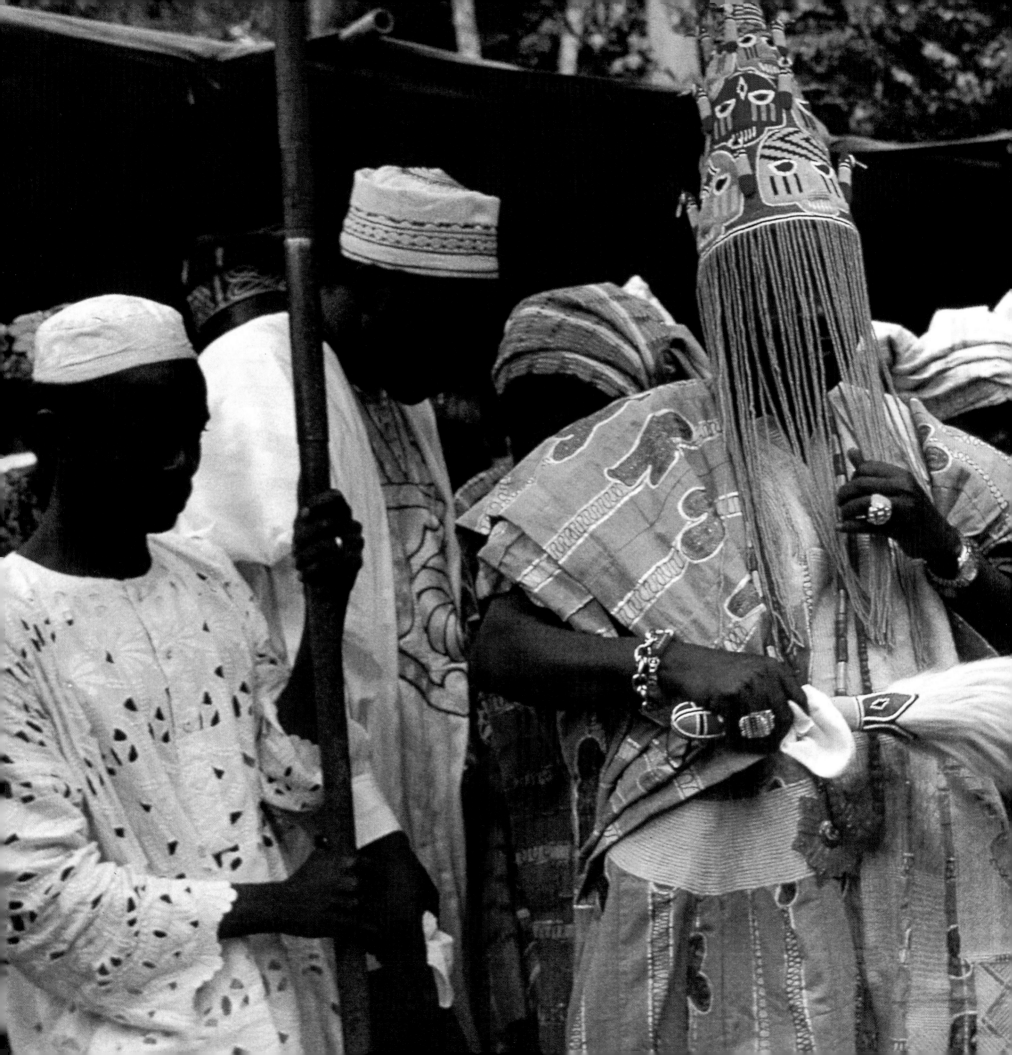

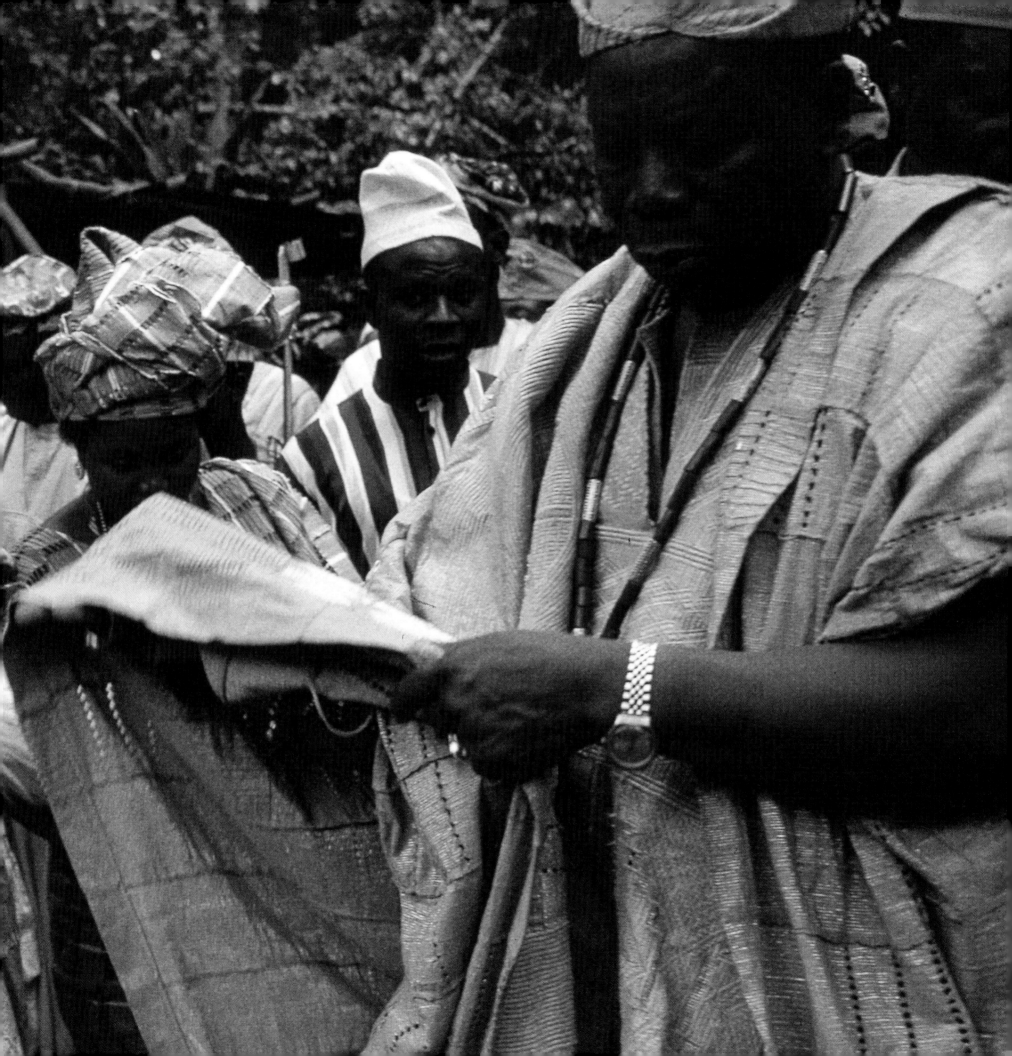

ALAYELUWA OBA OKUNADE SIJUWADE OLUBUSE II, Oni of Ife. On July

30, 1988, Trinidad officially invited the *Oni* (king) and sixty members of his retinue to preside over celebrations marking the 150th anniversary of the abolition of slavery. For five days, the *Oni* was treated like a head of state and an *orisha* (god). The throne that was built for him was higher than those of the Prime Minister and the President of Trinidad. The priests of the afro-American cult considered him the incarnation of a Yoruba god. In 1980, Sijuwade became the fiftieth *Oni* of Ife, one of the oldest dynasties in Africa.

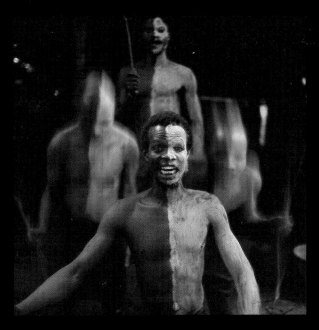

A celebration in Ife

Formerly, during his coronation, an *oni* had to kiss the sword of justice and enter his palace seated on a cloth stiffened by the dried blood of men and women who had been sacrificed. Today, the *Oni*, a wealthy businessman, owns a number of residences in Nigeria and England. One of his wives supervises the two stylists whose sole task is to supply his impressive wardrobe. The previous *oni*, Adesoji Aderemi, was the first African to own a Rolls Royce. In 1953, he led the Nigerian delegation to the coronation of Queen Elizabeth II of England. According to legend, the Muslim party expelled Oduduwa, the first king of Ife, from Mecca. Seeking revenge, his grandson, Oranmiyan, led a punitive expedition, which ended in a quarrel with his brothers. Frustrated, Oranmiyan refused to return to Ife. He took up residence in Oyo, leaving behind his treasures and fetishes with Adimu, his faithful servant. Adimu's mother was a slave, who was spared being a sacrifice victim because she was pregnant. In time, Adimu would become the king of Ife, with the title of *oni*, a contraction of the phrase *Omo Oluwoni* meaning "he is the son of the sacrifice victim."

Previous pages: The Ataoja of Oshogbo during the annual celebrations in honor of the Yoruba god Shango

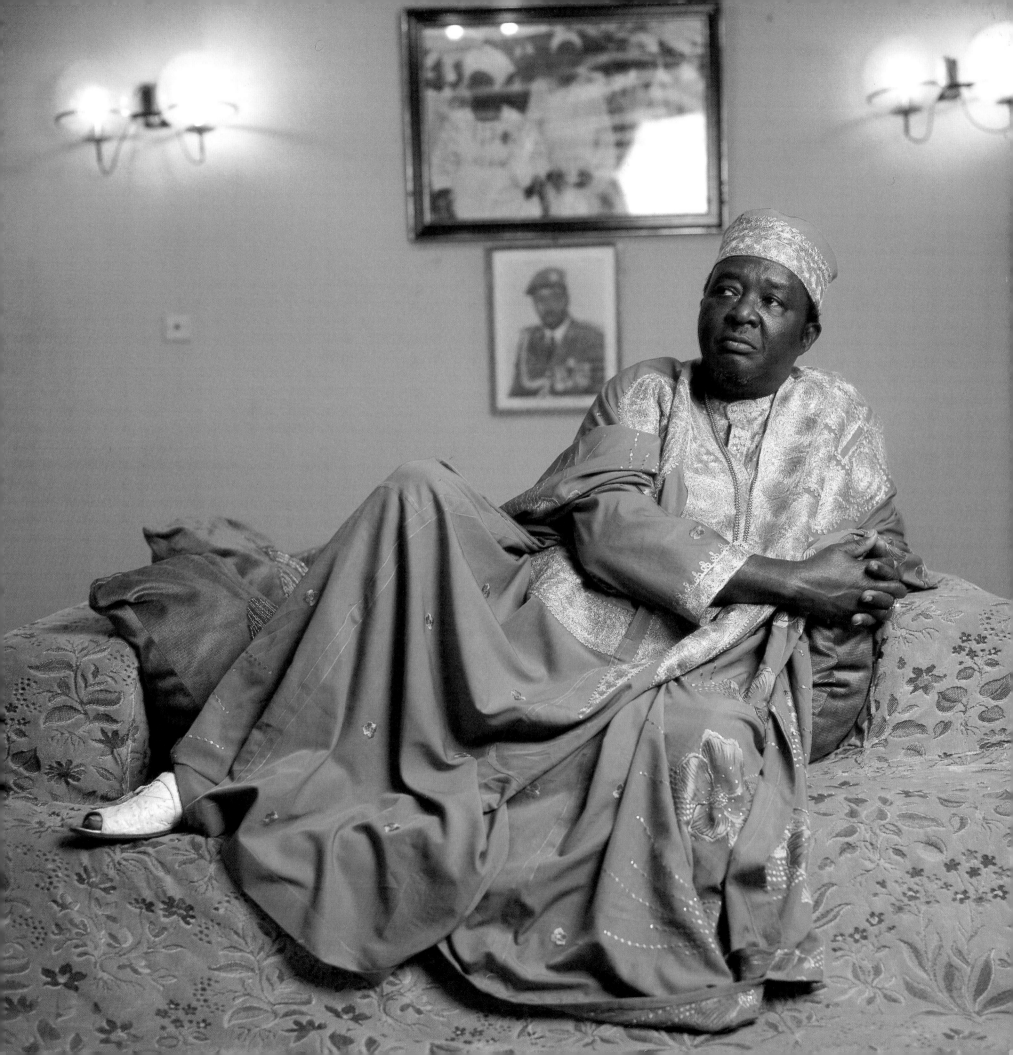

OTAMERE EDOHEN, Edohen of Benin. At the time of this photograph, the Edohen was twenty-eight years old. He was enthroned in 1982. He is the youngest Uzama in the history of the Benin Empire. There are seven Uzama (king-makers), which is a hereditary title. At first the Edohen governed the kingdom jointly with three other Uzama. The kingdom grew and eventually became the Benin Empire, and Obagodo, the eldest of these rulers, was crowned Ogiso, the sun king. Yet the sovereigns of this dynasty were hardly extraordinary leaders and Owodo, the last king, was the weakest of all. His problem was that he had many wives but only one son, and the oracle ordered him to sacrifice the boy. When King Owodo refused, he was banished from the empire and the other Uzama went to Oduduwa, the King of Ife, in the spiritual birthplace of the Yoruba, to request a new sovereign. The king sent his grandson, Prince Oranmiyan, accompanied by a doctor and a priest. Oranmiyan was crowned

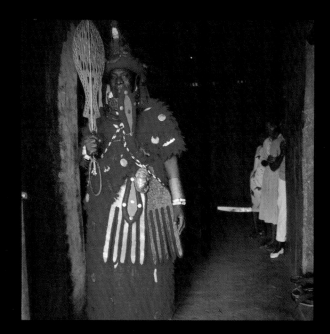

A Benin chief in his pangolin apparel

Eweka, the first oba of the second dynasty, and the prince's companions became Uzama. The first king of the dynasty and the Uzuma were often in conflict. Ever since, the Uzuma have celebrated a ceremony at the palace of Benin called the "rite of rebellion" in which the king's soldiers defeat them. Ezomo, the seventh Uzama of Benin was named the head of the royal army because he killed a rampaging elephant that had been terrorizing Benin.

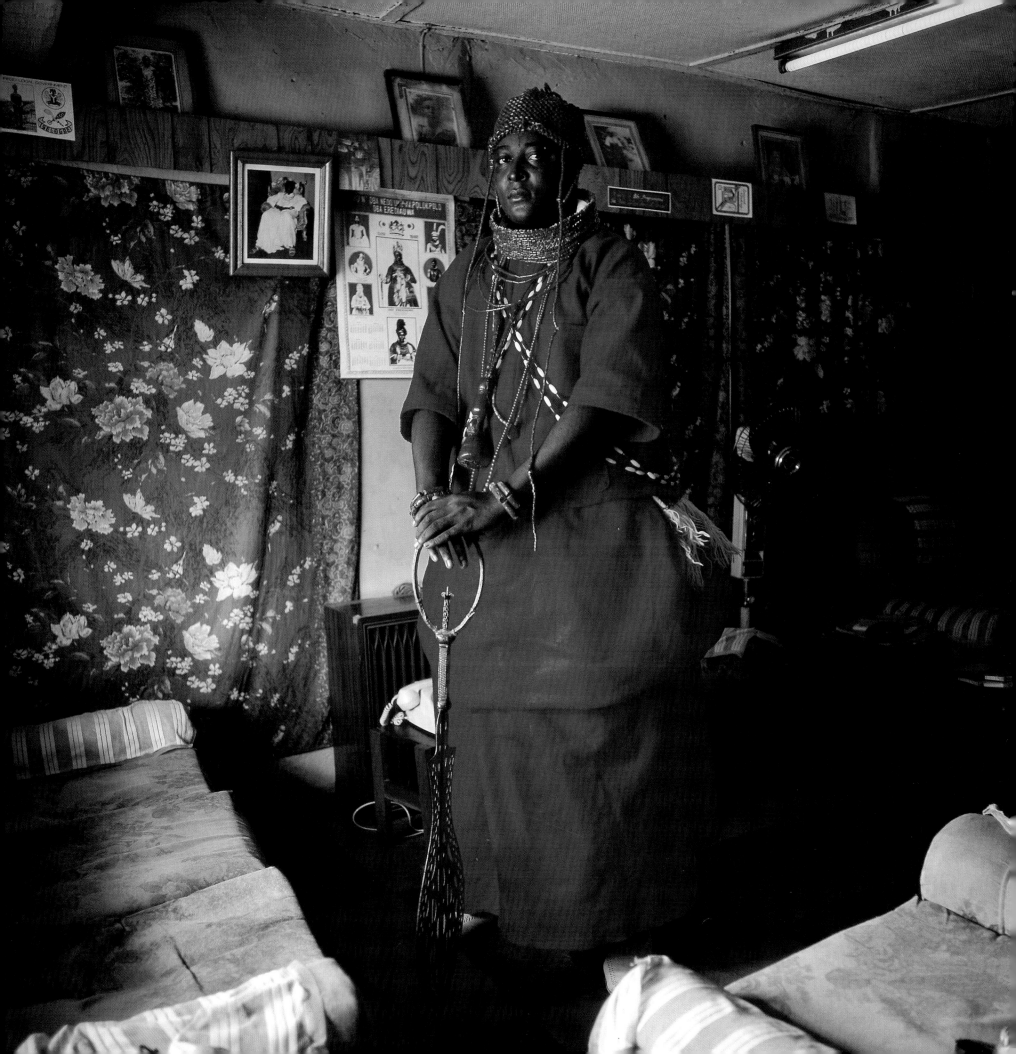

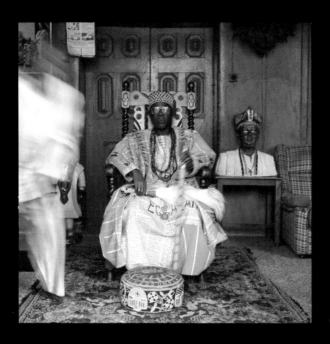

Oba Oyebade Lipede, Alake of Abeokuta

OBA O.A. AWOFESO, ABERE OJE I, Elerunwon of Erunwon-Ijebu. The *Elerunwon*, a former bank manager, still reigns with nine chiefs. Each of them has a specific responsibility:

* The *Olisa*, who must be the son of a queen, acts as interim king in the sovereign's absence.
* The *Kakanfo*, the war chief, is the minister of defense and the minister of public relations.
* The *Oliwo* is the head of parliament, which meets every seventy days.
* The *Olutu Apessa* is in charge of rituals.
* The *Ologbo* is responsible for the cult of Ogun, god of fire and patron of Erunwon.
* The *Lisoku* is guardian of the beaded crown and the only one authorized to handle it.
* The *Eketa Ilu*, whose ancestor was lost during the great exodus, has visited many towns. Now he arranges the king's travels.
* The *Olowa*, the chief of the Oro cult, prevents evil spirits from haunting the kingdom.
* Finally, the *Ayora*, the only woman in the royal retinue, looks after the king's throne and resting places.

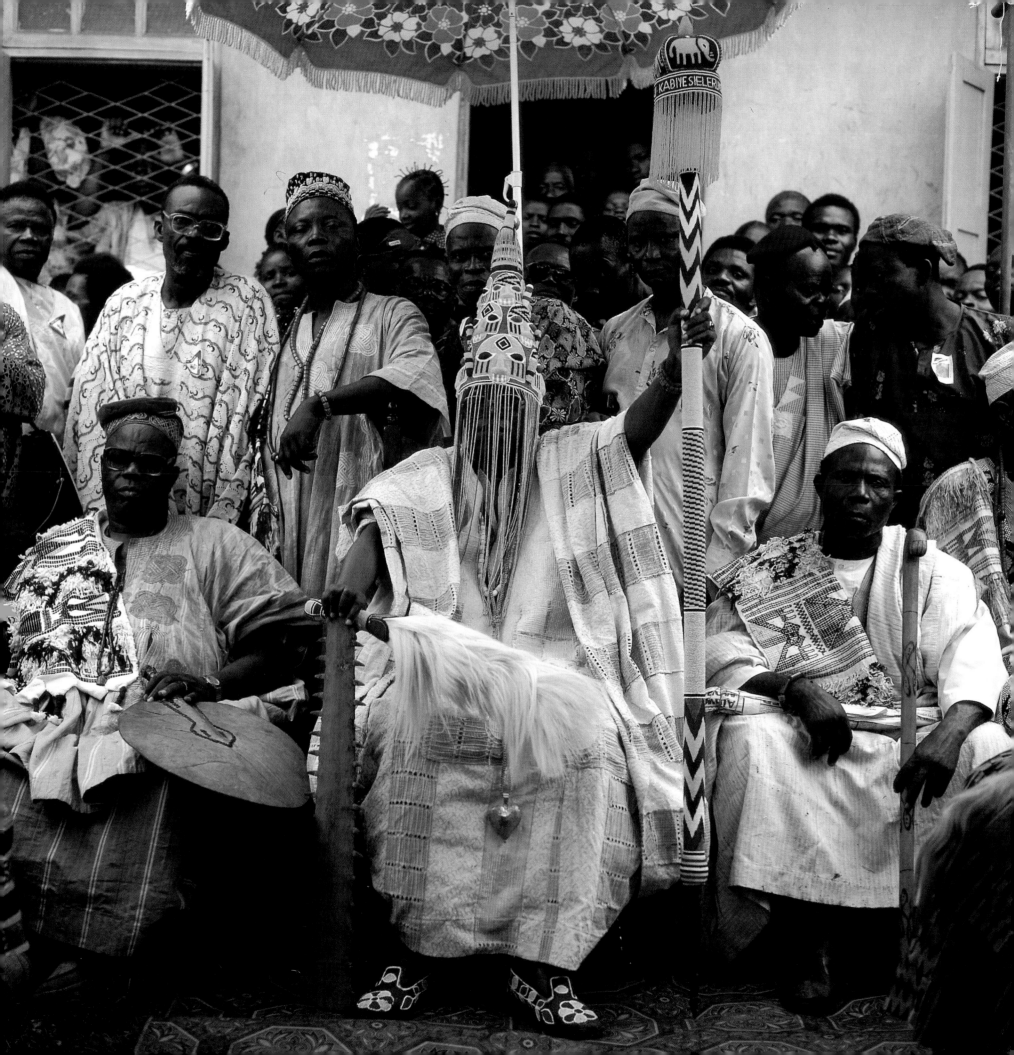

CHIEF OGBRIFE NWAKAIBE, of Onitsha.

In Onitsha, the king would only pose in his royal apparel for traditional celebrations in honor of his ancestors. Chief Ogbrife, on the other hand, was more than willing to don his ceremonial crown at home without ritual, even though the ceremonial costume is sacred and has a well-defined ritual function. It is often forbidden for a monarch to wear the crown for occasions other than a specific celebration. A violation of this prohibition was punishable by death in the past. Situated in the heart of Igboland, Onitsha is one of Nigeria's major business centers. It is also a sacred monarchy, an exception in this population of more than five million people. The Igbo have never recognized the centralized power of the king as a political authority. Their chief was the eldest member of the major clan in their city-state. His sole function was to represent them. True power lay in the hands of the associations composed of the members of various clans, which organized trade relations between cities of the interior and the trading posts on the coast. Initiation societies controlled security, adjudicated cases of witchcraft, and arbitrated blood debts.

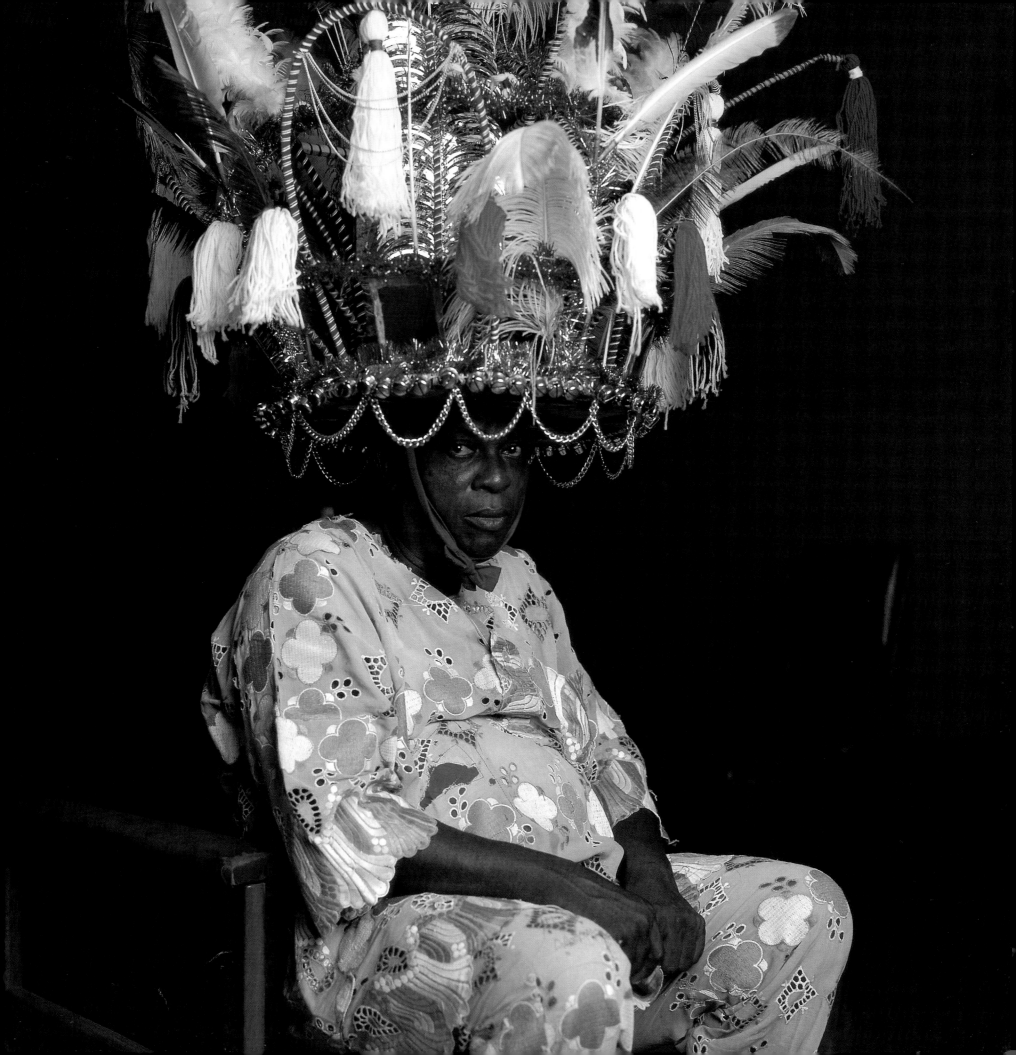

EZE OPARA REBISI. The *Eze* (chief) is one of sixteen chiefs who attend the king of Port Harcourt. He inherited the responsibility from his father in 1983. He resolves minor problems that crop up in his small chiefdom.

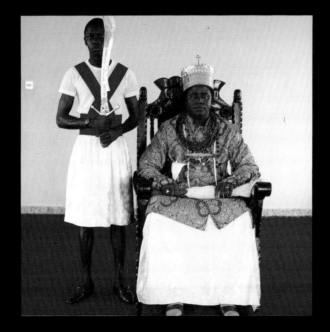

OGIAME, ATUWATSE II, Olu of Warri. In the middle of the sixteenth century, Atuwatse I, an ancestor of the Olu of Warri, went to study in Portugal at the University of Coïmbra and became the first African king to receive a university

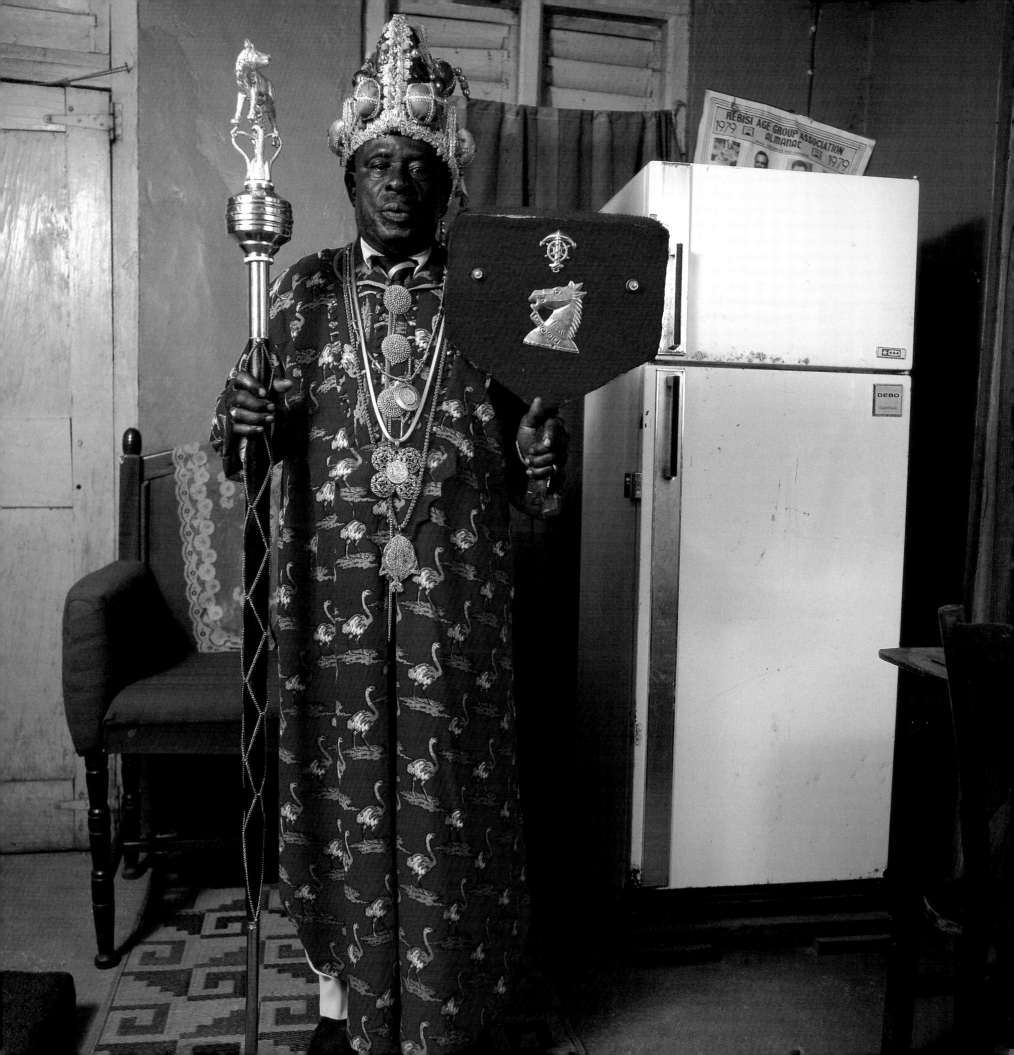

CHUKUMELA NNAM OBI II, the Oba of Ogba. Since the fifteenth century, the kingdom of Ogba has banned

female dogs from its territory. In 1453, the great ancestor Okalaka fled the kingdom of Benin and went to the prosperous lands of the Omuku region. His descendants waged frequent war, defending their prized fertile lands. Their fiercest foe, the monarch of Agbor, controlled the neighboring marshlands. One famous battle saw the army of King Ekeye of Ogba lay a trap for the Agbor army. Forbidden to engage in combat, King Ekeye hid some distance from the battlefield. Just as the Agbor forces were about to fall into the ambush, a dog barked, revealing the king's hiding-place. The soldiers rushed toward Ekeye and slew him. Since that tragedy, female dogs have disappeared from the Omuku region and the red in the king's regalia is a grim reminder of Ogba's bloody origins! The kingdom of Ogba is rich, accounting for twenty-eight percent of Nigeria's oil production. Taxing the petroleum revenues would make the *Oba* Chukumela the wealthiest man in Africa. Before the Biafran war, the *Oba* worked as an engineer for an American oil prospecting company. The ruler has four wives and twenty-eight children. For the past twenty years he has ensured the well being of his 400,000 subjects. He is a priest overseeing the practice of ancestor worship and a devout Catholic. It is essential for the *oba* to remain in good health. A blind or one-eyed man cannot be king. He must not steal, enter a marketplace, or reap financial gain from the services he renders.

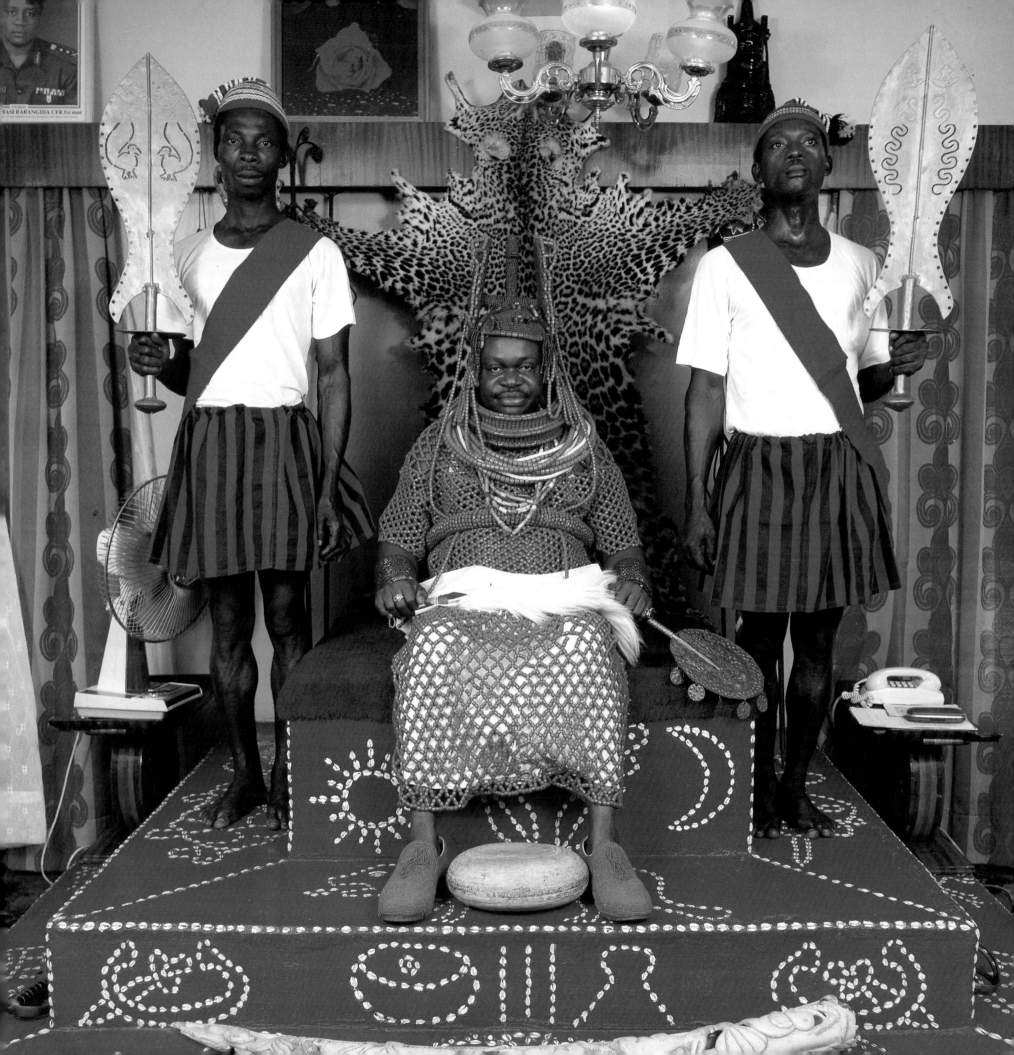

OTASOWIE, OLIHA, Oliha of Benin.

The *Oliha* of Benin is popularly known as "the *oba* behind the *oba*" (the king behind the king) because he is responsible for the surveillance of the empire gates. He has the authority to prevent undesirable persons from entering the kingdom. As the head of the *Uzama* (kingmakers), he is the only one authorized to crown an *oba*. Before his enthronement, Ota Sowie was an important farmer. He is the descendant of one of the four sovereigns who founded the Empire of Benin. In the twelfth century, they agreed to delegate their power to their elder, Obagodo, who founded the dynasty of the sun kings (*Ogiso*), Benin's first royal lineage.

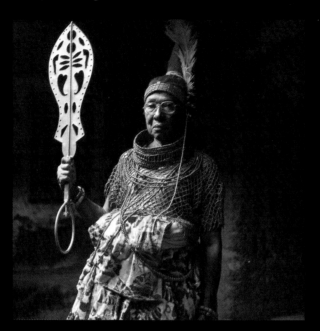

ISIENWENRO JAMES IYOHA INNEH, Ekegbian of Benin.

James Inneh is a former business man. *Oba* (king) Akenzua named him commander of the *Isienwenro* (royal guard) in 1962. Bodyguards known as *Asaka no s'oghionba*, meaning "the ants sting the king's enemies," see to the King's safety. In some rituals, they are armed with bows and arrows, machetes and javelins, and glide around the monarch, surrounding him like an army of ants.

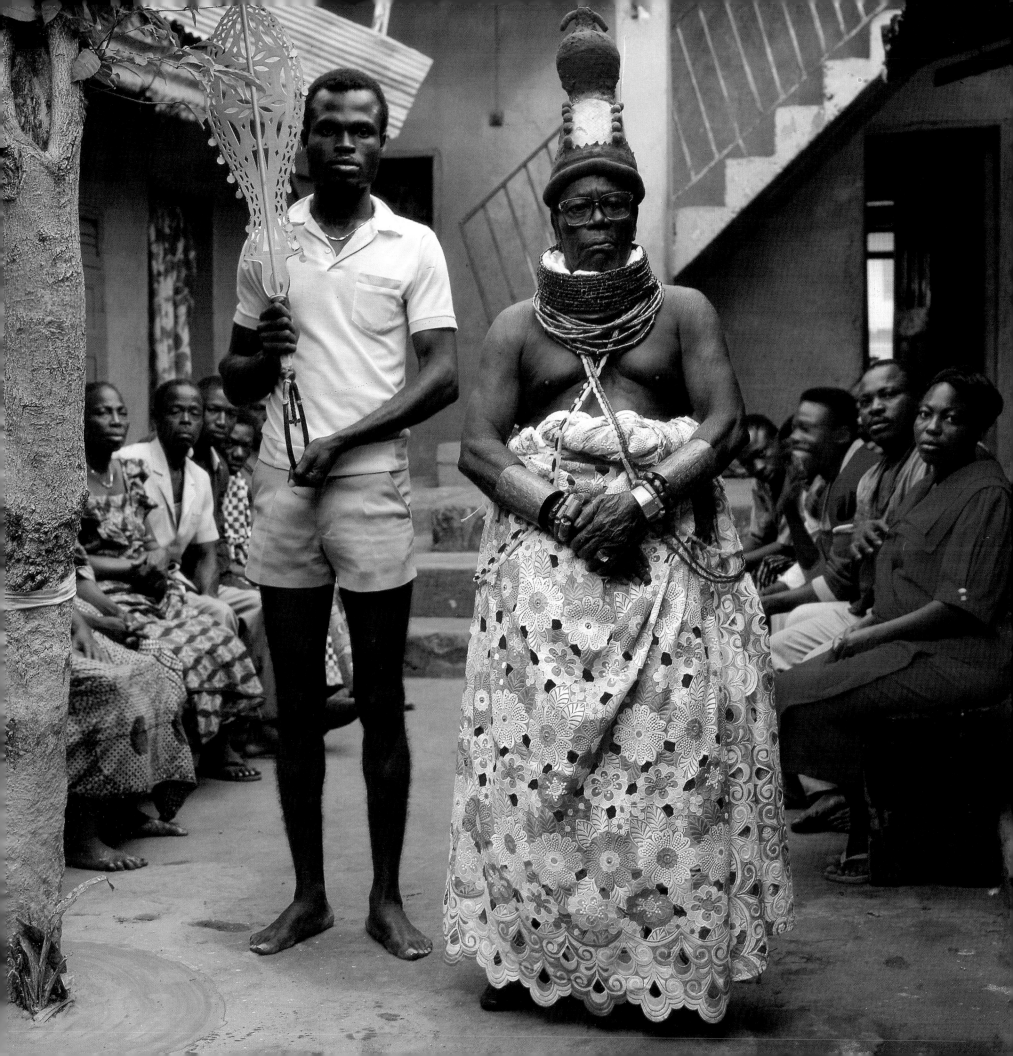

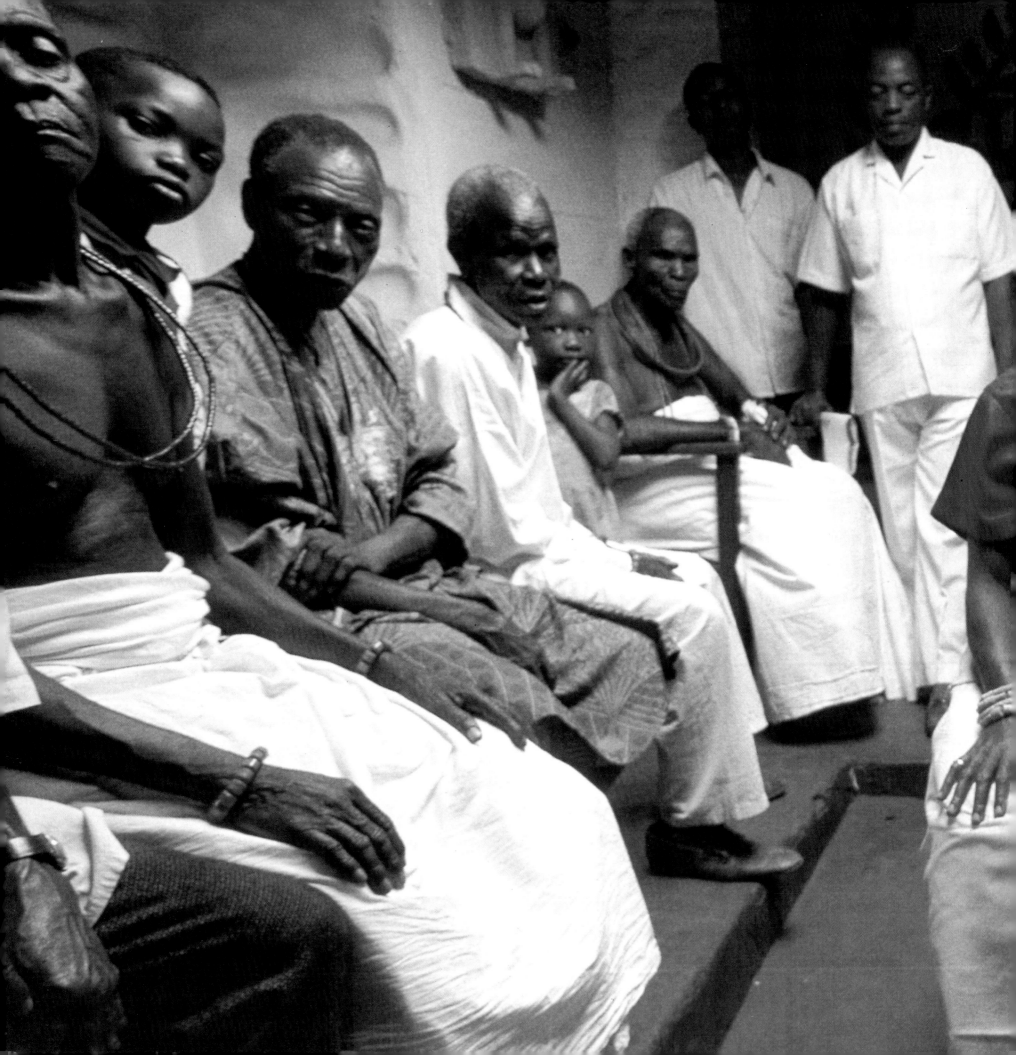

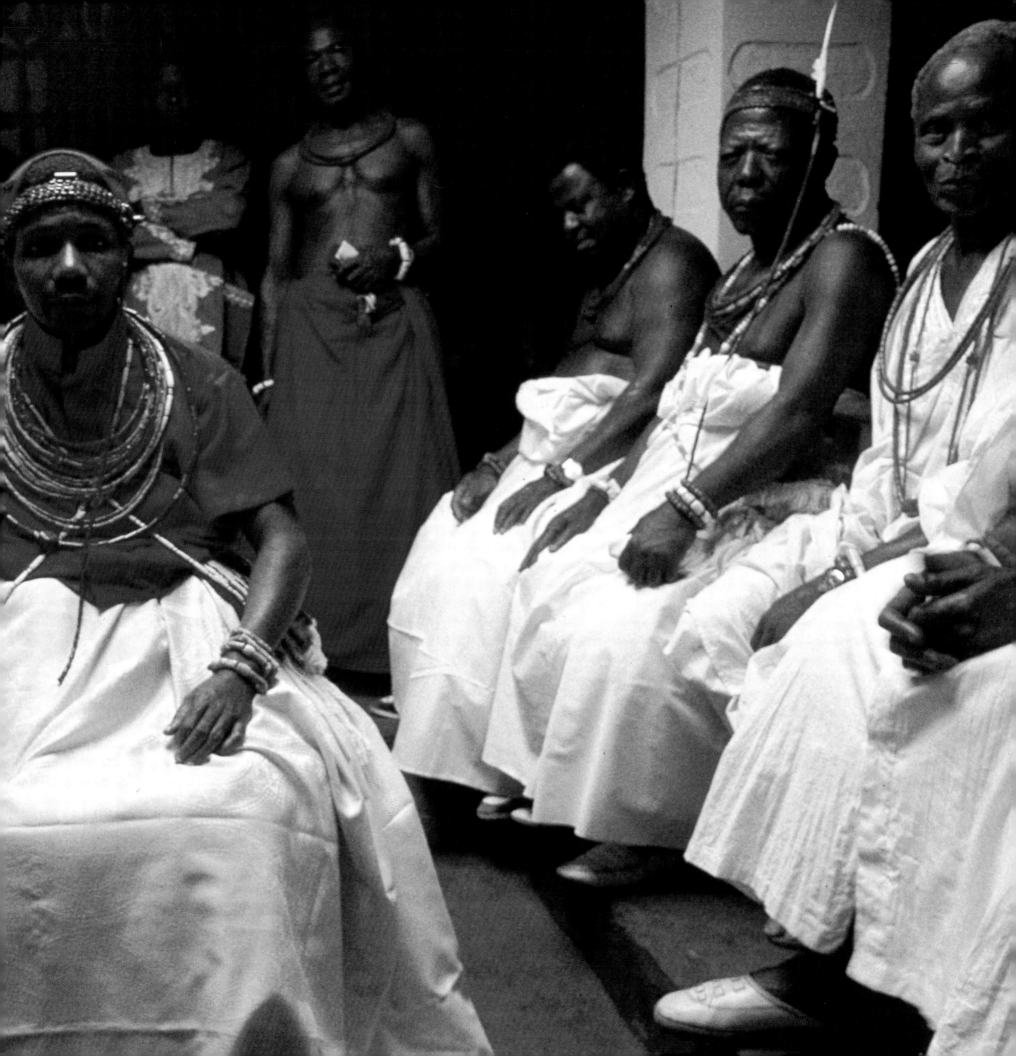

JOSEPH LANGANFIN, representative of the Abomey dynasty. Joseph Langanfin is the president of CAFRA, the administrative council of Abomey's twelve royal families. As such, he is the official representative of the kings of Abomey. He presided over ceremonies marking the centenary of the death of his great-grandfather, King Gbele. In 1889, after the funeral services for King Gbele, his son Kondo was crowned under the name Gbehanzin, a contraction meaning "the world holds the egg that the earth desires," and took a shark as the royal emblem. The Shark-King wanted to repel the Europeans, who came from the sea. Ever since the Berlin Conference, which partitioned Africa among European powers in 1884, the French had coveted the kingdom of Abomey; they wanted to halt the English advance into the Gulf of Guinea. The French failed in their attempt to woo Gbehanzin. "The king gives his country to no one. The land of our ancestors is sacred," he told them. So the French ordered General Dodds, a Senegalese-born métis, to conquer the kingdom of Abomey. The king's armies were soon decimated and Gbehanzin was forced to surrender. To lure Gbehanzin away from Africa, the treacherous General Dodds promised him an audience with the president of the French Republic. The trusting Gbehanzin boarded a boat, but instead of proceeding to France, he was deported to Martinique. He died in 1906 in an Algerian prison.

Previous pages:
Notables of the
kingdom of Benin
during the Igwe Festival
in Benin City, Nigeria

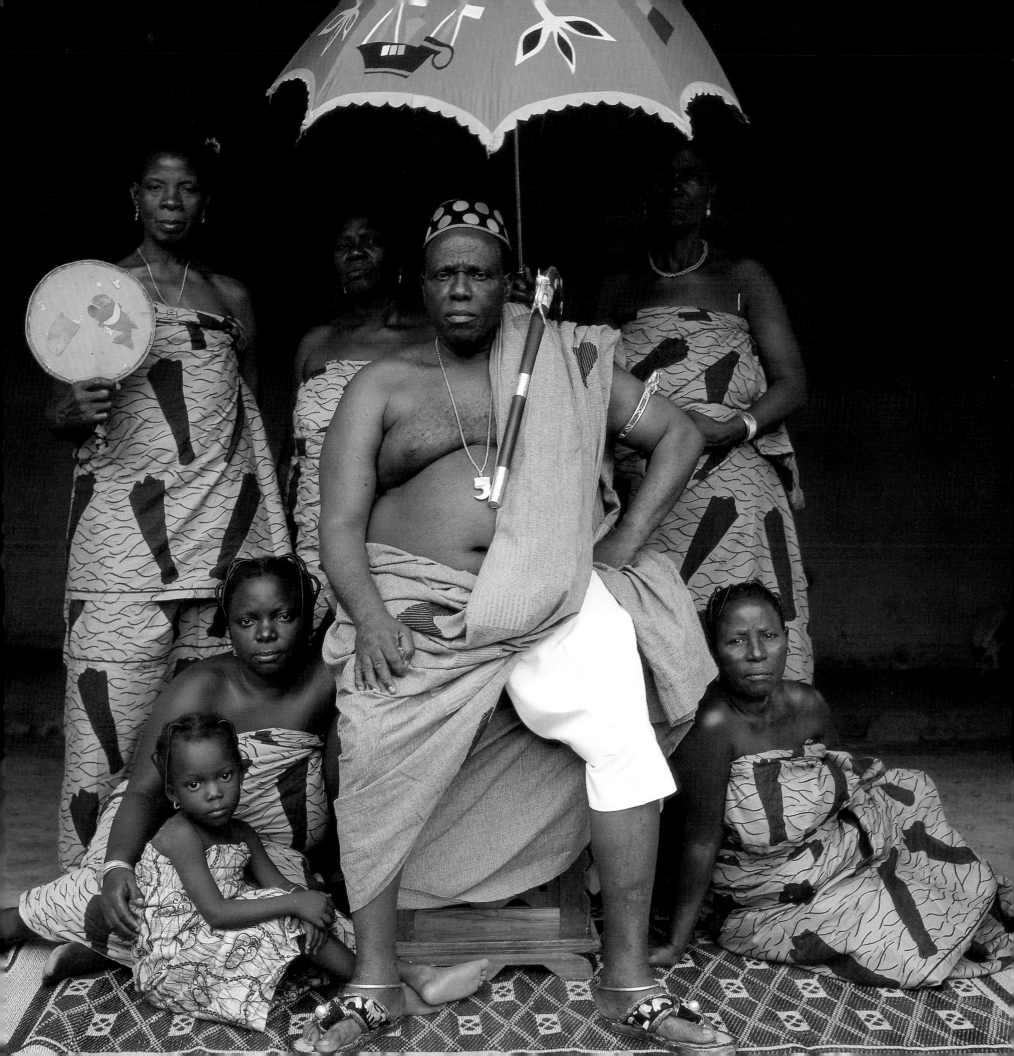

TOFFA GHEHINTO SEGLA, representative of King Toffa I of Porto-Novo. Prince Toffa, a district chief, is a

retired roads department bureaucrat. He represents the royal branch of the Toffa. He is not a king; he is a claimant to the throne. He presides over official and traditional ceremonies, resolves legal disputes, thefts, and other conflicts. Since the death of the last paramount chief in 1976, the Porto-Novo throne has been vacant. None of the five royal branches, which are supposed to govern in rotation, can agree on the successor. Unofficially, since July 23, 1987, Prince Toffa has been considered the king of Porto-Novo and he does not hesitate to wear the ceremonial costume of the kings. In 1752, the navigator Eucharistas de Campos named the ancient royal city Porto-Novo. Twenty-five kings who reigned there obliged slave traders to pass through the city. In 1883, the armies of the King of Abomey invaded Porto-Novo. King Toffa I authorized the French to intervene militarily in order to drive the enemy forces away. Then, under the same protectorate agreement, the colonial army occupied Porto-Novo and abolished the kingdom, replacing it with a paramount chiefdom whose objective was to turn the king into a kind of indigenous administrator, entirely at the service of the French.

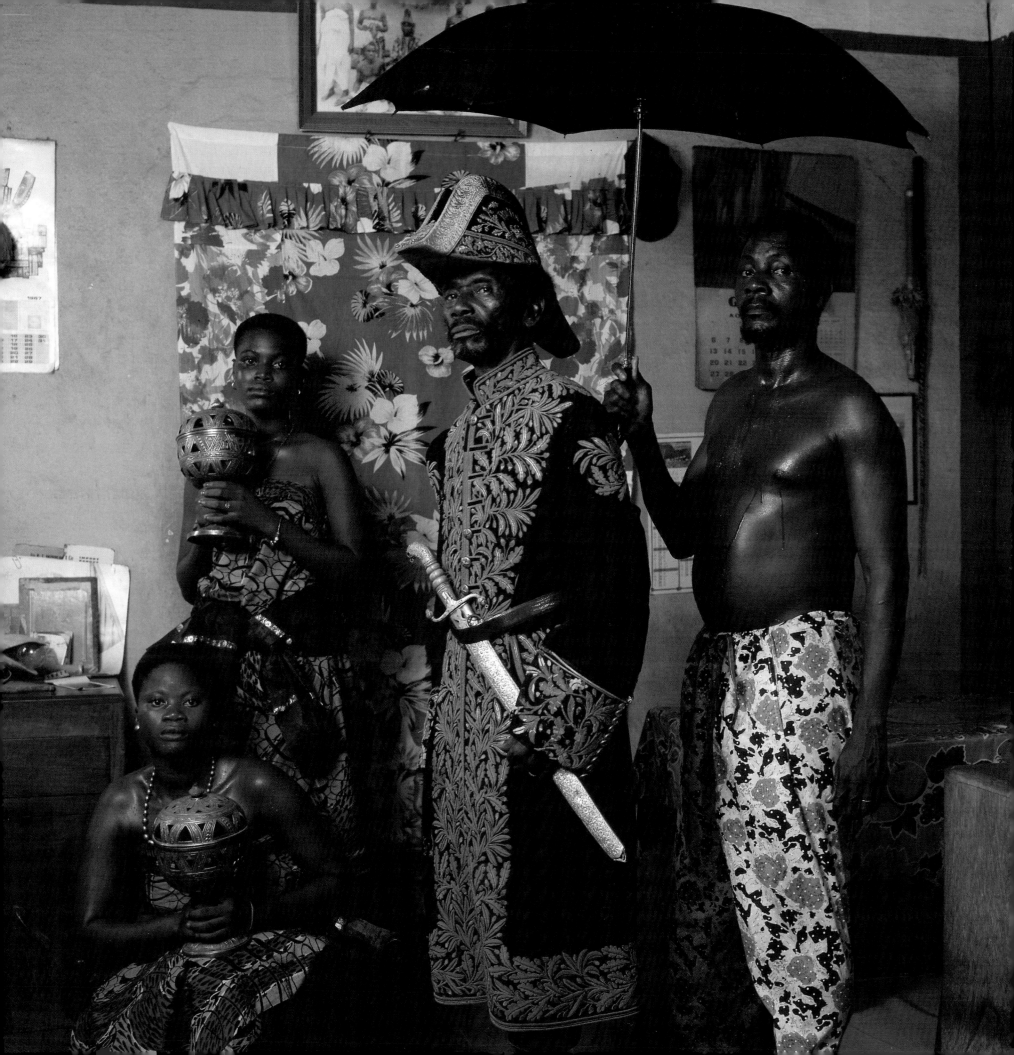

AGBOLI-AGBO DEDJLANI, King of Abomey. Dedjlani waited six years until his retirement from the police before

being enthroned in secret ceremonies. Officially, there are no longer any kings in Benin. But on September 30, 1989, he put on the royal shoes and became the king of Abomey at fifty-four years of age. As he had been monogamous, he had to wed two other wives to manage the palace. When he goes out, tradition dictates that he take shelter under the state umbrella that bears his emblem and that one of his wives keep the royal spitting bowl close by at all times. The king must carry his royal scepter everywhere he goes. He holds it in his hand or hangs it from his shoulder. It is more than a symbol; it is the king. In the past, it was accorded the same respect as the king. Wherever the scepter went, there went the king. It validated his commands. A foreigner, who requested an audience with the king, had to wait in the Port of Ouidah "until the road was opened" by the scepter. The silver "dust protector," inherited from King Gbele, dates back to the nineteenth century. It protected the king's nostrils from the dust stirred up during the important royal processions at Abomey. Dedjlani is the grandson of Agboli-Agbo, the last king of Abomey. At the end of the nineteenth century, the French crushed King Gbehanzin's armies and chose his brother, Goutchili, the commander-in-chief of the Dahomey armies, to succeed him. Goutchili became King Agboli-Agbo, meaning "take care, Dahomey. The kingdom has stumbled, but not fallen." His royal emblem depicted a foot above a rock with a bow. The alliance did not last long. Agboli-Agbo had a falling out with the colonial administration and was exiled to the Congo.

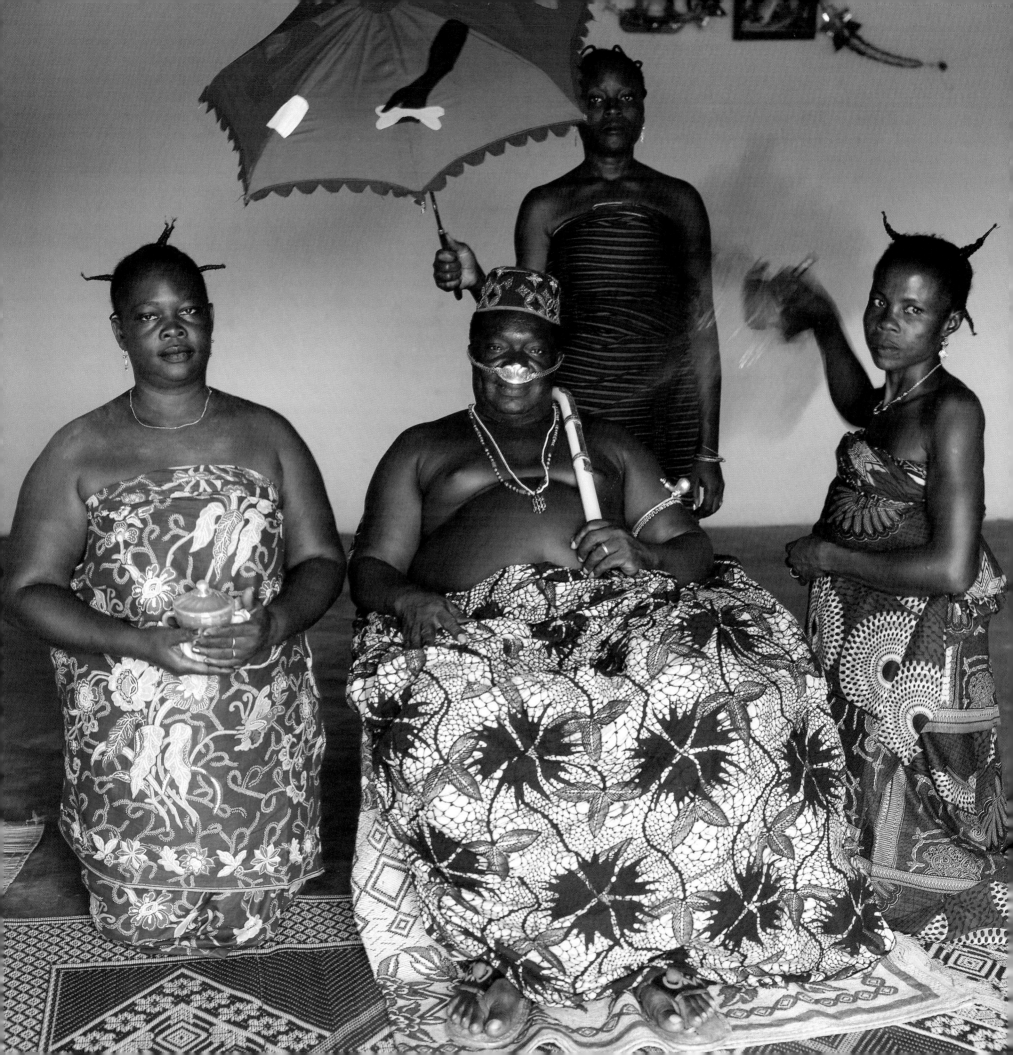

JIMMY MOXON, ALIAS NANA KOFI OBONYA. Jimmy Moxon is one of the few white chiefs

in Africa recognized by a government. On September 13, 1963, Ghana's official newspaper announced the investiture of Nana Kofi Obonya (literally, "the chief born on Friday, who lives at the bottom of the cliff"). Jimmy Moxon was twenty years old and just out of Cambridge University when World War II broke out. He became an administrative colonel on the Gold Coast. In 1957, when Ghana became the first African country to achieve independence, he was reluctant to leave. The king of Aburi offered to make him a noble. The "white nana" carries out his functions seriously and respectfully; he settles disputes, sits on the royal council, and coaches a soccer team. People must bow to him. He is the only white person in Africa who is borne on a processional litter. It has become a trend among some African kings in Ghana and Nigeria to have a "white chief," who is not involved in quarrels among Africans. The investiture ceremony costs between twenty-five hundred and seventy-five hundred dollars. We have found about twenty "white chiefs," most of whom reside in Nigeria, including a French cultural attaché and a number of businessmen who take advantage of opportunities offered by traditional chieftaincy to boost their profits.

**Previous pages:
Nana Gorkelu IV
leads his royal
procession (Ghana)**

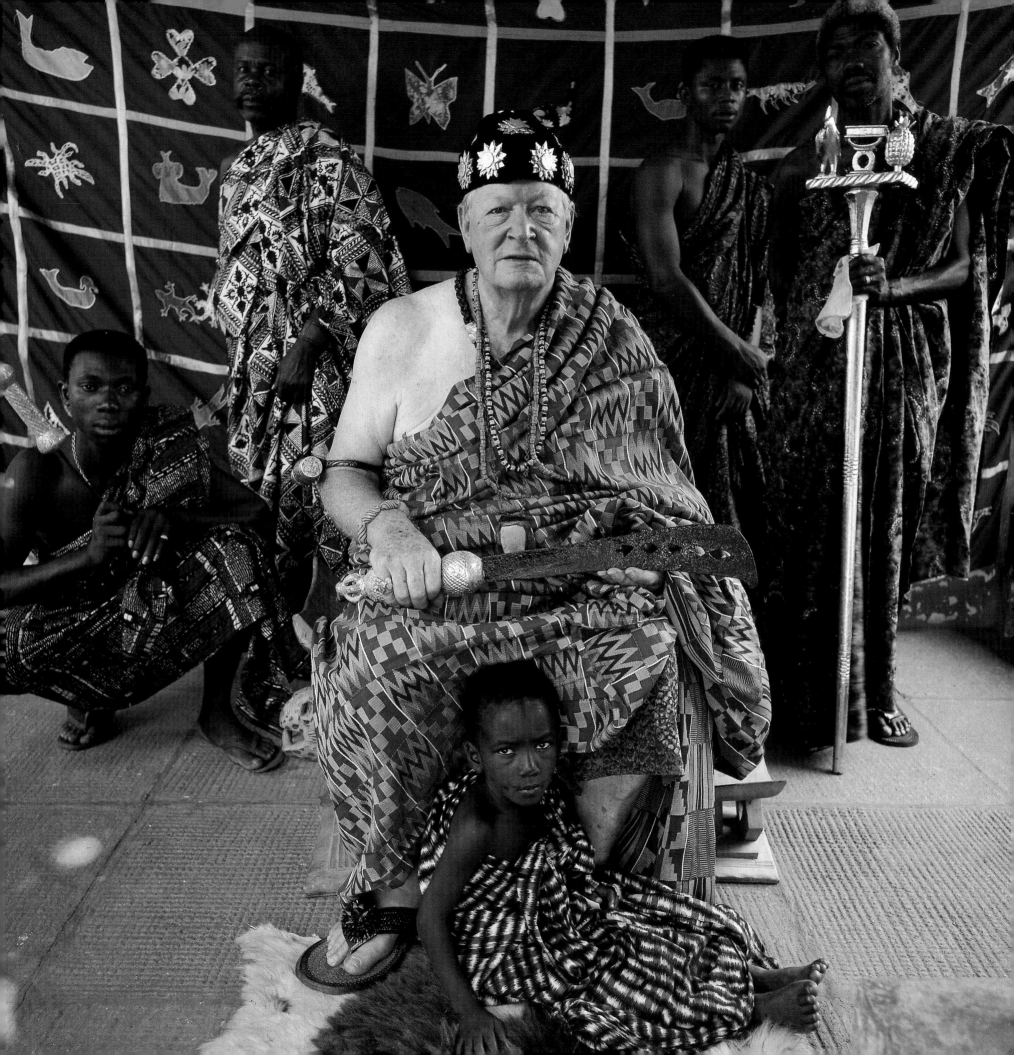

OSEADEEYO ADDO DANKWA III, Okuapehene, King of Akropong-Akuapem. The King of Akropong is

a graduate of the University of London and an economic adviser in Accra, the capital of Ghana. For the past sixteen years, he has been the chief of the "sacred seat" of the Akuapem-Asona, one of the seven main Akan clans. To his right, his spokesman is holding the royal emblem, an elephant, which serves as a reminder that the kingdom was founded by force. In 1733, Akwamu led his army against the city-state of Akropong, which had been saved from the Ashanti. The city appealed to the Akim to come to its defense; Akim soldiers were known to love a good battle. These hereditary enemies of the Ashanti liberated Akropong. As a reward, the chief of the Akim was crowned King of Akropong. At the foot of the king sits a child—his *Okra*, or soul. Protected by amulets, he serves as a human shield, defending the king against evil spirits, disease, and death. The king is considered the nation and he must never be injured or fall ill, because the whole nation would be weakened. The *Okra* diverts the forces of evil away from the king and absorbs them himself, and so must die before his master. In battle, the *Okra* would ring the bells hanging from his neck to signal the king's presence and fire his soldiers' courage. If the king were afraid to alert the enemy and muted the bells, his soldiers would see it as a form of desertion and abandon the battle.

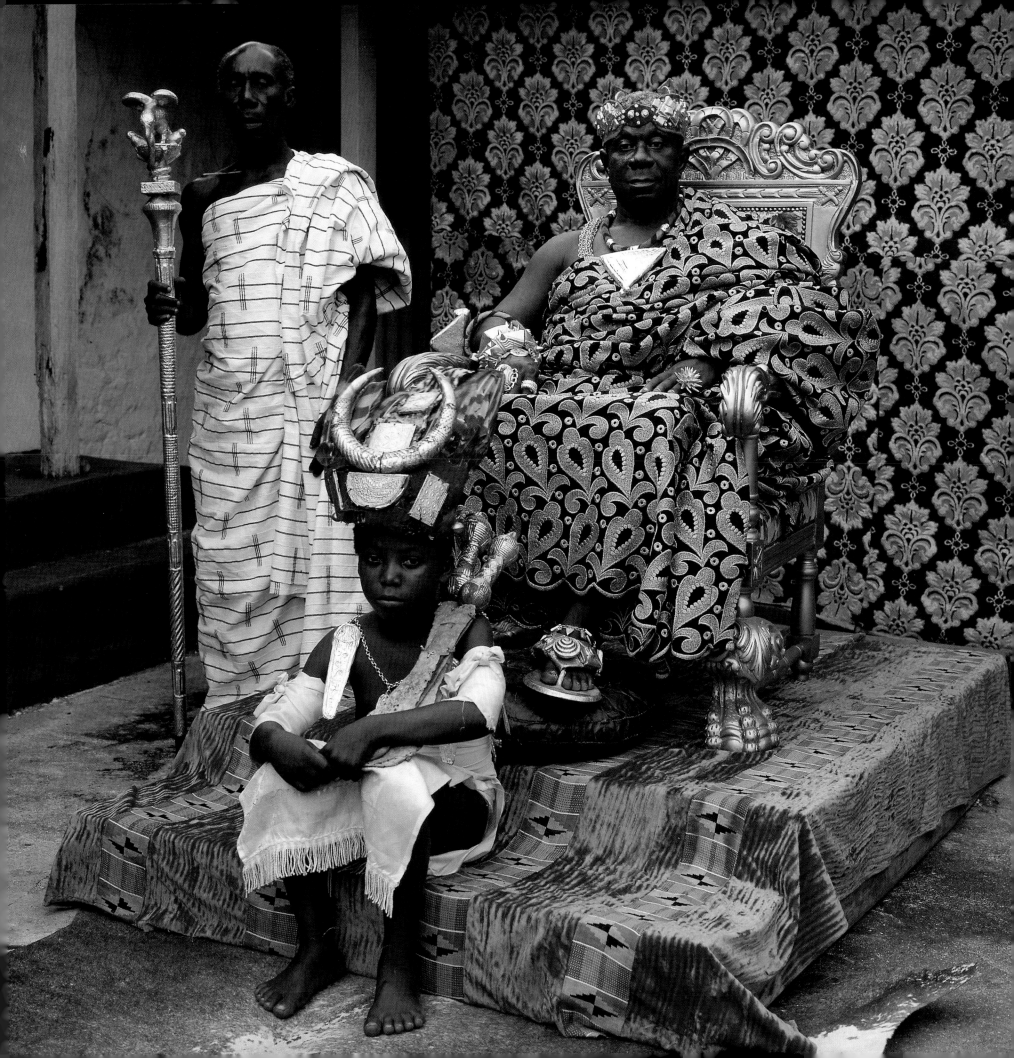

NANA PHILIP KODJO GORKELU, Asafoatse Gorkelu IV. During the week, Philip Kodjo Gorkelu works

as an accountant in a small plastic-wrap company. On the weekend he returns to carry out his responsibilities in his village and four other communities in this area on the coast of Ghana about sixty miles from Accra. Once a year, in August, Nana greets his subjects from his processional litter called "Mercedes." If he tumbled from his litter, he would be deposed without delay; his fall would signify the fall of the people he embodies. Enthroned in 1987, he is the descendant of the Gorkelu dynasty, founded by his ancestor Tetteh, the conqueror of the Krobo, Eure and Utkawawu in the wars of 1819 and 1844. As a reward for his valiant deeds, the ancestor received a "sacred seat" under the name of Andronti Asafoatse, Captain Gorkelu I. This tiny domain is one of the newest kingships on the Gold Coast in Ghana. From the fifteenth century on, many small centralized states emerged. In contact with European merchants, their chiefs became rich through the slave trade.

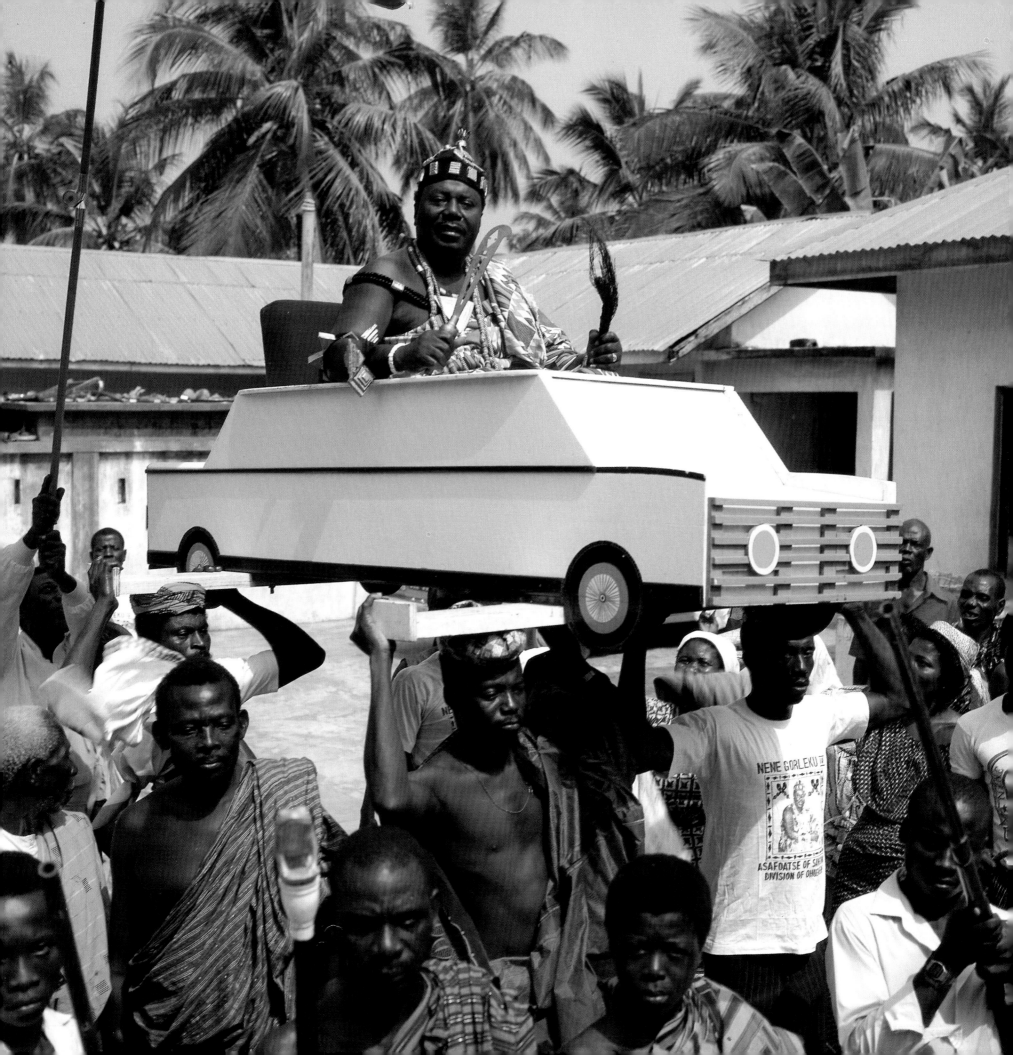

NANA AMON NDOUFOU, King of Sanwi. A former officer of the Ghanaian army, Nana Amon Ndoufou is the

most important Akan monarch in the Ivory Coast. In the seventeenth and eighteenth centuries, four Anyi clans crossed the Komoé River and settled in Krinjabo. The chief of the first clan was immediately enthroned king of Sanwi because the Akan could not conceive of human society without a king. He is more than a symbol; he is the soul of his people, the father of his subjects. His person is sacred and inviolable. The king identifies with long departed ancestors; that is why he is called "Nana" or "Nanan," which means "elder" or "wise man." Whatever his age, this sacred king is called "Nana" by all his subjects, even including elderly men, because he is ageless and therefore the eldest. His enthronement has connected him with all the generations of long-lost kings protecting him. He is the traditional chief, but he is not the supreme judge. He governs jointly with his war chiefs and provincial heads, the *Asafohene*. The Akan state is pyramidal in structure with the king at the apex, followed by the Asafohene and finally the village chiefs. In the event of open conflict, the Asafohene address a solemn warning to the king. If he fails to heed it, he is deposed. In Sanwi, this process has led to the dethronement of several monarchs; in the powerful Ashanti Confederacy, three kings were deposed in this way. In fact, an Akan king was even accused of sorcery and found guilty, and a similar fate befell Boa Koassi I, the king of the Ndenye.

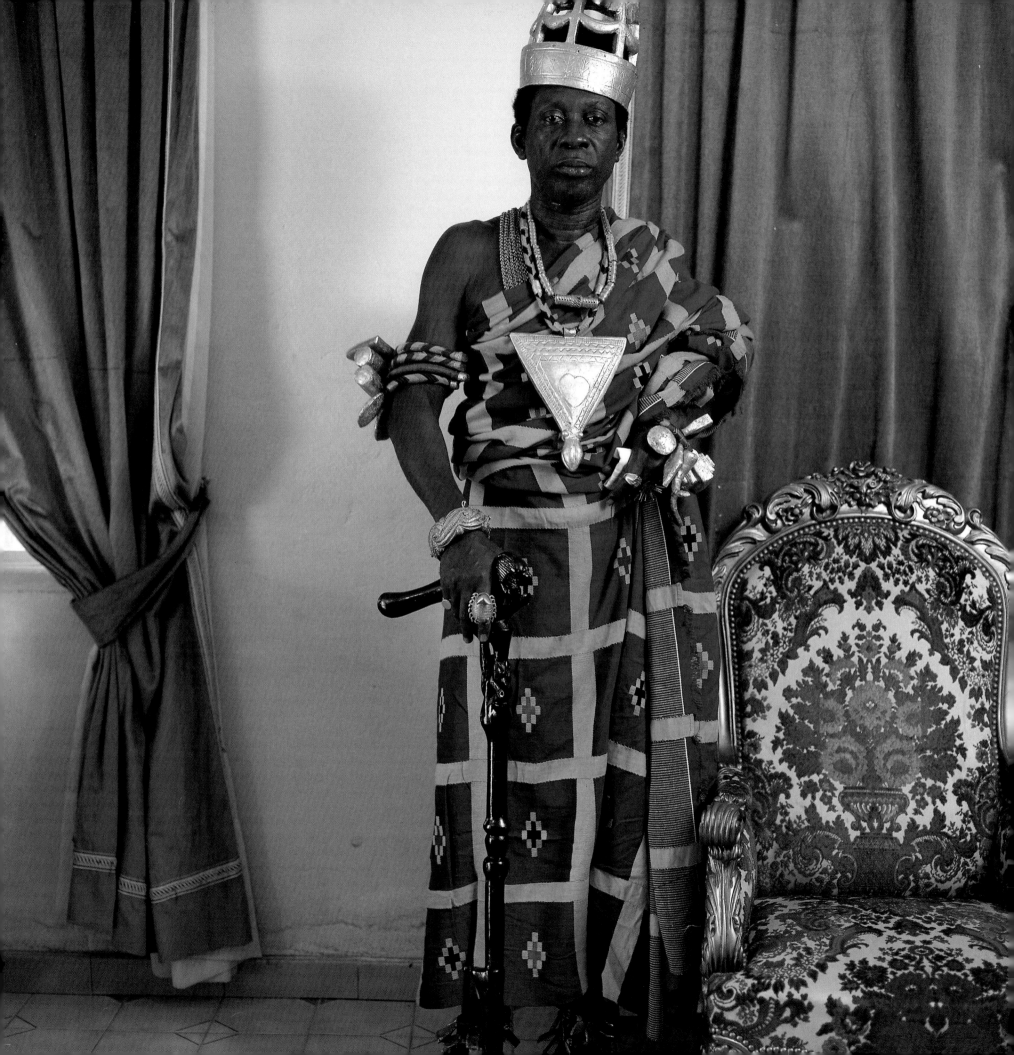

SAMUEL OSABU LOMOTEY ANSAH, Nii Osabu Adjin I of Adjin-We, Nungua-Mantse. Samuel Osabu,

a retired officer in the Ghanaian army, performs the dual duties of king and "technical storeman." Since the wars of Tongo and Katamansu against the Ashanti, the two royal houses—the Adjin and the Kwei—have shared the power of the "sacred seat." The families rule in rotation. In the fifteenth century, Samuel Osabu's ancestor King Odai Akoto, the founder of the kingdom, negotiated a contract with the Danes to construct the fort of Christiansborg, the current seat of the Ghanaian presidency. At the time, the Europeans needed fortified places to protect themselves from indigenous attacks, to store their merchandise and, above all, to keep their slaves. White people considered Africa to be nothing but a dense forest stuck between the desert and the ocean; a vast pool of labor, which could be shipped to the New World. The disgraceful trade attracted adventurers. Gold, ivory, and especially slaves were exchanged for trinkets, tobacco, alcohol, clothing, and old rifles.

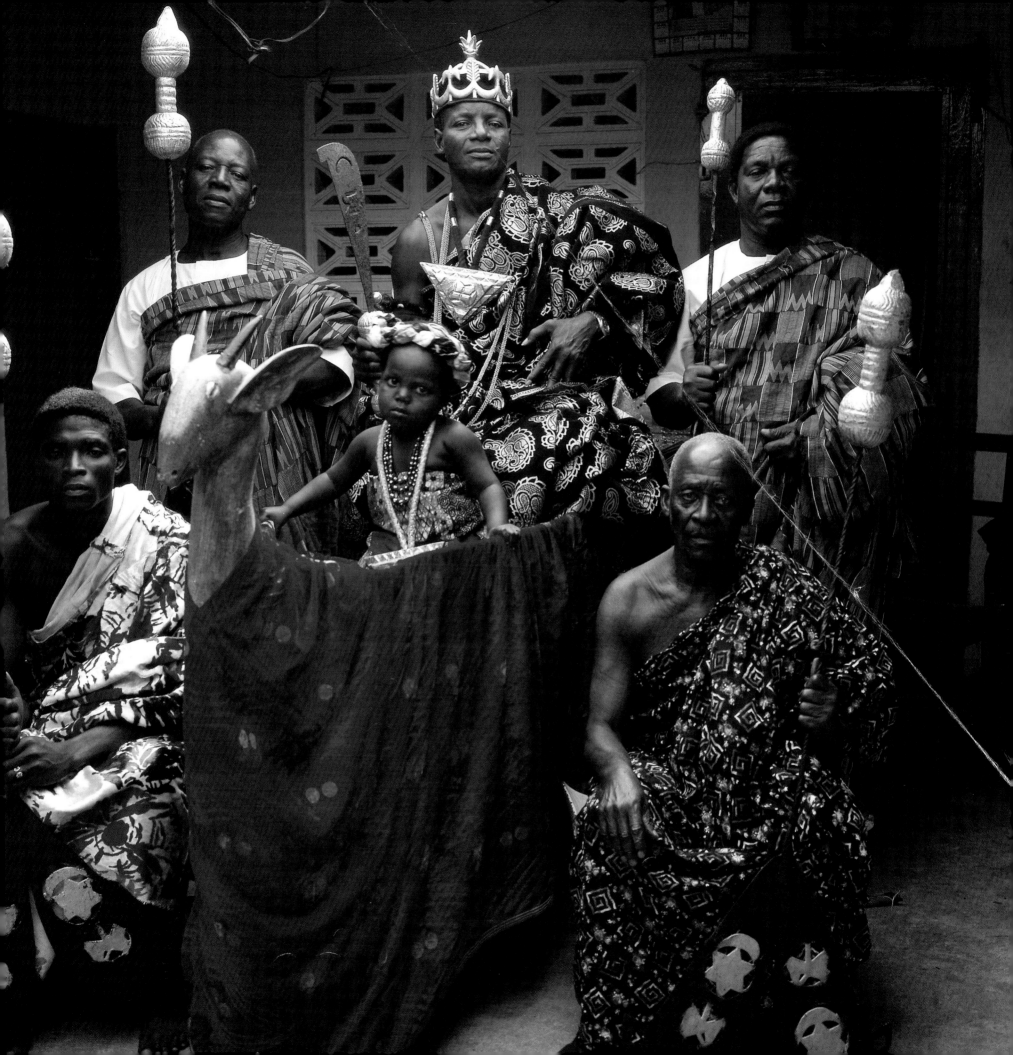

TOGBI ADELADZA II, Awoamefia of Anlo. The King of the Anlo is also a farmer. He has three wives and eighteen children and has reigned for more than three decades. Power is passed from the father to the eldest son, and, unlike Akan society, not through the mother. According to Anlo oral traditions, which go back to the thirteenth century, ancestors from a far-off land in the North migrated to West Africa. Next they settled in Weme, near Nigeria, then continued their long exodus towards the Gold Coast. When they arrived in what is now Togo, some of the Ewe founded Notsé, and the others went along the ocean farther east until they reached Anlo, about sixty miles from Accra, the capital of Ghana. Today, the frontier between Ghana and Togo divides the Anlo people in half. They are victims of colonial partition, which showed little regard for ethnicity.

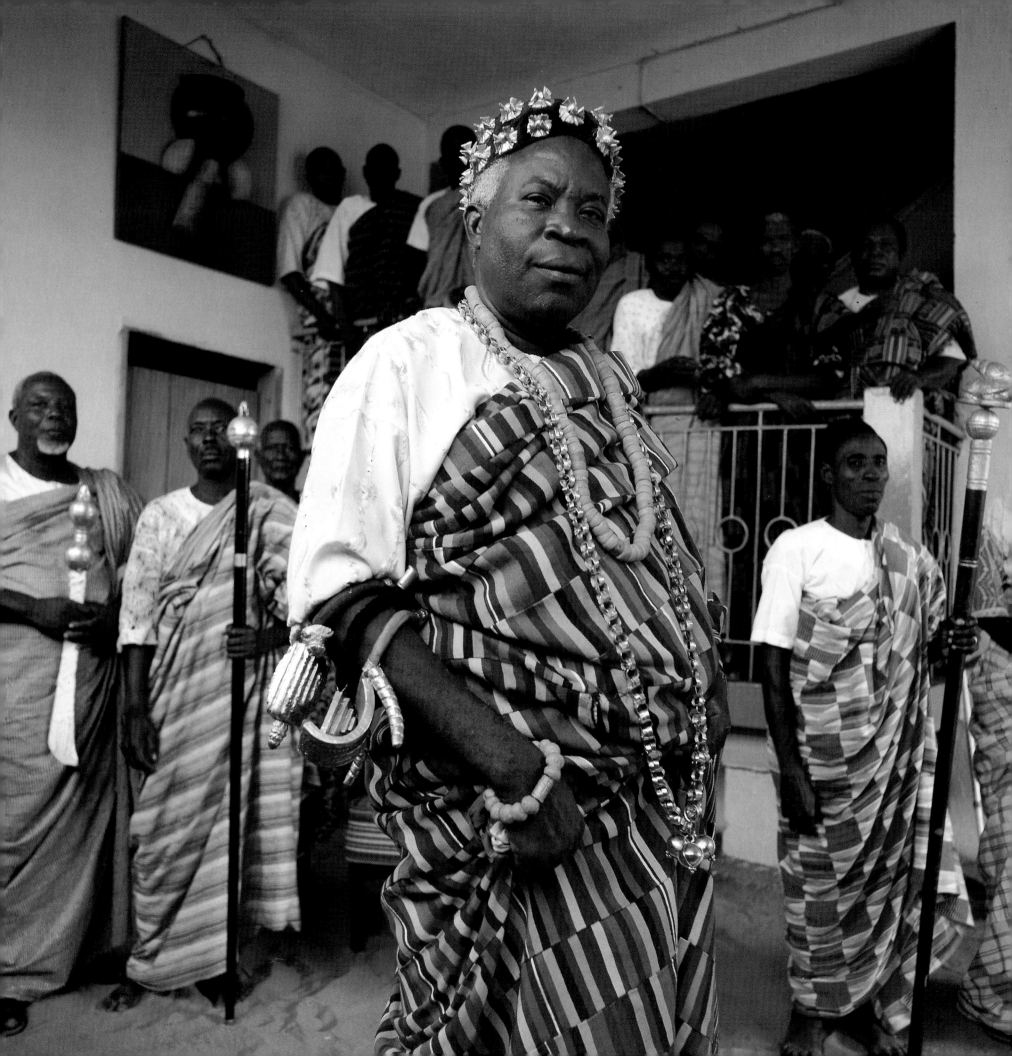

ODEEFUO BOA AMPOSEM III, Denkyerahene.

The *Denkyerahene* (King of the Fanti) is wearing the Akan rulers' warrior costume, adorned by Manding amulets. Though pagan, Akan monarchs believed in the power of Muslim magic and thought it would make them invulnerable to bullets and arrows. In that era, some thirty kingdoms prospered from the trade between the coast and the northern savannas. They fought each other to gain control of the trade with the Europeans and acquire firearms. By the second half of the seventeenth century, Denkyera had established a trade monopoly and become the dominant power in the Bight of Benin. It even collected a *coutume* for the rental of the fort of El Mina. The king headed a remarkable military and political organization. Each provincial chief commanded an army, which was kept in a state of permanent mobilization. According to tradition, princes had to stay in a foreign court for several years. Having avoided being poisoned by a claimant to the throne, they also served as hostages, ensuring peace in the kingdoms. The future king of the Ashanti, Osei Tutu, was a servant of the king of Denkyera. When a priest helped him return to the country, Osei Tutu put an end to fifty years of Denkyera ascendancy. Legend has it that one day Dim Gyakari, the king of Denkyera, fell ill. To determine the cause of this illness, the priest Okomfo Anyoke went into a trance and demanded that an albino be sacrificed. The Denkyera killed the priest's mother who was an albino, and King Dim Gyakari was cured. When Okomfo Anyoke awoke, he swore he would get revenge. He turned himself into a beautiful woman and was immediately invited by the king into his chambers. The young woman learned the secret of the sovereign's fetishes and flew away. She regained the original form of the priest as she landed in Ashantiland and created a fetish that enabled Osei Tutu to crush King Dim Gyakari's armies.

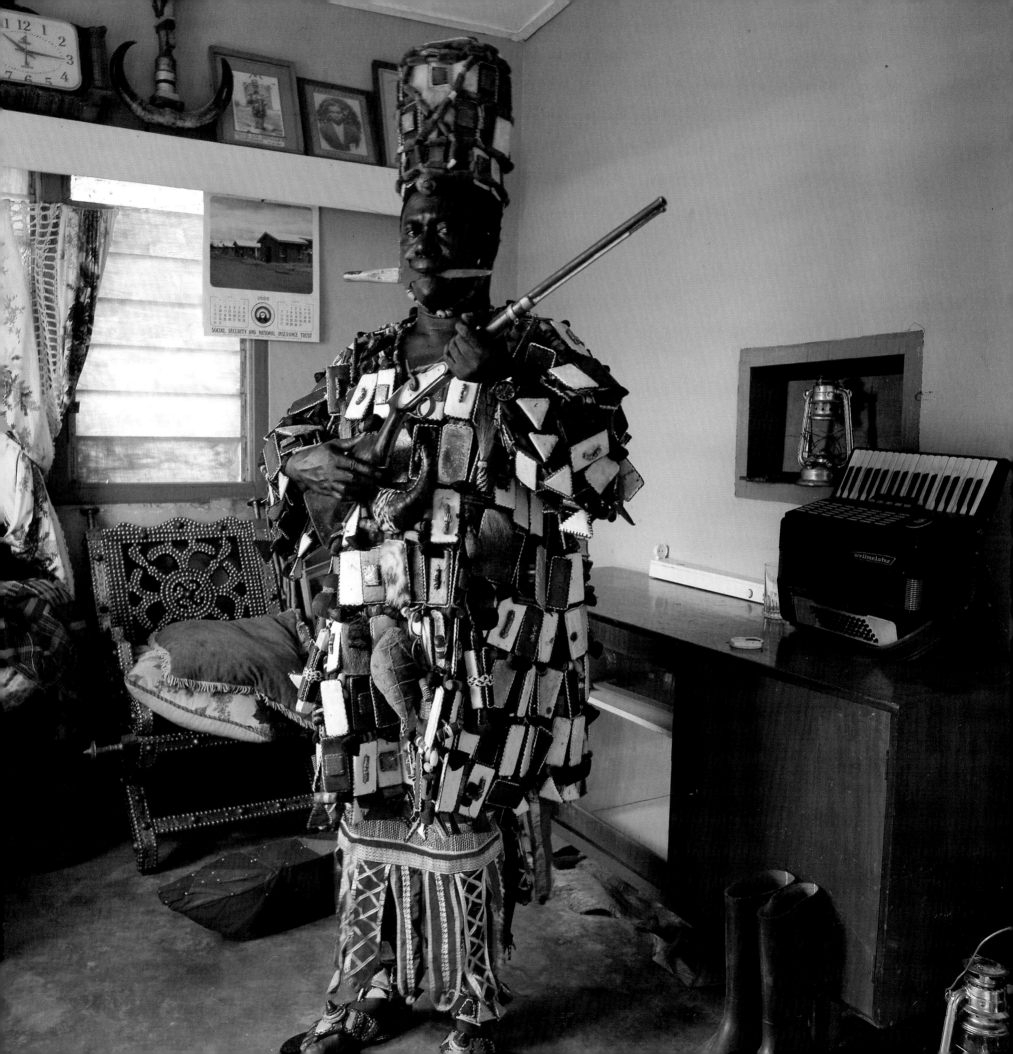

OTUMFO NANA OPUKO WARE II, King of the Ashanti. Since 1970, Matthew Poku, a former lawyer, has

had someone else cut his hair and nails. He is the gold king. The fourteenth *Asantehene* (king), he reigns over Ghana's most powerful Akan group, the Ashanti. In the sixteenth century, the Fanti of Denkyera controlled a large segment of the Akan population. Every year, the Fanti exacted a tribute of nubile young girls and four jars of gold powder from the Ashanti. To get out from under the yoke, Okomfo Anyoke, a village priest in Kiwaman, assembled the chiefs of the principal clans in the city of Kumasi. He went into a trance and used his magic to make a Golden Throne appear before Osei Tutu, the chief of the Ashanti. The priest declared the throne sacred. From then on, it symbolized the Ashanti nation, and no one was allowed to sit on it. Osei Tutu was crowned first *Asantehene*. With Okomfo Anyoke's help, Osei Tutu defied Dim Gyakyeri, the formidable king of the Denkyera. In 1701, the two armies clashed at Feyiase. The *Asantehene* crushed the Denkyera forces. Over a hundred thousand died on the battlefield. Pillage and looting went on for nearly two weeks. The victory marked the beginning of an Ashanti supremacy that was to last two centuries. It took the English seventy years and seven military campaigns to defeat the Ashanti armies. During one of those campaigns Colonel Baden-Powell, the founder of the Boy Scouts, sacked Kumasi, the Ashanti capital. In 1896, the English broke Ashanti resistance, looted gold and art objects, captured King Prempeh and deported him to the Seychelles. The Golden Throne had disappeared. The English were sure they had taken it, but were mistaken. The real throne reappeared thirty-five years later in Kumasi.

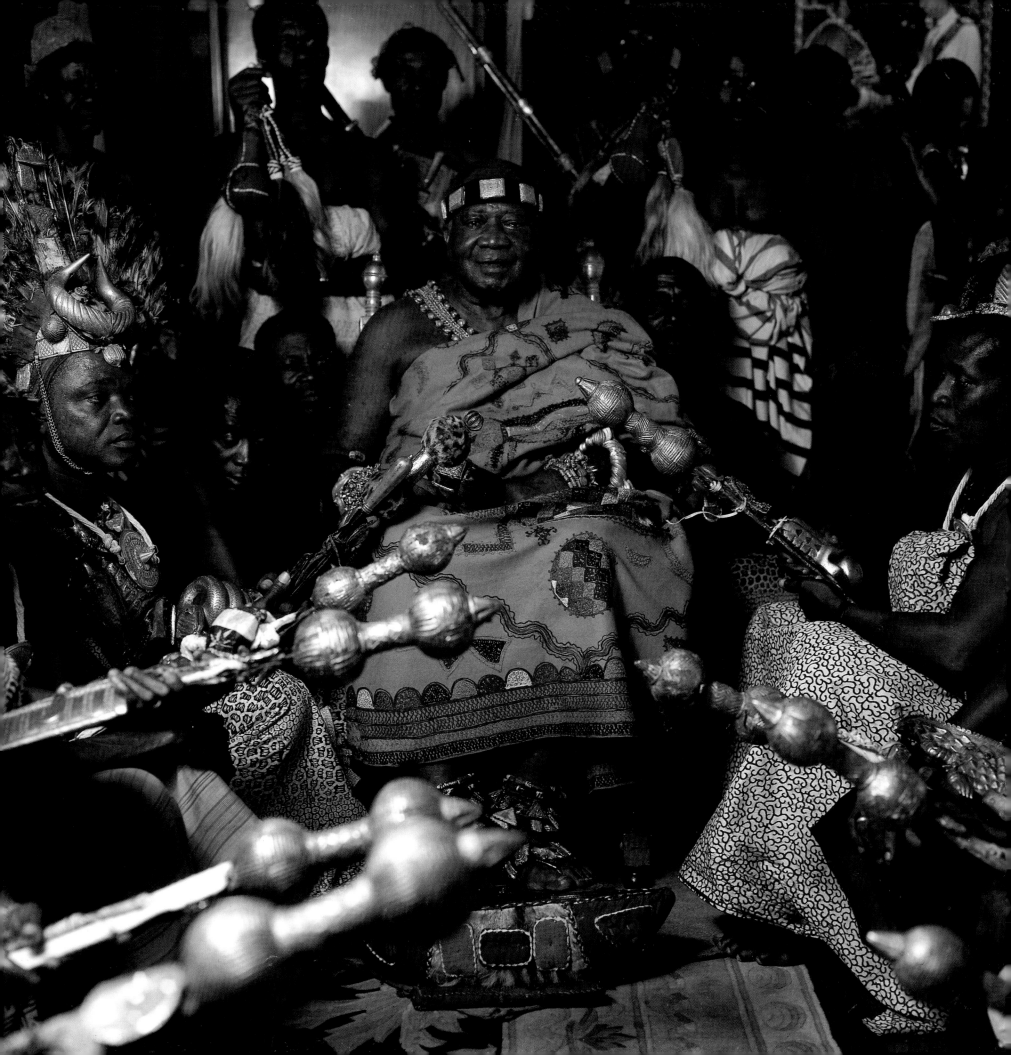

OSAGYEFO KUNTUNKUNUNKU II, Okyenhene, King of the Akim. *Okyenhene* Osagyefo is a

former general practitioner, who studied in Czechoslovakia. His grandfather, Sir Ofori Atta I, was one of the greatest Akim kings and a World War I hero. Serving in the Gold Coast Regiment, he bought a plane to fight the Germans. In 1918, the English made

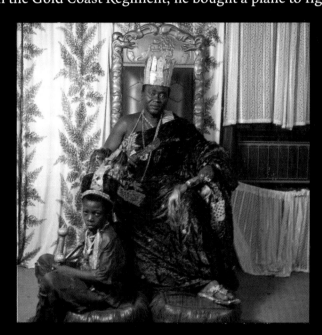

him a Commander of the Order of the British Empire and in 1928, invited him to England to be knighted. He was the first West African to receive the honor. The Akim, the hereditary enemies of the Ashanti, laid a trap for the great Ashanti king Osei Tutu and killed him. Since the assassination, Ashanti kings have been forbidden by custom to enter a battlefield, and bodyguards protect them against attacks from the rear.

ODENEHO KWAKO AKOTO II, Omanhene, King of Akwamu. Eighty-two years of age at the time of

this photo, the King of Akwamu is the oldest monarch in Africa. He has ruled since 1937. Though he has only four wives, he has twenty-nine children. In the fifteenth and sixteenth centuries, the residents of Twifoo migrated to central Ghana. When they reached Abakrempa, the coastal Fanti people came to watch them go by and stayed for hours, straining their necks to view the migrants. They called the newcomers *Akonbufo* (neck twisters) in Twi. In time the word became *Akwamu*. Isolated in the interior of the country, the Akwamu, like many Akan kingdoms of the time, sought access to the sea. The priest-king of Accra, then a key coastal town, called on the Akwamu to put down a cabal of nobles. The military intervention marked the beginning of a century of Akwamu hegemony. Second only to Adense among the powerful Akan societies, the Akwamu became the military model for the Akan and the mighty Ashanti Confederacy, which would eventually dominate the region until the end of the nineteenth century.

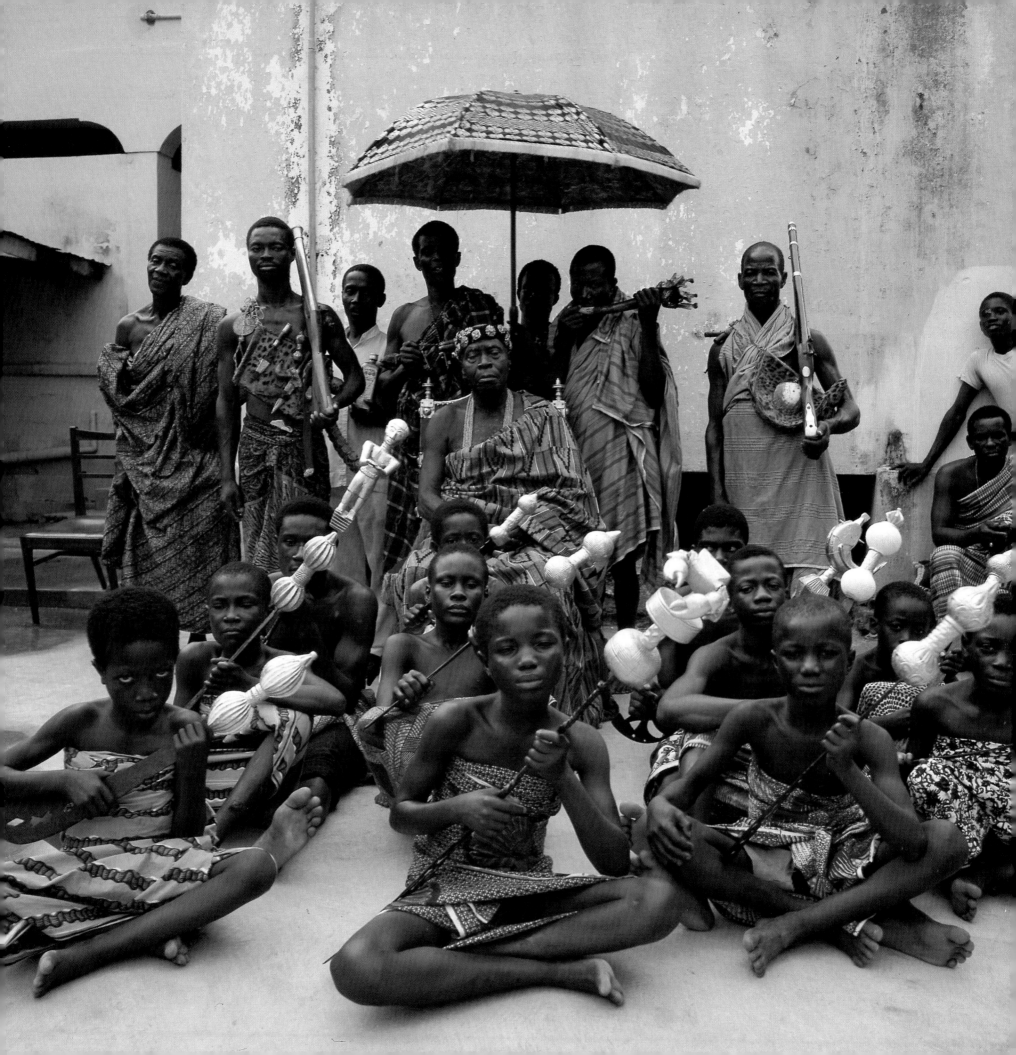

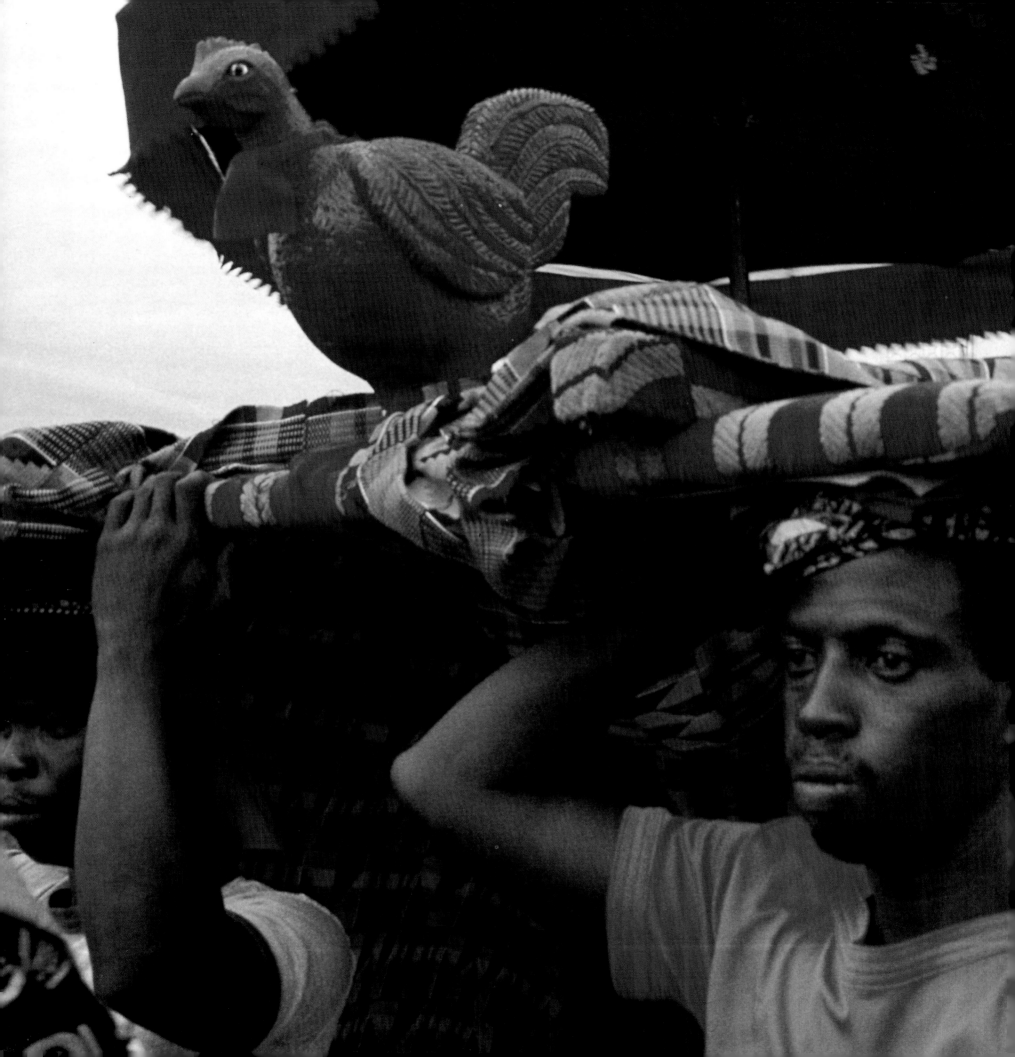

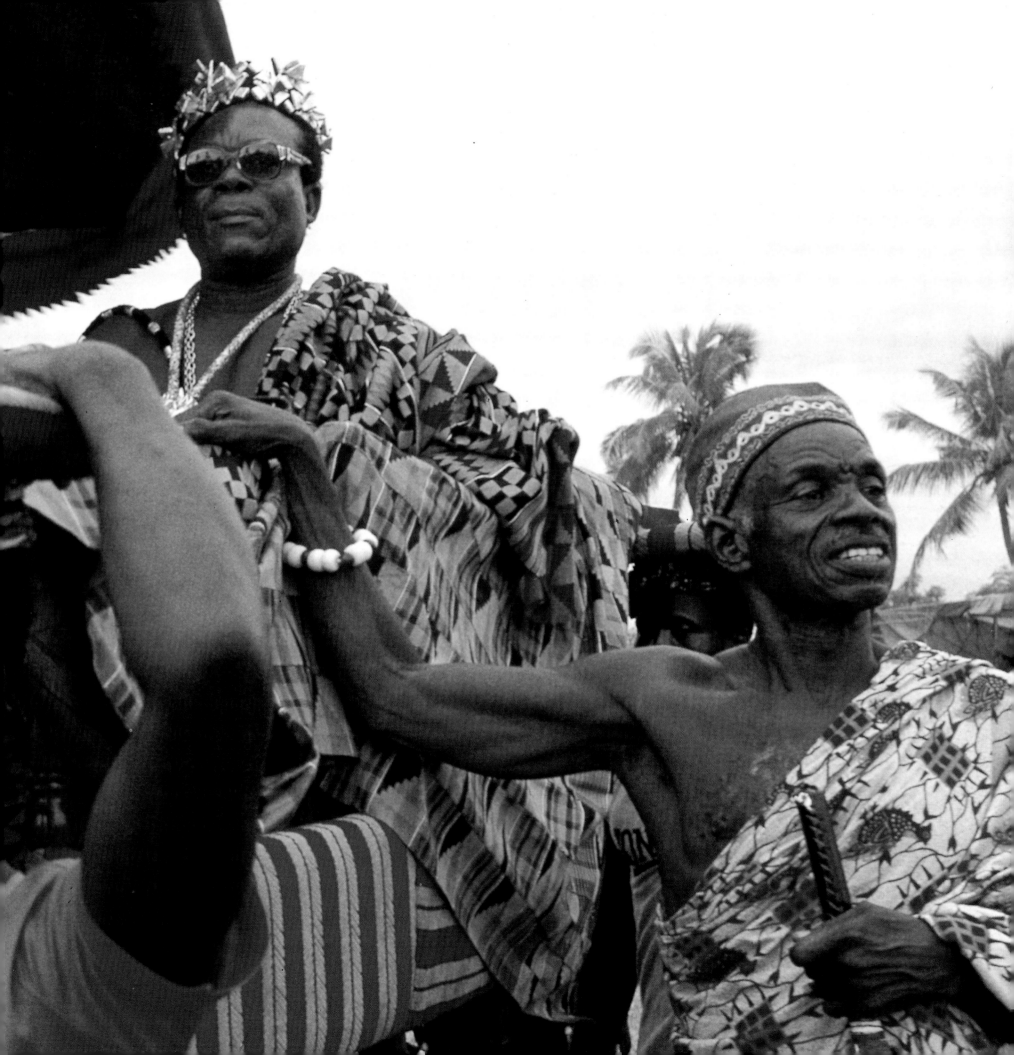

GE TONYO, FOLI BEBE XIV, King of the Gen. Foli Bebe XIV must not receive white foreigners without first noti-

fying Togolese authorities. To visit him, you must obtain signed authorization from the ministers of information and the interior. At the time of independence, some African chiefs of state tried to diminish the prestige of the monarchies that had survived colonization. They thought the kings would impede progress and limit their personal power. When they did not manage to control the monarchs (as they did with Foli Bebe XIV), they eliminated them. In Uganda, Milton Obote and Idi Amin abolished the kingdoms of Buganda, Bunyoro, Toro, and Busoga. In what was then Zaire, Joseph Mobutu (later Mobutu Sese Seko) condemned Emperor Lunda to death and stripped the Msiri (king) of the Yeke of his fortune. In Ethiopia, the celebrated King of Kings, Emperor Haile Selassie I, was deposed. The history of the Gen people dated back to the eighteenth century when the Europeans, seeking profitable trade opportunities, made pacts with kings on the Gold Coast. If the kings became too dangerous or too rich, the Europeans broke their alliances and concluded agreements with other kings. This practice caused the wars among the kings to escalate, and the situation was exacerbated later on by the invasion of the Ashanti, who were attracted by the riches from the "land of the whites." In the late eighteenth century, Ofiri, the king of the Gen, and his general Foli Bebe had to flee Accra to avoid being subjugated by the army of the powerful kingdom of Akwamu. With what was left of their armies, they settled in Glidji in Togo, where King Ofiri was killed. Foli Bebe was proclaimed the chief of the Gen and the first king of Glidji. He had to contain the attacks by the Fon in the east and the Anlo in the west and was killed in the battle of Aflao, which is now the border between Togo and Ghana.

Previous pages:
Traditional Ewe chief
borne on his processional
litter in Ada in Southern Ghana

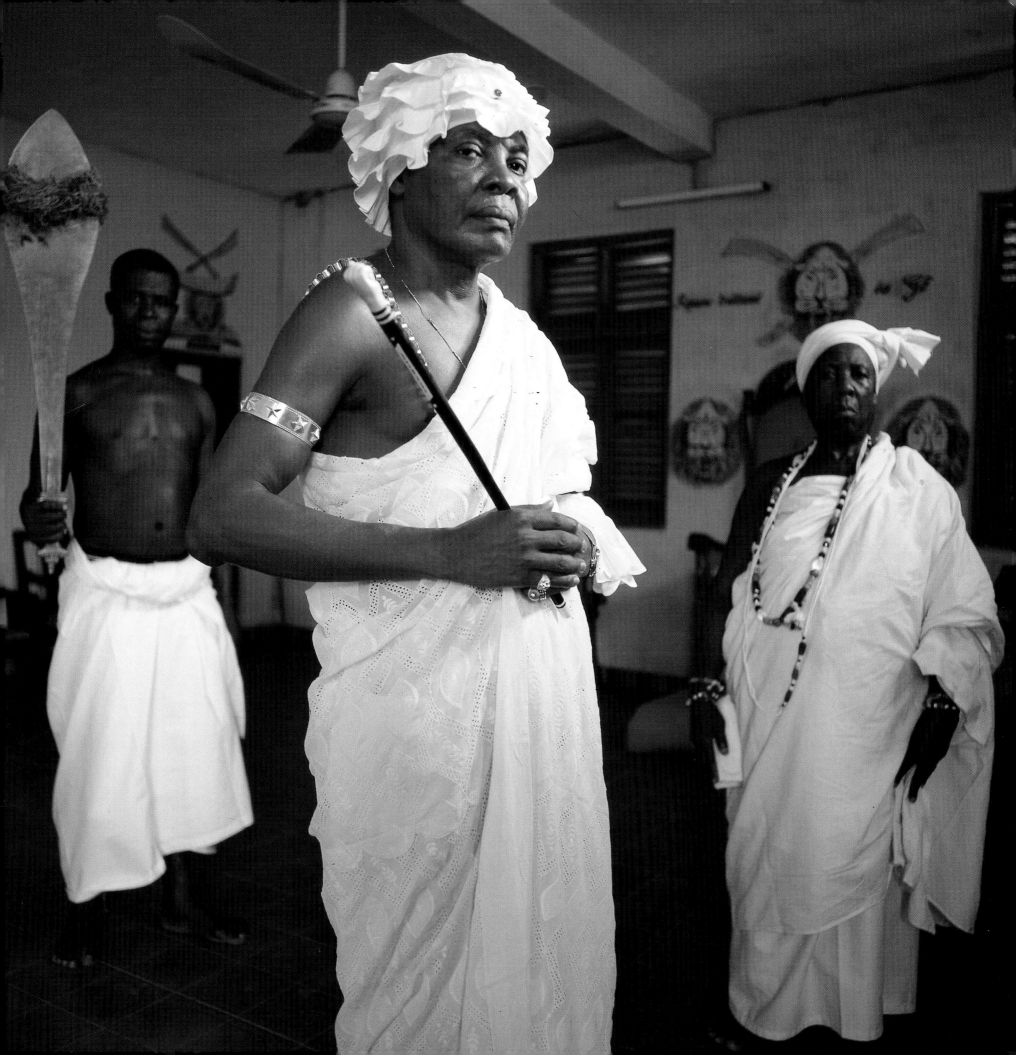

NANA BONZOU II, King of the Ndenye.

In the early eighteenth century, the Ashanti crushed the powerful Denkyera army. The defeat led to a massive exodus of the Denkyera peoples, to whom Nana Bonzou's ancestors belonged. Fearing an Ashanti reprisal, they settled in Ndenye in southern Ivory Coast. But they were not safe for long. The Ashanti exacted a heavy tribute in gold powder from them. Gold was in great supply in the Akan kingdoms. The kings claimed a third of the gold production and the largest nuggets from their subjects. Adu Kpanhi, a Ndenye chief, was immensely rich. It is said that he spread out his gold to dry in the sun and that he amassed a fabulous treasure—seven jars of gold powder, which he buried in a secret hiding place. When he died, none of his successors could find the gold. Akan kings attended important ceremonies with their arms so laden with gold that it took two people to support them. All the royal insignia were covered with gold, but the Akan chiefs were not permitted to make as lavish a display of them as the sovereign. A chief's status in the hierarchy was indicated by the amount of gold he wore and the figurines that adorned his parasols.

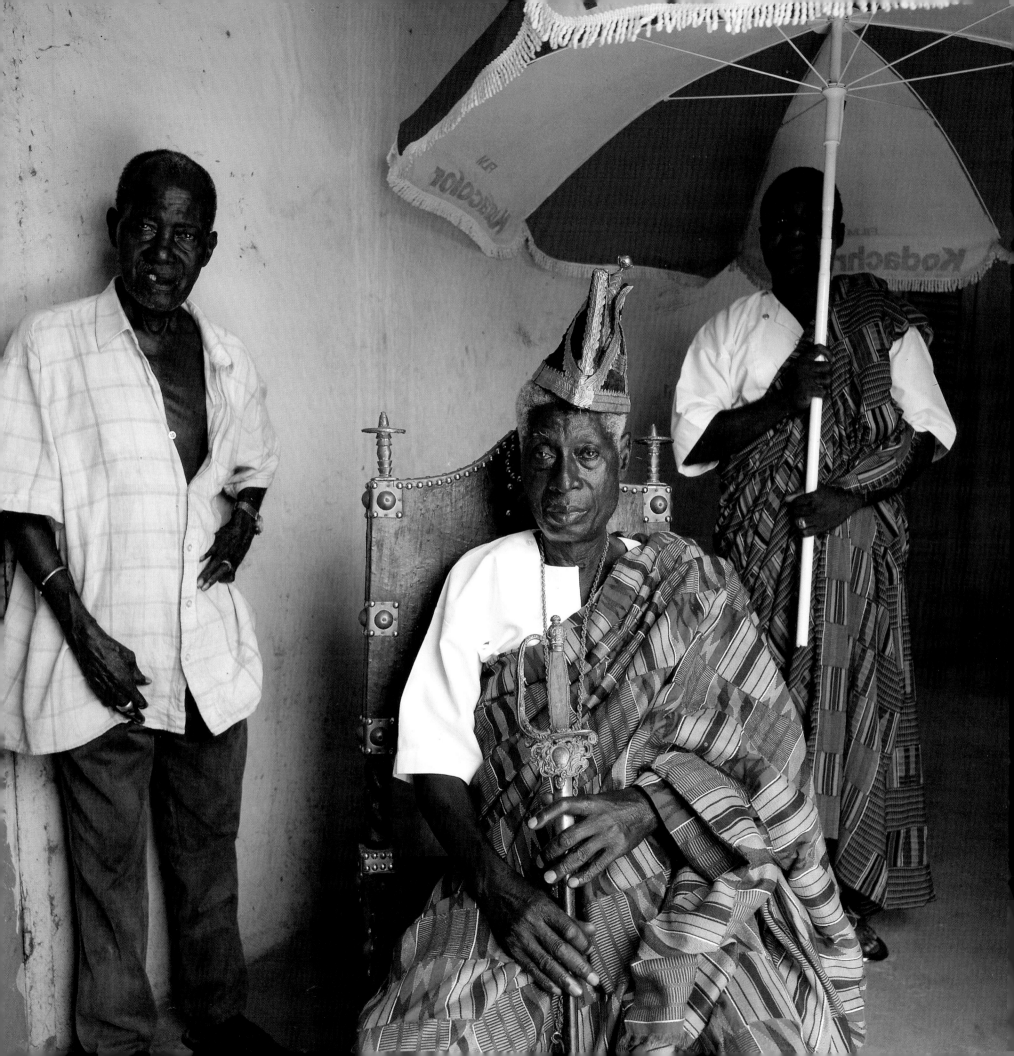

NANA KOFFI YEBOUA, King of the Abron. When Nana Koffi Yeboua was enthroned, two old women lifted him by the armpits and went through the motions of sitting him on the *Adyabia* (seat of heritage) three times, making sure that he did not touch it. It is said that if by some misfortune, the future king had even brushed this sacred seat, he would have become impotent. The ritual accomplished, Nana Koffi Yeboua became king of the Abron (an Akan clan) and possessor of the *Adyabia*. The clan is the basis of the Akan social system. Without the sacred seat, the chief is powerless. In the past, he was responsible for each of his subjects. If one of them contracted a debt, the chief could sell or offer as collateral possessions or even persons. If the debt went unpaid, either the creditors kept the property, or the person offered as collateral was executed. For a large debt, the creditor could demand, as a last resort, the heritage seat as a guaranty. In the eyes of the Akan society the debtor clan lost all respect.

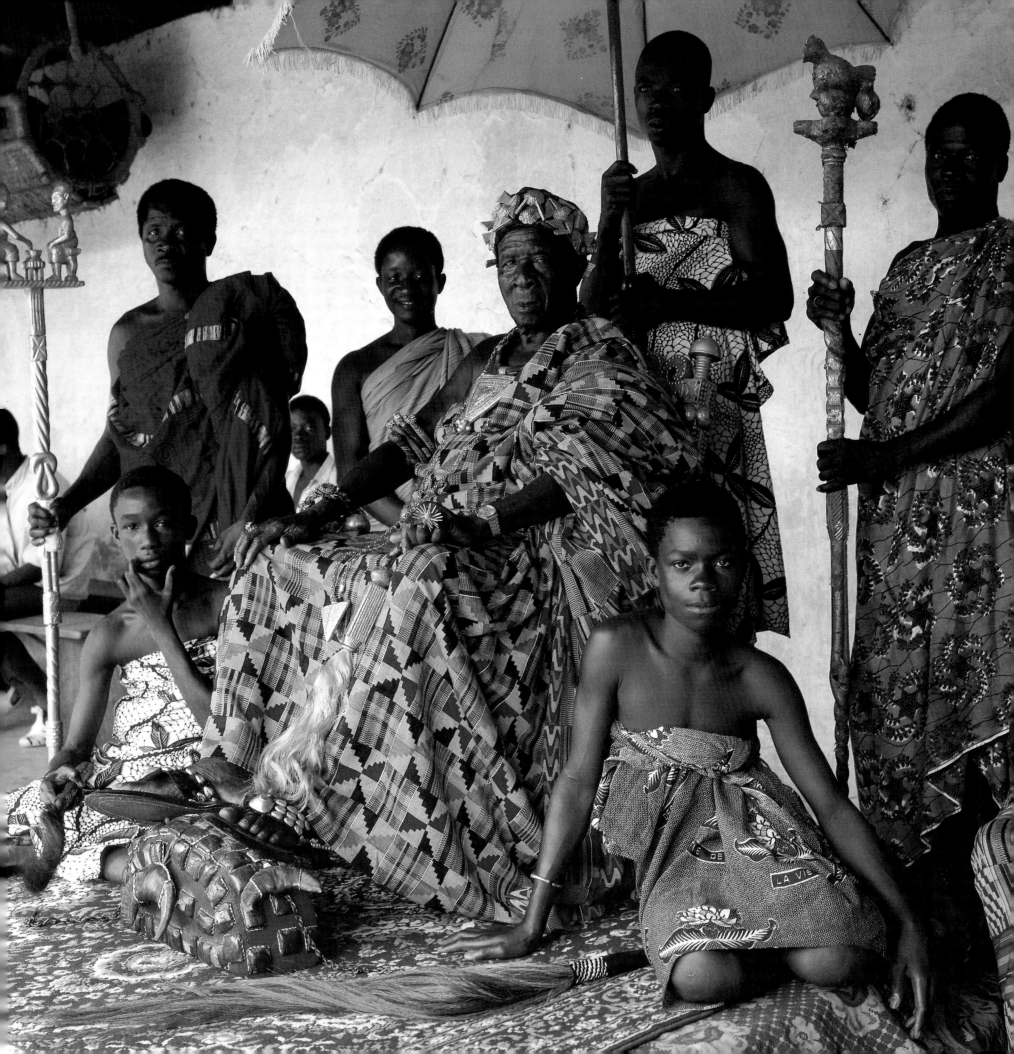

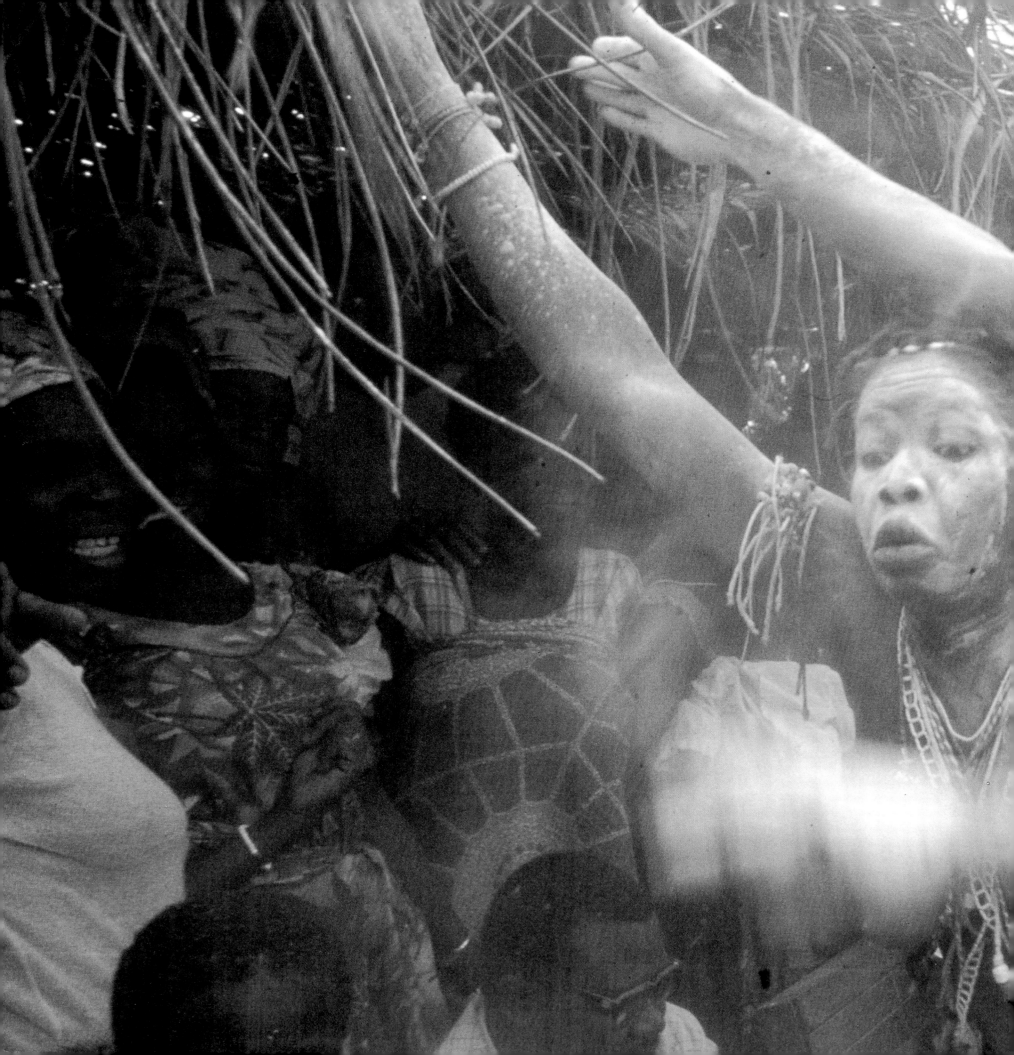

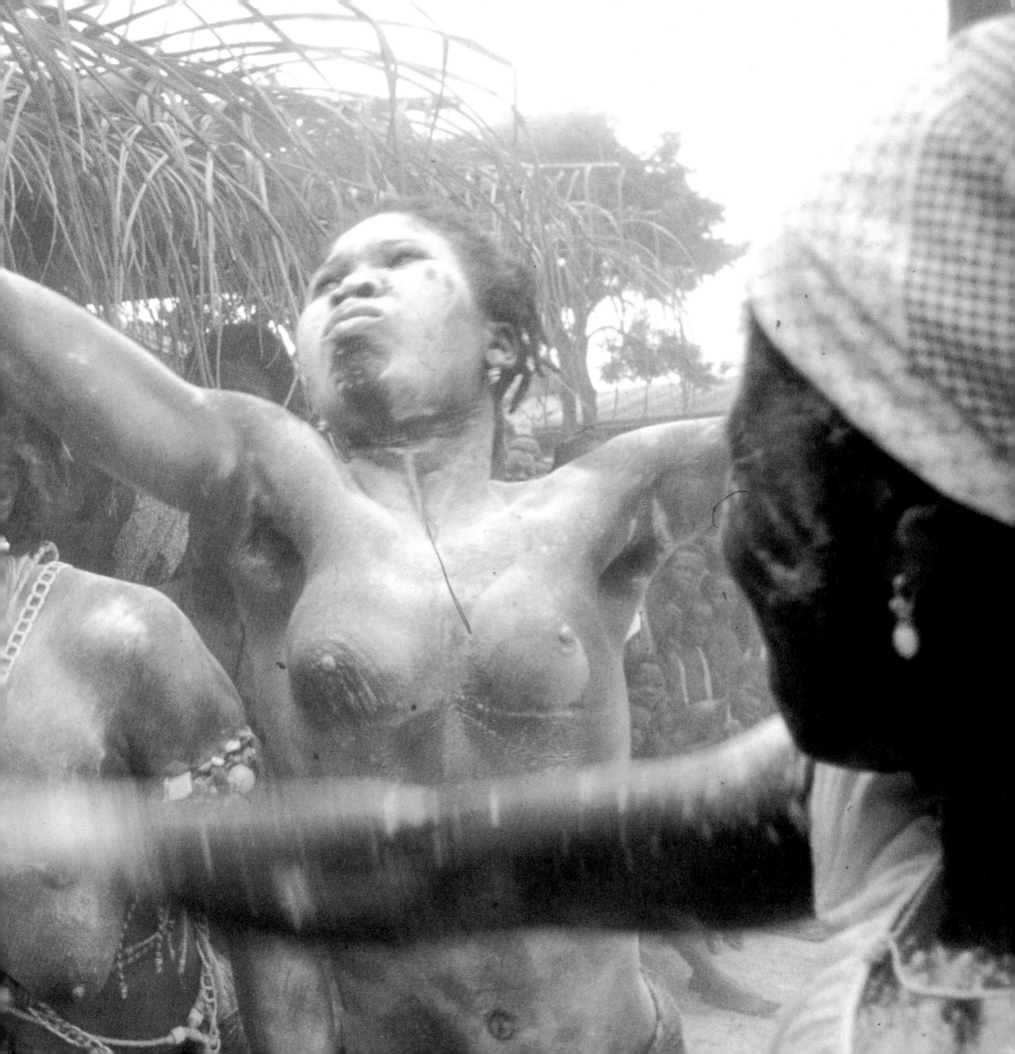

THE LITUNGA ILUTE YELA, King of the Lozi. The *Litunga* (king) is a sociologist by profession and a retired

diplomat. At the time of independence, he became the first Zambian to hold the post of director of social welfare. He also served as permanent secretary in the cabinet of the prime minister. Chosen by the Grand College of Electors whose names are kept secret, he was proclaimed *Litunga* in April 1977. *Litunga* means "guardian of the land." He owns the western province of Zambia and has immense power. Around the seventeenth century, the Luyana people extended their dominion over the other communities in the Upper Zambezi region and created the Lozi linguistic group, which accounts for more than a quarter of Zambia's population. Their chief, Mwam Bwa, was from the former Zaire. Her daughter succeeded her, but was deposed by a peasant revolt and had to abdicate in favor of her son Mboo, the first king of the Lozi. In 1840, the Kololo escaped the *Mfecane* (Zulu terror) and occupied the Lozi (or Rotse) kingdom for thirty years. But the real father of the kingdom was Lewanika. In 1900, he reached a protectorate agreement with the English and hosted the British royal family during their official visit. They presented him with an English admiral's uniform. The costume, now part of Lozi kings' regalia, is made to measure in England for every king and stitched with golden thread.

Previous pages:
Apprentice fetishists
of Tanguelan performing
a ritual dance before Akan
chiefs (Ivory Coast)

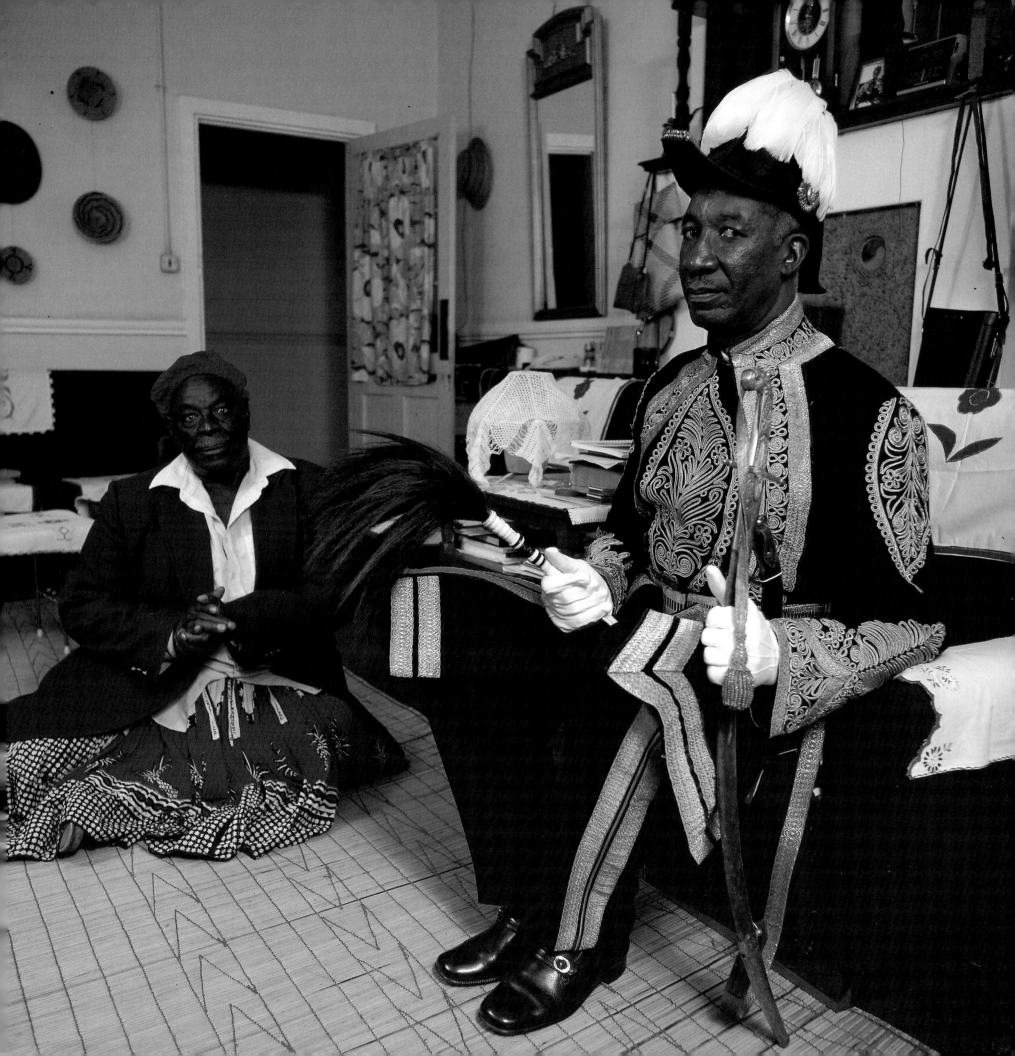

HALIDOU SALI, Lamido of Bibemi.

Halidou Sali, the twelfth *Lamido* (king) of Bibemi, was crowned in 1958. He is a descendant of Aido Sambo, one of forty-two *Lamido* of Adamawa. In the eighteenth century, Aido Sambo helped spearhead Usman dan Fodio's *jihad* in the western regions of his immense empire. Oral traditions say that the ancestors of the inhabitants of Bibemi were called "Yillaga hard heads" because their impetuous temperament made them warlike. A dispute with their neighbor from Macina caused them to emigrate from the ancient Empire of Mali. The exodus spanned several centuries. In 1770, they expelled the Nyam-Nyam and settled in Bibemi.

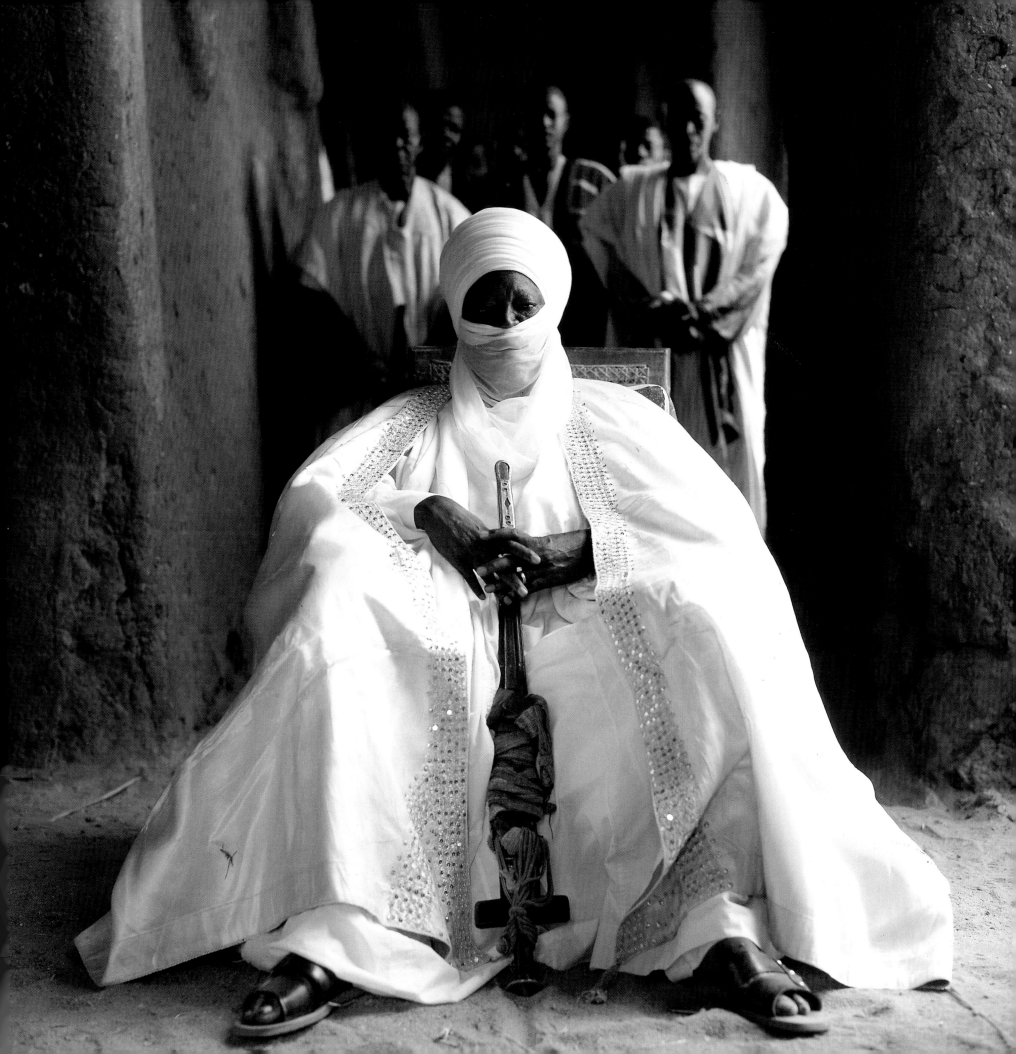

NJIMONLUH SEIDOU, King of the Bangangte.

By the age of forty-four, Njimouluh had about forty wives and twenty-five children. An agricultural engineer, and a graduate in economics from the Loughborough University in England, the king is currently the director of the Caplande development agency. He is also a member of the party in power, the Cameroon Peoples' Democratic Movement, and second assistant to the principal administrator. His ancestor Ngami, a hunter, fled the Banka region with his twin brother toward the end of the eighteenth century and settled in the land of the Bamiléké, where there were many autonomous districts headed by minor chiefs. Whenever he went hunting, he always gave the game he killed to them. His generosity quickly earned him the praise name *Nessa Bou* (the man with long arms). Through bribery and guile, he gradually brought all the chiefs under his control and created a federation of nine districts under his sole authority. He became king of the tiny nation. His neighbors, the Bamum, tried to conquer the new kingdom, but ran into surprisingly fierce opposition from the long-armed king. Henceforth, the kingdom was known as *Bag ngante* meaning "we will not be vassals." There are no specific rules of succession. The king can secretly designate his successor, who must then hide in a distant village to avoid being assassinated by the many pretenders to the throne. If the king fails to name an heir before he dies, a council of dignitaries selects the wisest, strongest, most intelligent prince to be king. In the past, at the time of a deceased king's funeral ceremonies, the successor was immediately arrested and sequestered for nine months (now nine weeks) in a secret place where he learned the duties and responsibilities of his office.

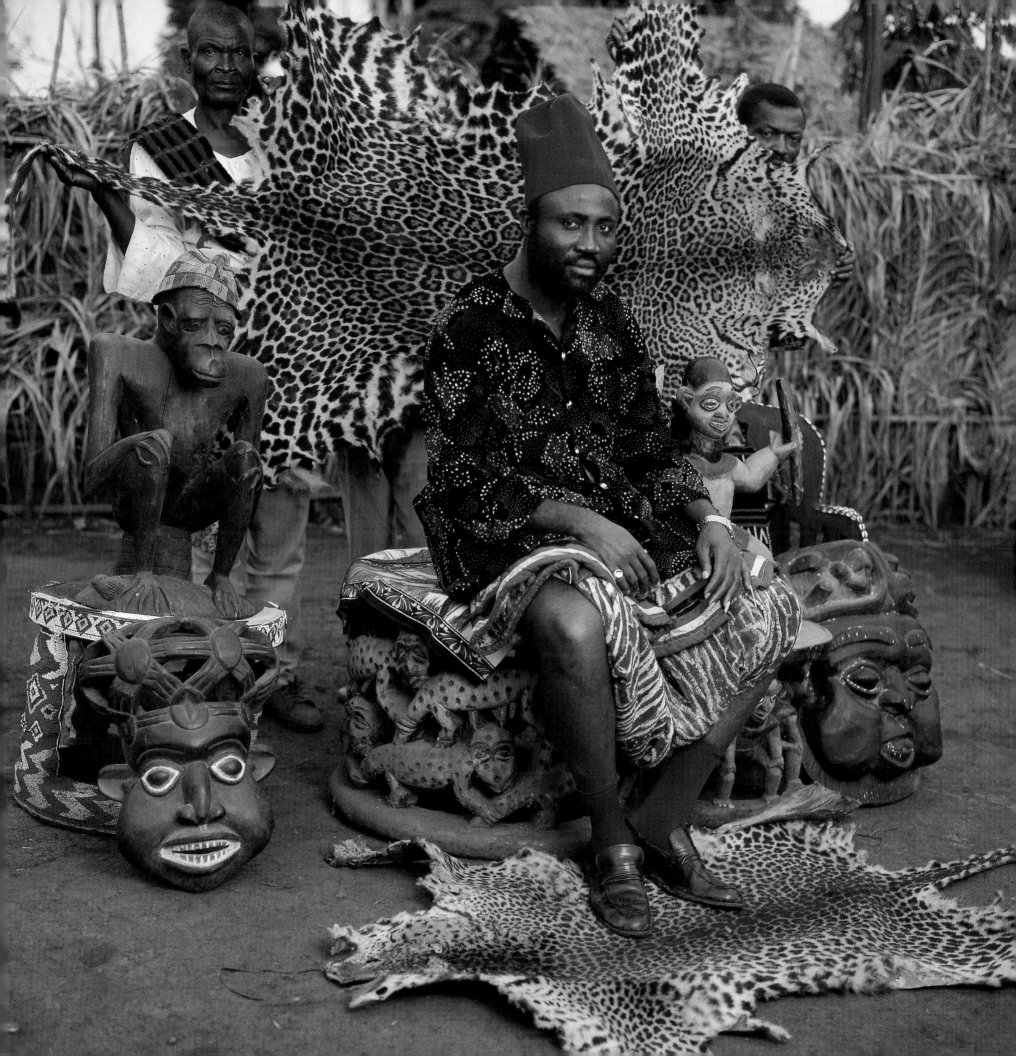

EL HADJ SEIDOU NJIMOLUH NJOYA. Sultan of Foumban, Eighteenth Mfon of the Bamum. The sultan of Bamum has twenty-seven wives and eighty-six children. By his eighties, the sultan had reigned for over fifty years. At twenty-nine, he inherited the famous Bamum throne, which was founded in the sixteenth century. He was elected by the Council of Sages of the kingdom from among the 167 children of his father, Sultan Njoya, who astounded colonial Europe with his genius. The enlightened monarch spent twelve years inventing his own alphabet (the system included eighty symbols) so that he could record the history of his kingdom in the Bamum language. At the time, the oral tradition was dominant. Sultan Njoya told his subjects, "I will give you a book that talks without making a sound." He even established schools to teach the alphabet. Njoya revolutionized agriculture by introducing European plants in Africa, instituted a civil registry, installed a blast furnace, and founded a religion, *Novat Kovot*, a mixture of Islam and Catholicism, adapted to the African context. In 1913, when Cameroon was still a German colony, Njoya set up his own printing house. After the defeat of Germany, the French administration took over and attacked the "Negro king's" initiatives. The colonizers destroyed his printing house and demanded that the sultan submit. When he refused, France deported him. In 1933, the most modern monarch in Africa died in exile.

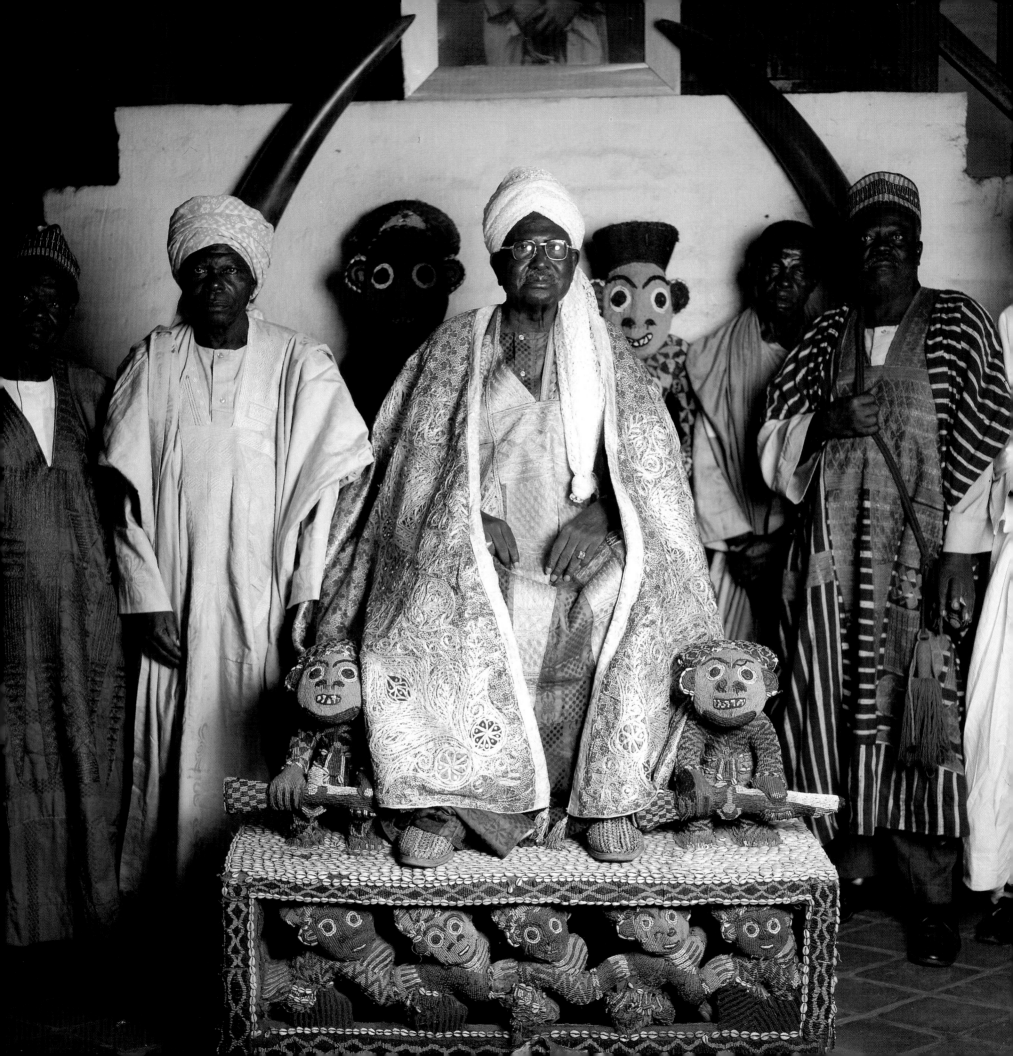

LAMIDO OF NGAOUNDERE. Like many other royal courts in Africa, the Ngaoundere's court has about a

hundred dignitaries and notables. The *Galdima*, the highest-ranking official in the realm after the *Lamido*, replaces him in his absence. In normal times, he gives orders to other officials on the *Lamido's* behalf. War, justice, trade, agriculture, and cults are entrusted to the great Fulani dignitaries. Dignitaries and notables from various backgrounds share the other responsibilities of the realm. For example, the *Mougadda* ("those who come close" in Arabic) are the *Lamido's* companions who share meals and evenings with him. The *Sarkin Pawa* is the chief of butchers; he controls market meat sales and receives a piece of meat from every slaughtered animal. There is a chief of millet; once, there was a chief of kola. The chief of the *Dogari*, or royal guards, was an executioner during German colonization. Armed with an axe and a knife, he would lead the condemned people to the riverbank, then break their legs with the axe and cut their throats with the knife. The horse is a prized animal at the *Lamido's* court, and the *Samaki* is the only noble allowed to place the royal saddle on the Lamido's horse. The *Sarkin Yara*, the chief of young people, can jail anyone guilty of offensive behavior. But the "satisfied man" has the most pleasant duty in the kingdom. His function, known as *Midjidadi* in Hausa, is to offer congratulations or condolences to other monarchs in the region on behalf of the *Lamido*.

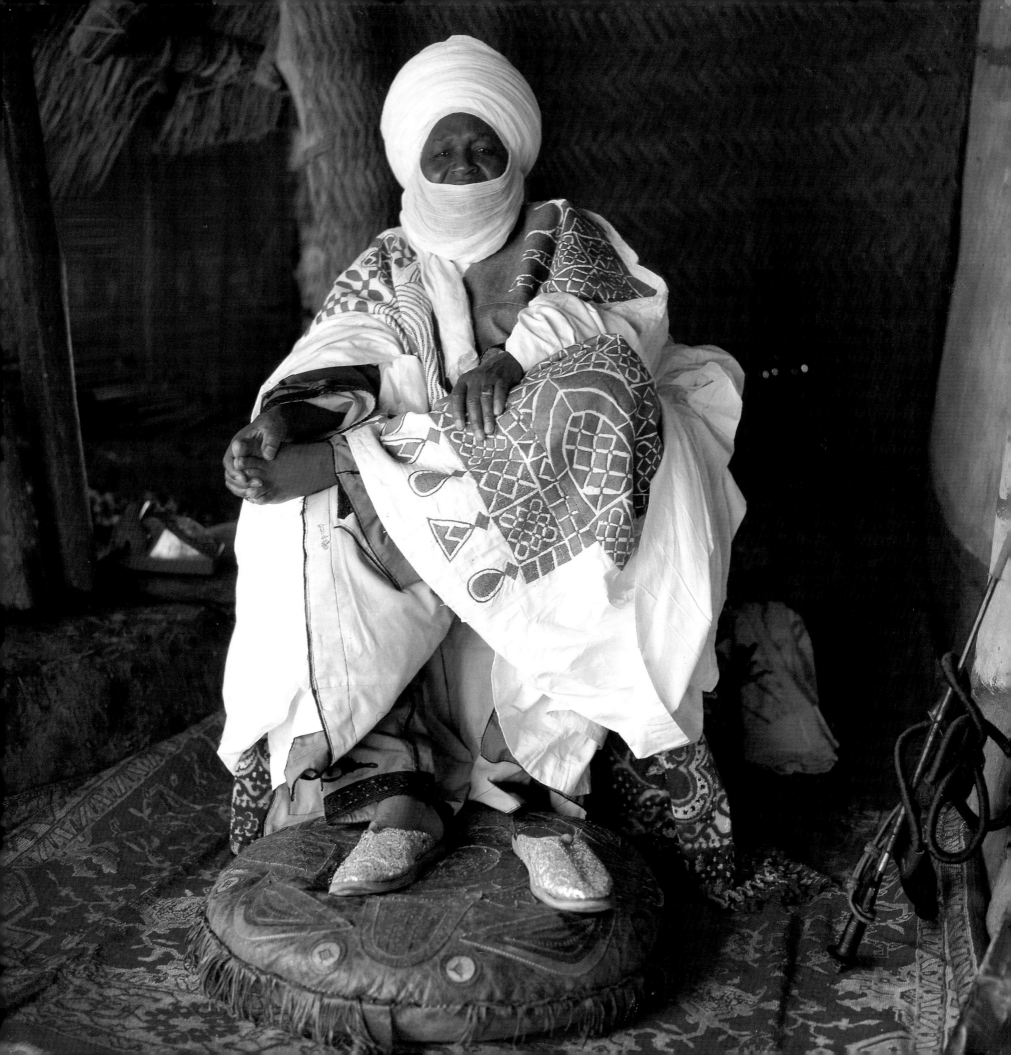

HAPI IV, King of Bana. A tragic event led to the foundation of the kingdom of Bana. In the middle of the seventeenth century, several Bamiléké communities set up small villages around present-day Bana. According to legend, a village chief named Mfenge was accused of sorcery by his fellow chiefs. To prove his innocence, he cut off his mother's head and gave her corpse to specialists for examination. Sorcery, thought to be transmitted through the mother's womb, was not substantiated. So Mfenge insisted that mothers in other families be decapitated, too. His four sons went from house to house looking for wives and mothers to send them to the palace for examination. If a women resisted in any way, she was beheaded on the spot! Panic-stricken, the chiefs and officials fled, and Mfenge became the king of Bana. On the Bamiléké plateau of western Cameroon, the king is called

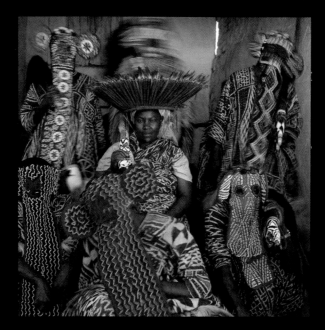

A princess of Bana

the *Mfe* and the dynastic or village name is added to this title. In Bana, the name of the chiefdom is *Nee*, which means "warlike village." To the Germans, "Nee" sounded like "Na" which was combined with "Ba" a Bantu prefix meaning "the people of" Na. The Germans strengthened Bana's dominant position, since they needed the support of strong chiefdoms to maintain their influence. When the French arrived, chiefs such as the Sultan of Bandjun, who had assisted the Germans, fell into disfavor and their fiefs were converted into large administrative areas.

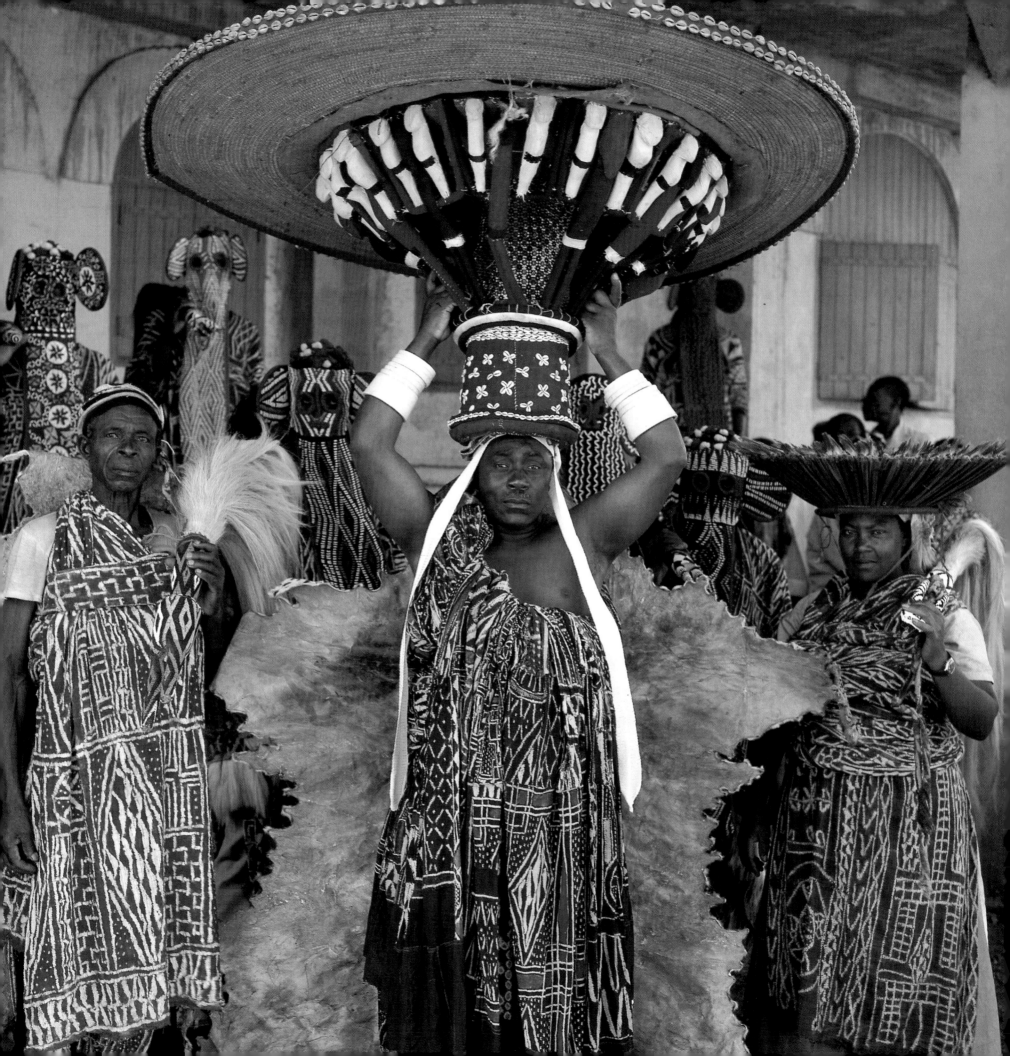

NGIE KAMGA JOSEPH, Fon of Bandjun. The *Fon* (king) is the brother of brave and powerful animals. It is said that at night he can change into a panther and commune with his domain until dawn. He haunts the forest and roams over the savanna, quenching his thirst in the torrent. When a hunter kills a panther, it strikes terror in the hearts of the *Fon* in the Bamiléké region. They fear one of them will die because his double has been killed. The former prefect was a private secretary to Cameroon's minister of Finance in 1964. Kamga Joseph is the thirteenth *Fon* of Bandjun. On the day of his predecessor's funeral, two Bamiléké chiefs—his "executioners"—stopped him in the Bandjun marketplace amid the princes and nobles mourning the passing of the king. Wearing a sisal headdress as a sign of humility, he was bundled off to the home of a noble, the *Tafo Meru*, where he underwent a nine-week period of apprenticeship to prepare him for his kingly duties. In the past, the process lasted nine months. During his retreat, the monarch was accompanied by the woman he eventually would wed before his enthronement, the *nrounq* (love), as well as the *djvikam* (the noble's wife), the first queen. When he returned to his *Tsa* (palace), he took care of the late *Fon's* wives, who became his spouses.

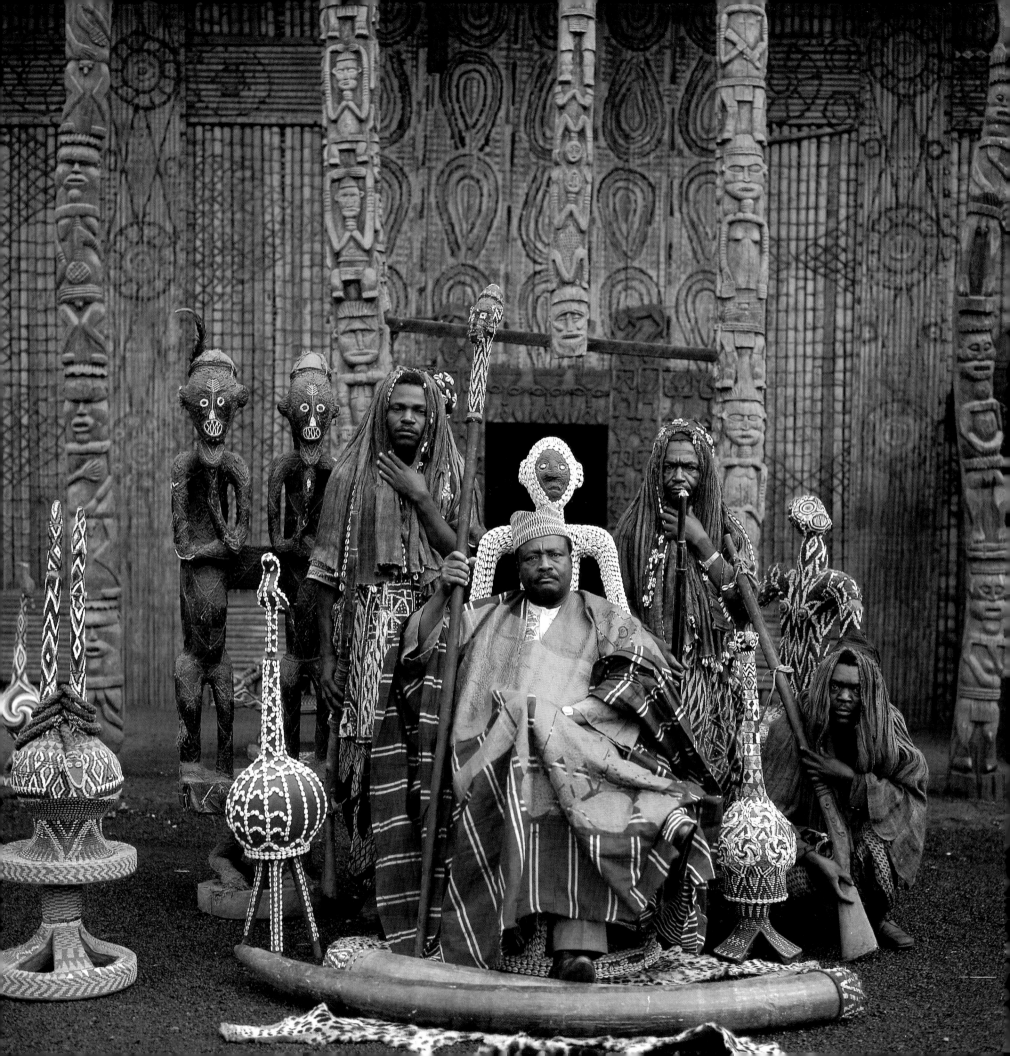

CAMEROON

BOUBA ABDOULAYE, Baba of Rey Bouba.

The Baba reigns over 55,000 subjects and a territory as large as Belgium and Luxembourg combined (almost 22,000 square miles). It is a mistake to call him *Lamido* since he was never a vassal of Sokoto. Bouba Abdoulaye had to resign from the National Assembly of Cameroon and give up modern life altogether to succeed his father. In 1799, his great-grandfather Bouba Ndjidda came from Mali with his Fulani warriors and settled in the outermost limits of Adamawa on the banks of the Mayo Rey River. There, he set up a white standard, a silver drum, a sword, and a basket containing the royal secrets. He also built a palace, made of *banco* (dried mud) with a surrounding wall half a mile long and twenty-three feet high. Today, the palace is home to one of the most traditional sovereigns in Africa. His power is constant but out of sight. He cannot leave the palace more than three times a year. The *Baba* is at the center of the kingdom and of the world. He is all-knowing and must be so. He has hundreds of agents who keep him constantly informed about the goings-on of everyone in the kingdom. Before marrying, his subjects must consult him to obtain his consent. He is reputed to have more than eighty wives and concubines, and to sleep only four hours a night. He spends ten hours a day listening to his subjects' problems. Sometimes they wait for days outside the palace to get to see him. Apparently, one peasant had to wait six months for an audience. It is impossible to enter the palace without the monarch's consent. The *Dogari* (palace guard) are on duty fourteen hours a day, 365 days a year. Before an audience with the monarch, visitors must remove their shoes and shirt, and face the front. They take their leave from the sovereign the same way, making sure never to turn their back on him.

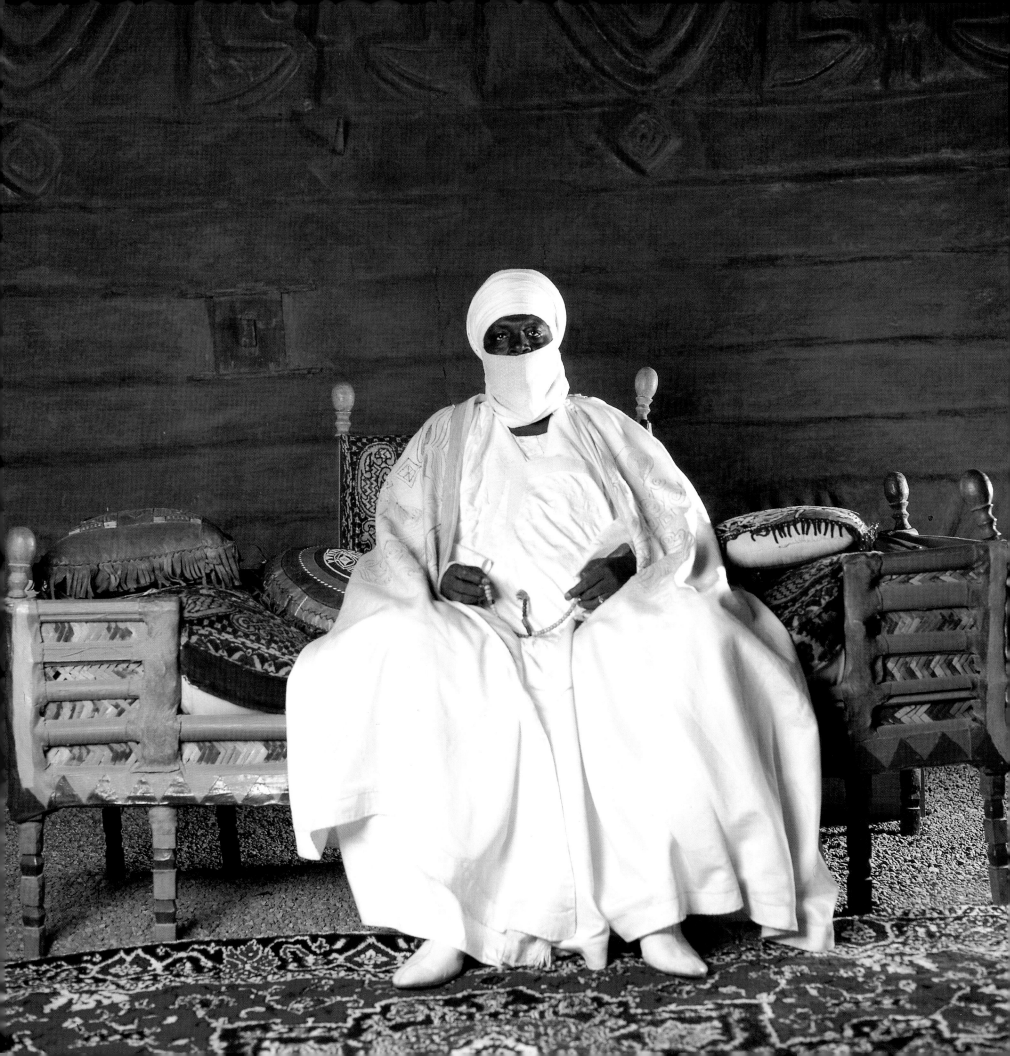

FON OF NSO.

Three hundred years ago, under immense pressure from the Fulani, the Tikar, Nso, and Bamum peoples fled the Lake Chad region. They left together, but when they reached the banks of the Mboui River, they fell into dispute. The Bamum chief Nsare crossed the river, then ordered the boats destroyed, preventing the Nso from reaching the rich lands of

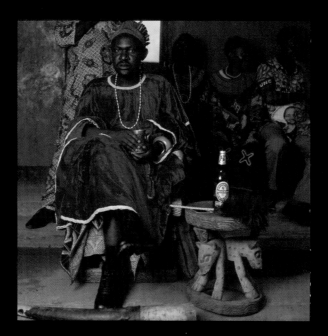

Foumban. Instead, they went along the river to Mount Okou and settled there. The Tikar's second migratory wave reached other peoples in the English-speaking Cameroon region. The first Fon built a powerful and dreaded kingdom, assassinating neighboring village chiefs whom he had invited to dine with him.

ABOUMBI II, FON OF BAFUT.

Like many monarchs in western Cameroon, the *Fon* (king) shares his power with a secret society, the *Kwifor*. The members of the organization are a power behind the throne. In fact, they once acted as official executioners. At night they would put on masks and go out to kill their victims. In Africa, the best known of these associations was the "Panther-Men" society. To be initiated, a candidate had to kill a member of his own family, be it his wife, a child or a parent. The victims were lured outside the village and then their throats were cut with an iron pantherlike claw. The initiates traced the outline of a panther around the corpse to create the illusion that the animal had done the deed and instill fear in the peasants. After committing the crime, the panther-men removed the victim's organs and served them up in a ritual meal. Secret fraternities still exist. In all likelihood they are still eliminating or poisoning anyone who has committed a serious offense or insulted an influential person.

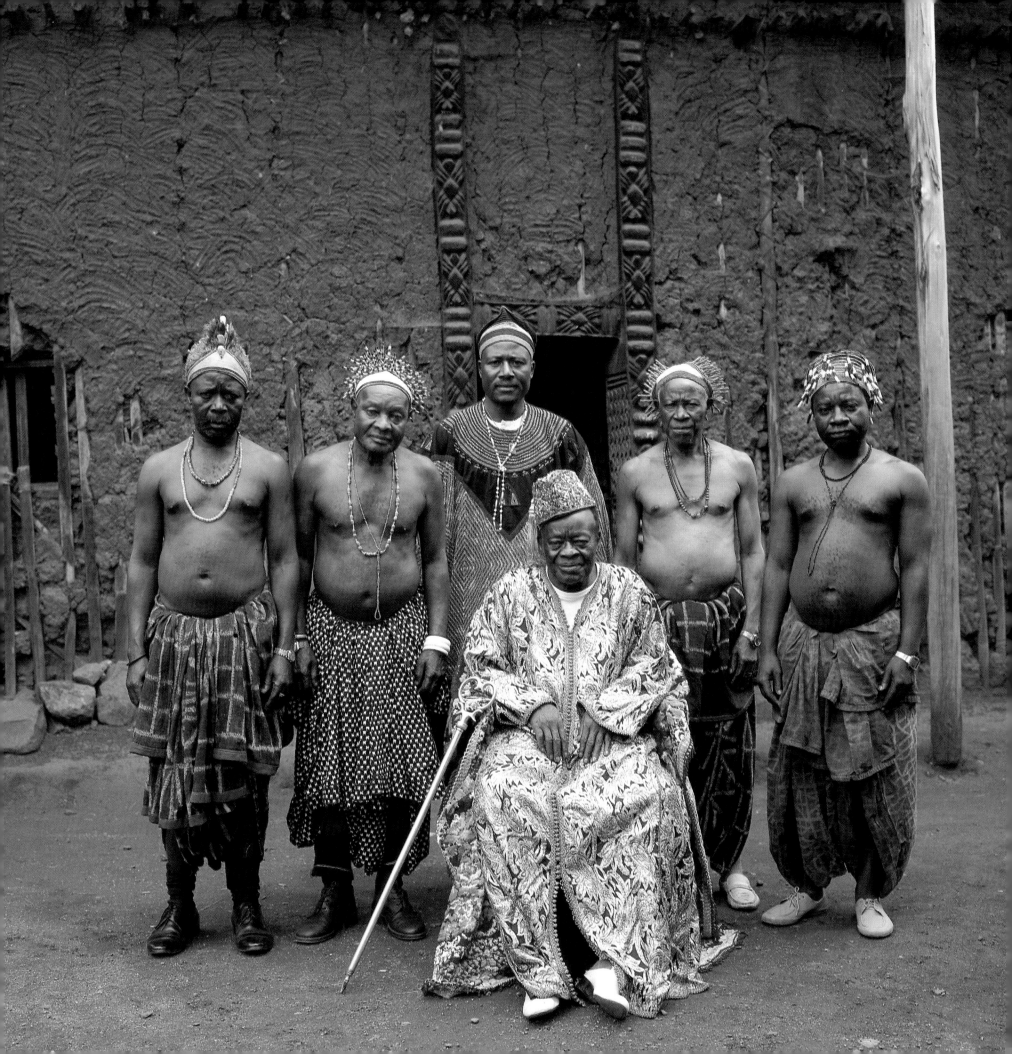

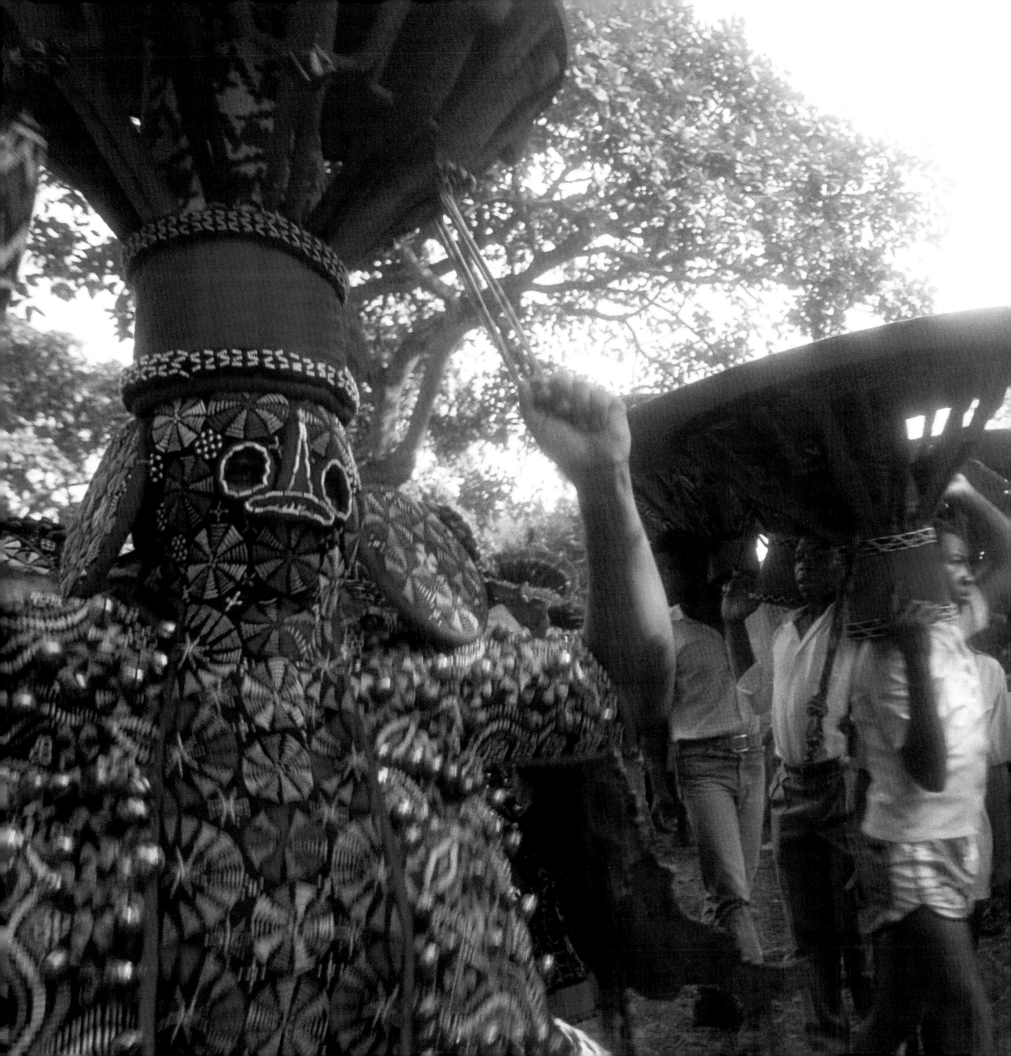

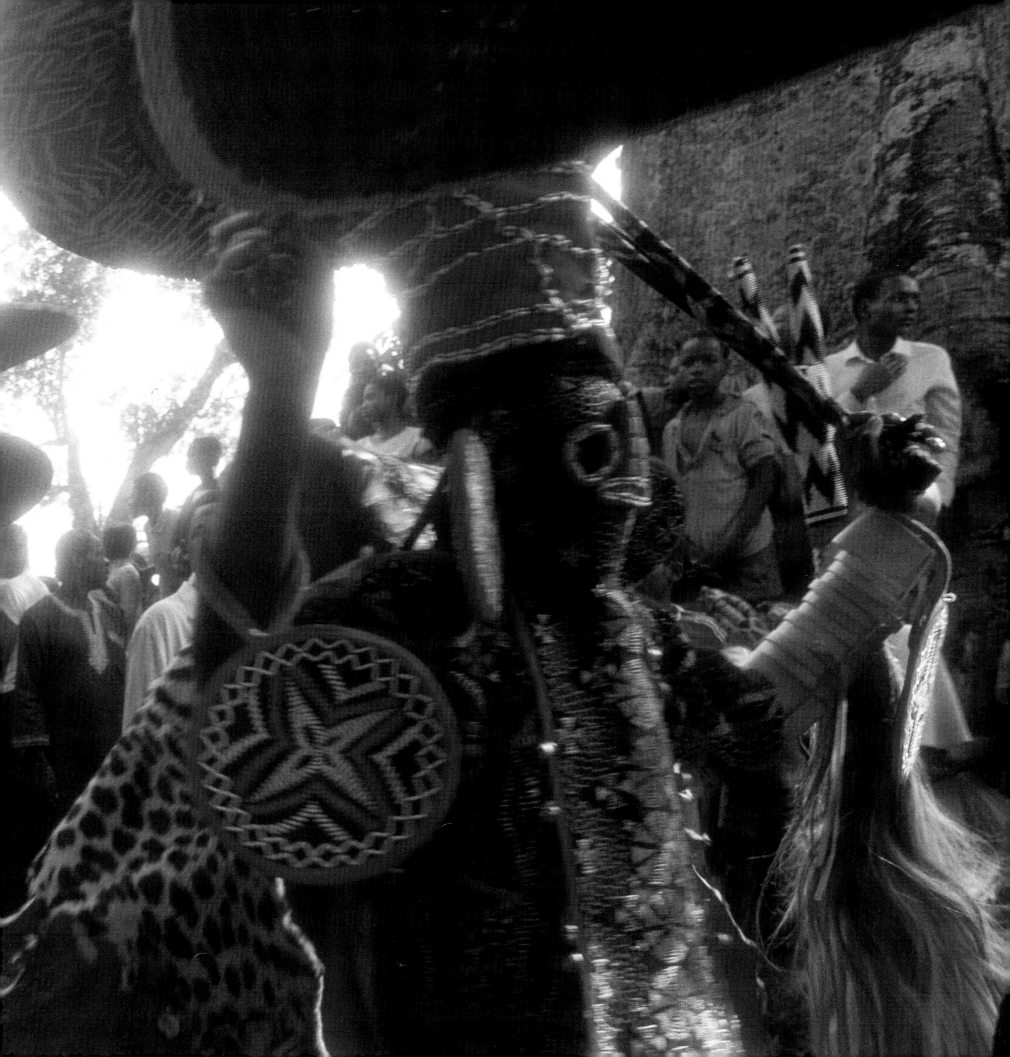

CONGO

THE MSIRI GODEFROID MUNONGO, King of the Yeke. *Msiri* (king) Munongo has left an indelible mark on the history of the Democratic Republic of the Congo (formerly Zaire). He was born in Katanga, a rich province with copper and cobalt mines that sustain the country. In the late 1950s, he and Moise Tshombe founded *Conakat*, a party of "authentic" Katangans that targeted "foreigners" laboring in the mines of upper Katanga. The workers (especially from the Luba-Kasai ethnic group) were thrown into camps or exterminated. Munongo had the reputation of being violent, hot tempered, and authoritarian. Not surprisingly, he was known as the Terror of Katanga. He also was the Minister of the Interior and the head of State Security in the province. The driving force behind secession, Munongo was the enemy of Patrice Lumumba, a progressive hero who attempted to unite the Congo against the Belgians and counter the secessionist movements in Kasai and Katanga. On January 17, 1961, Joseph Mobutu (later called Mobutu Sese Seko) captured Lumumba, who was gravely ill, and delivered him and two of his companions to Katanga. Munongo and his police force were waiting for him at the Elizabethville (Lumumbashi) airport. He was never seen alive again. To this day, Munongo has been tight-mouthed about the facts surrounding Lumumba's death. And yet, Munongo's legend does not entirely do him justice. He can be brilliant, friendly, and cordial. His grandfather made a fortune trafficking in copper and ivory. His caravans at the time traveled all the way to Zanzibar. In 1850, bolstered by his notoriety and his rifles, the future Msiri conquered the kingdoms of Upper Katanga. The former trafficker had himself proclaimed king of the Yeke. For about forty years, the *Msiri* consolidated his kingdom in the face of constant revolt. At the end of the century, with a stroke of a pen, the kingdom became the private property of the Leopold II, the king of Belgium. In fact, Leopold made a gift to himself of the Congo Free State. The *Msiri* put up a desperate resistance. Finally, he was tracked down and slain by Captain Dobson (in the employ of King Léopold), but not before dealing his assailant a fatal blow.

Previous pages:
Bamiléké nobles
in a royal procession
in Bandjun, Cameroon

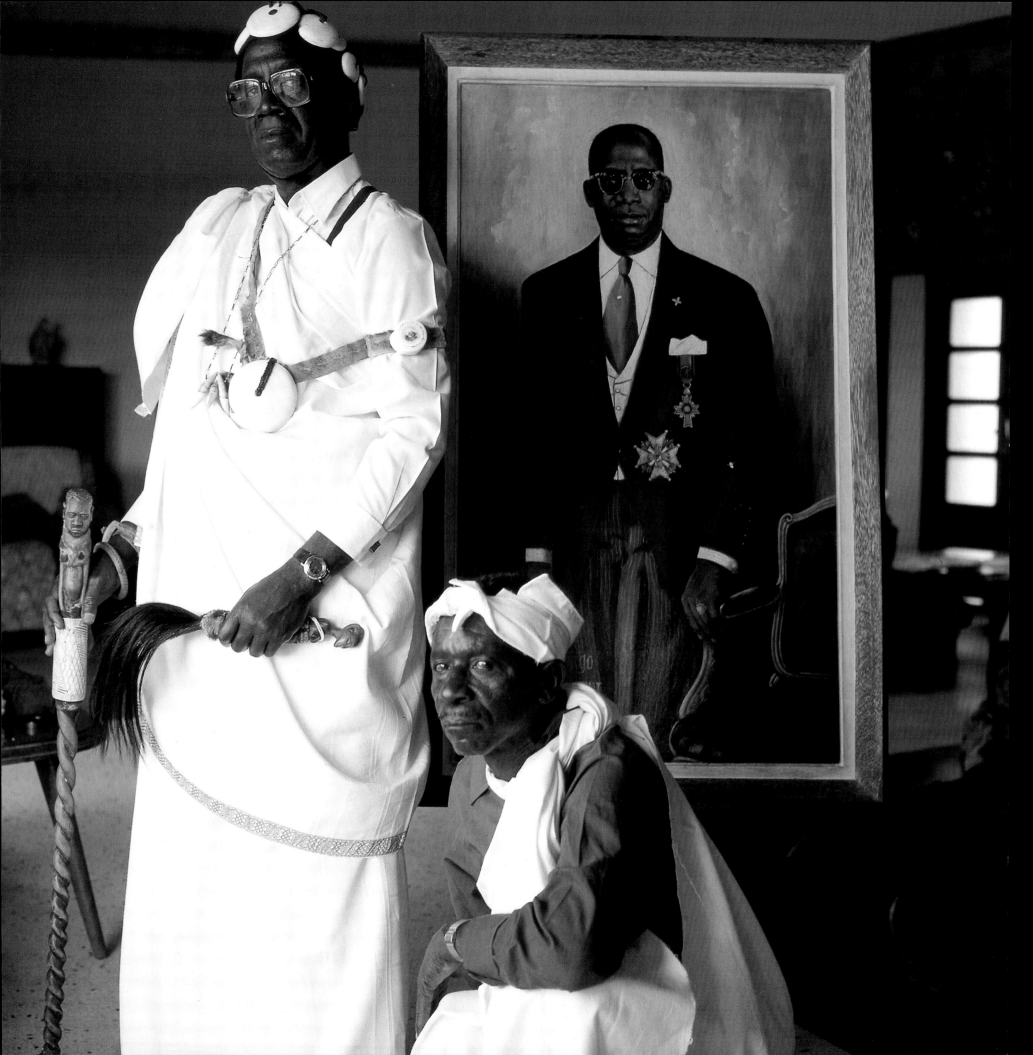

CONGO

KABONGO KI KUNTA KIMBALESA DILENGE, Dianda Ulopwe Kabongo Dianda III. The king's

ancestor, Kabongo Ngoy Dilenge, is rumored to have been able to move arrow or bullet wounds from a sensitive part of the body to another part that was easier to heal—from the head to the legs, for example. He was a powerful monarch and fierce warrior who transformed his kingdom into a vast slave market. In exchange for the freedom of his son Kabongo Dianda, taken prisoner by the *Msiri* (king) of Yeke, he gave eighty slaves and decapitated ten others as a sacrifice. The Luba emperor Kasongo Nyembo ordered him to put a halt to the invasion by Pemba. He took advantage of the situation to conquer a substantial part of Shaba. He legitimized his conquests by offering ten slaves (men and women), three beaded belts (the equivalent in value of three Arab rifles), four goats, four baskets of smoked fish, two hundred rolls of precious fabrics, a hundred ordinary beaded belts, five dogs, and a stick of bamboo woven with a cord of beads. After paying his debt, he was enthroned; he received the sacred calabash, a staff, and a glass of honor—symbols of power. Not long afterward, a slave stole the sacred objects and sold them to the chief of the Kansense, who usurped the royal power. The ensuing dynastic quarrel lasted over a half century. Finally, the heir to the illegitimate Kansense dynasty returned the stolen royal symbols to Mr. Evrard, a Belgian administrator, and Kabongo Dianda was recognized as the sole Luba king in the region.

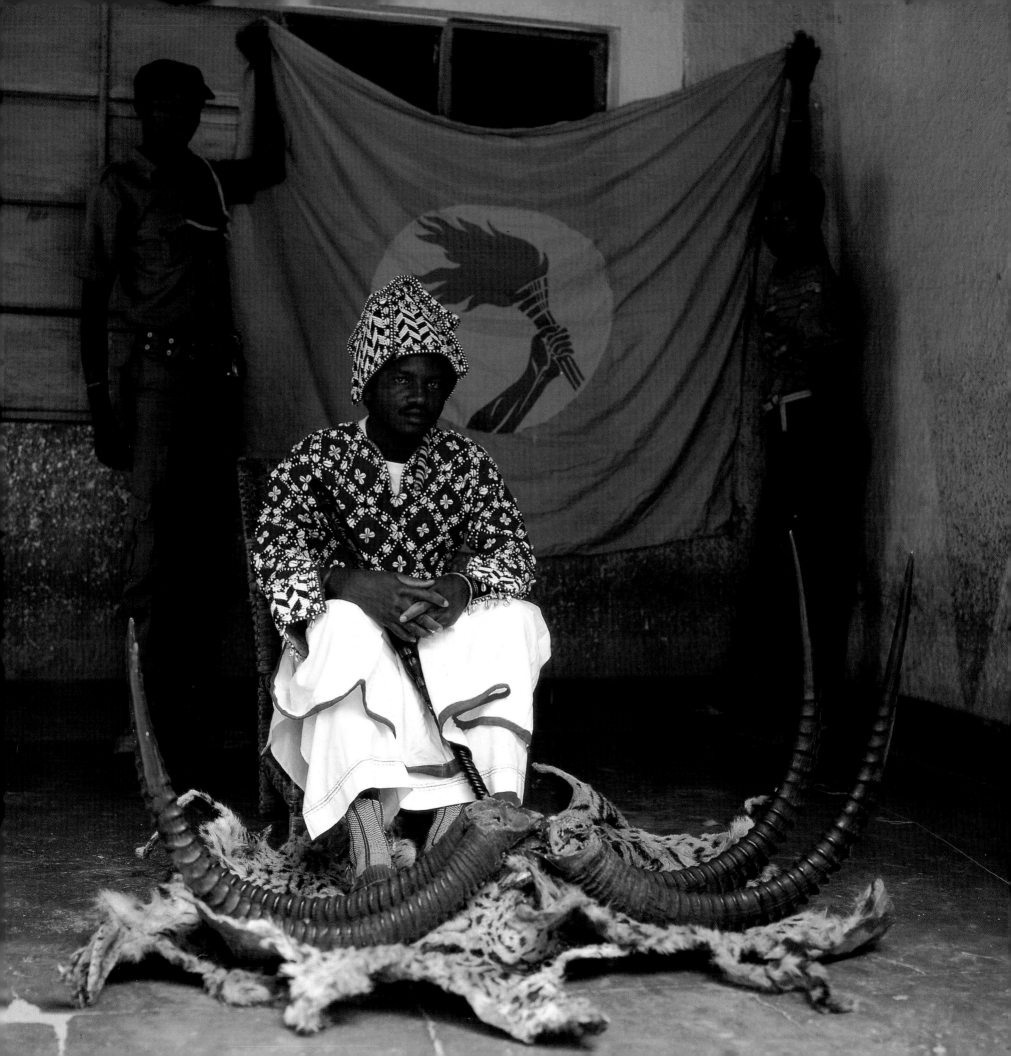

KASONGO-NIEMBO, Emperor of the Luba. People must never address the emperor without his consent. They must bow from a seated position, bare-chested, and covered with blue or red kaolin. It is strictly forbidden to cross one's legs or feet in his presence. When the sovereign goes by, the men stand up and the women lower their heads and hide their faces as a sign of respect. To greet the emperor, a noble must wear a loin cloth of leopard skin (or the hide of another animal known for its fighting qualities).

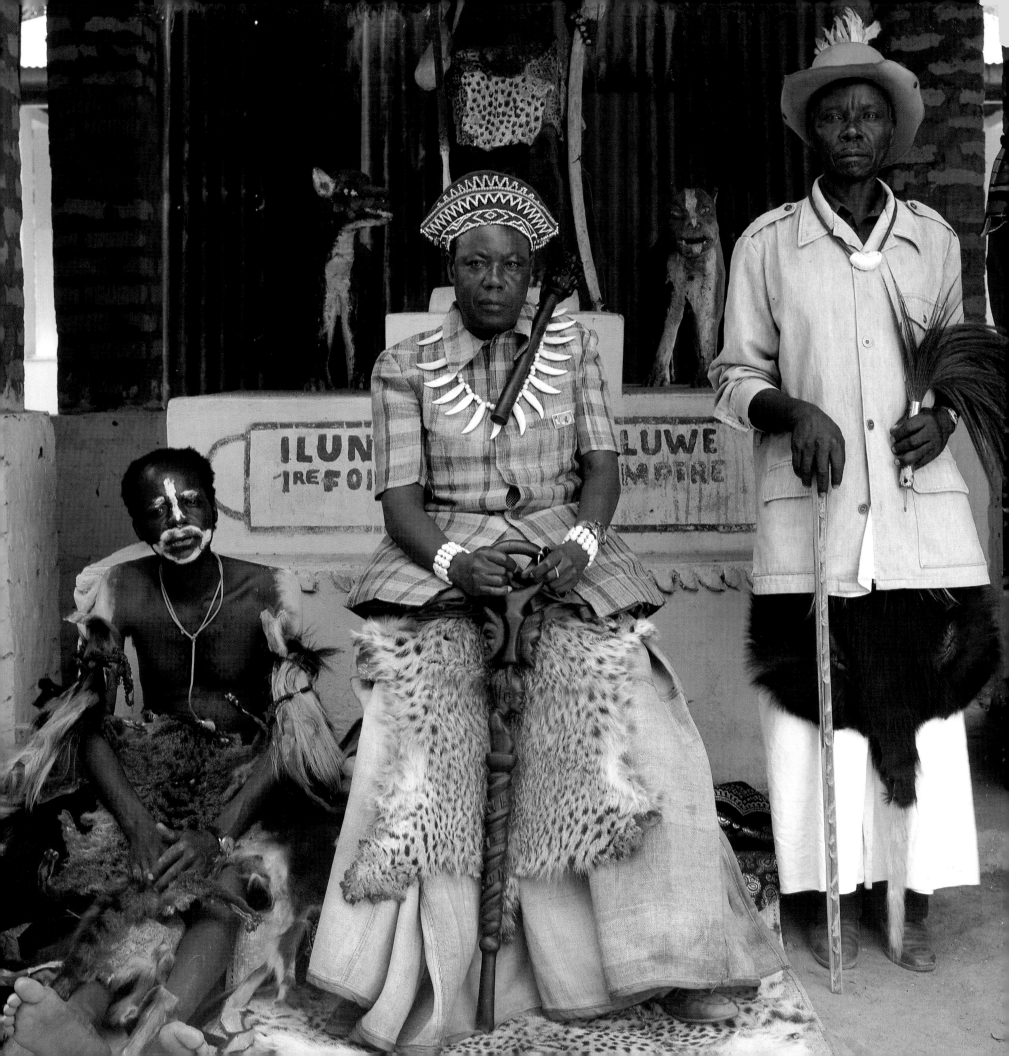

TSHOMBE ISOJ KABWIT, *Mwaant Yaav* Kawel, Emperor of the Lunda. The *Mwaant Yaav* (emperor) has five wives and thirty-two children. He studied to be a teacher and, in addition to carrying out imperial duties, he heads a leather goods company, which helps him support the 160 people who live in his palace. His nephew was Moise Tshombe, the president of the former state of Katanga, who was assassinated in Algeria. After the crisis in Katanga, General Mobutu carried out a witch-hunt. In 1966 the *Mwaant Yaav* was condemned to death in absentia and had to seek asylum in Belgium until the amnesty of 1974. Meanwhile, General Mobutu became a marshal and president for life and liquidated all his domestic opposition. Under colonization, the Lunda Empire, founded around the fifteenth century, crumbled. But the six million Lunda who inhabit the Democratic Republic of the Congo, Zambia, and Angola recognize the *Mwaant Yaav's* authority. His power is symbolized by the "royal ring," a bracelet made of braided human nerves, dating back to the fifteenth century. Until 1908, it had been the custom to sacrifice a man and a woman in homage to a new *Mwaant Yaav*. Their nerves were then added to the bracelet so that it now weighs almost nine pounds. No one other than the *Mwaant Yaav* and his first wife has the right to see the bracelet. If it disappeared, the *Mwaant Yaav* would lose his power. Somewhat like a fetish, the bracelet is ritually nourished with the blood of animals. In his palace in Sandoa, the Lunda emperor must eat alone and avoid pork. He is forbidden to receive menstruating women, and must never allow anyone to see him sleep. A *Mwaant Yaav* never sleeps!

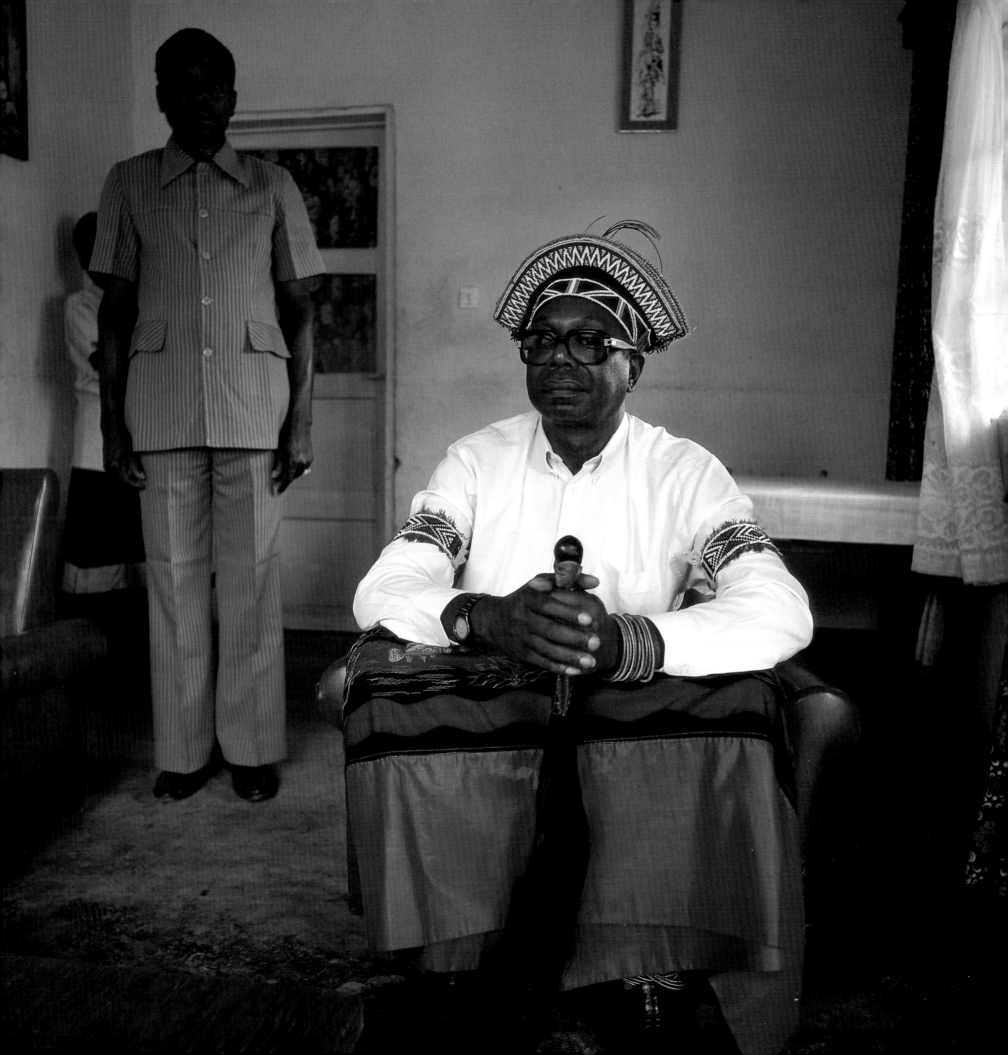

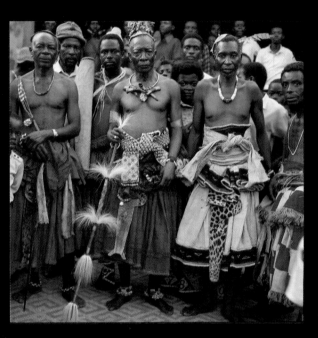

The prince regent of the Kuba

NYIMI KOK MABIINTSH III, King of the Kuba. It took me three weeks to photograph the *Nyimi* (King) of the

Kuba in his royal apparel, the *bwaantshy*. The word means "devour the python" in Kuba. The costume, made of material embroidered with beads and cowrie shells used as currency in parts of Africa, weighs almost 185 pounds. It takes more than two hours to dress the king and two days of rituals before he is sufficiently purified to put on the outfit. The *bwaantshy* is so heavy and warm that it cannot be worn for more than an hour. The previous king donned it only three times in his lifetime. When I took this photograph, the *Nyimi* Mabiintsh III was fifty years of age. He was enthroned twenty years ago. A descendant of the creator-god, the king possesses supernatural powers. His rank entails a number of constraints—he is not allowed to sit on the ground or cross a cultivated field. Only his cook has seen him eat. What's more, he always travels with his cook, his set of dishes, and his kitchen utensils. It wasn't until the late nineteenth century, that the first white man (in fact, an African-American missionary) set foot in Mushenge, the Kuba capital where he found one of the most magnificent collections of wooden sculptures in Africa. Every king was represented. The royal treasure vanished from Mushenge around 1930, turning up in private collections and in Belgian and American museums.

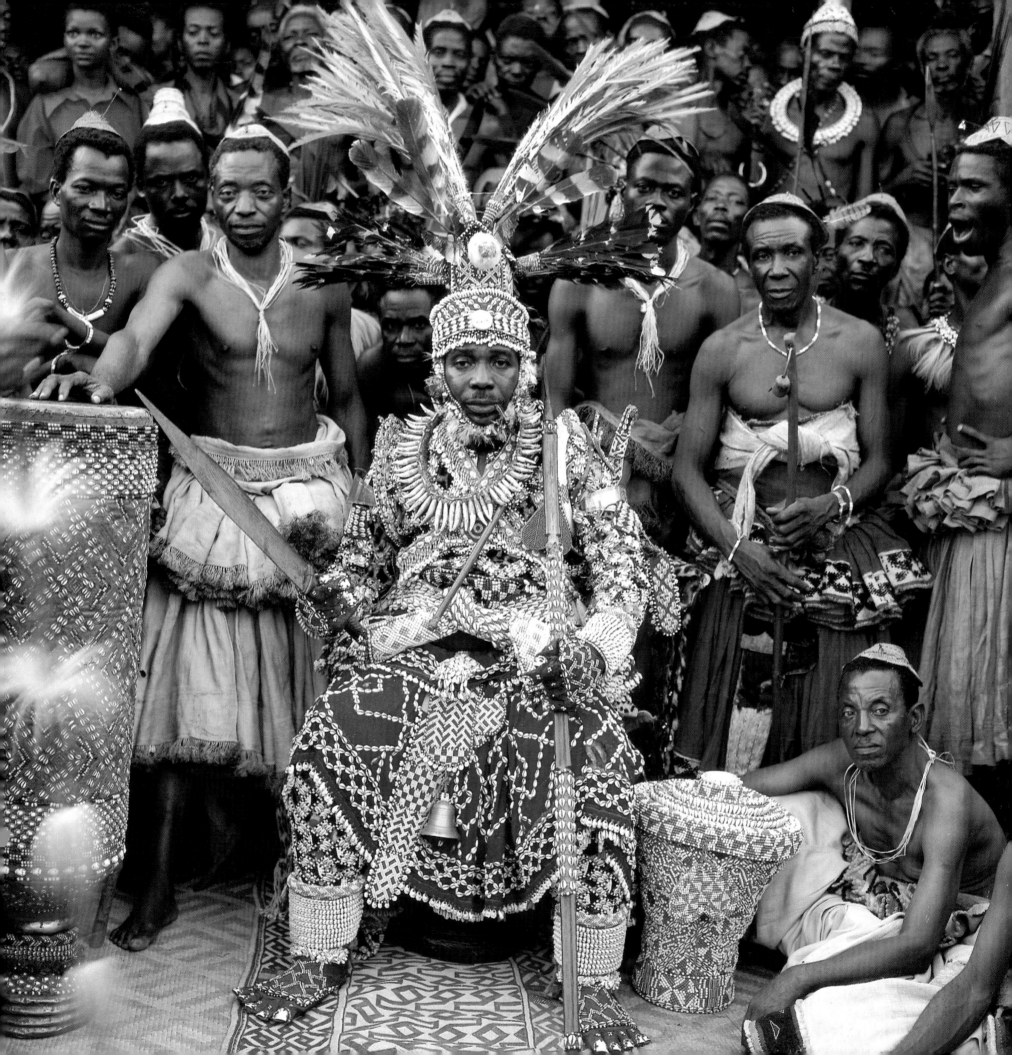

LUBA CHIEF OF BUKAMA.

Luba, is derived from the verb *kuluba*, meaning "to lose one's way" or "to err." The Luba are said to be people who are lost, who have lost their way. Archeologists believe that the Luba-Lunda Empire probably began between the eighth and ninth centuries. At its apogee, it occupied parts of present-day Congo, Zambia, and Angola. The empire became too vast and could not resist the quarrels between the Kasongo-Niembo and the Kabongo empires. Near the end of the eighteenth century, it fragmented into little kingdoms, which the Belgian colonizers turned into administrative chiefdoms, with the king becoming the chief of a collective dependent on the colony and, later, on the political authority.

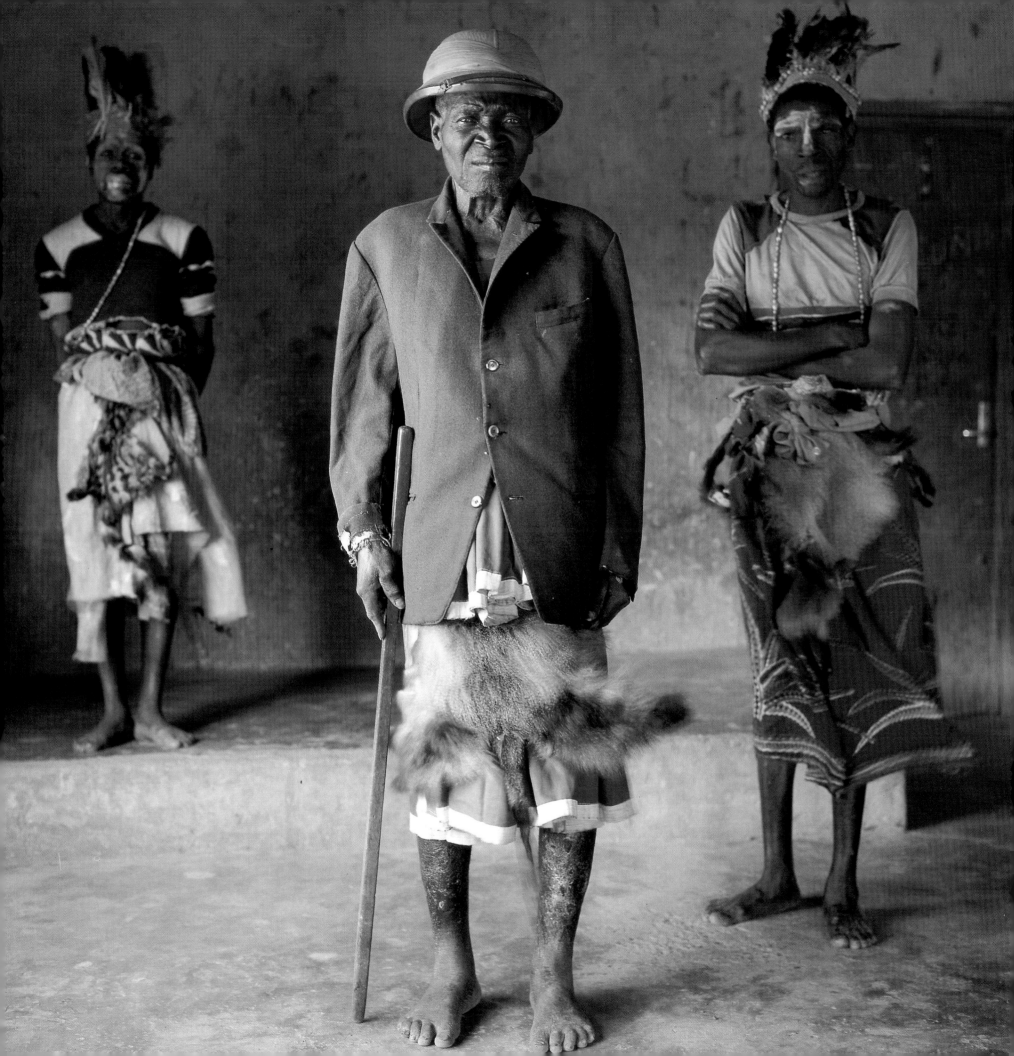

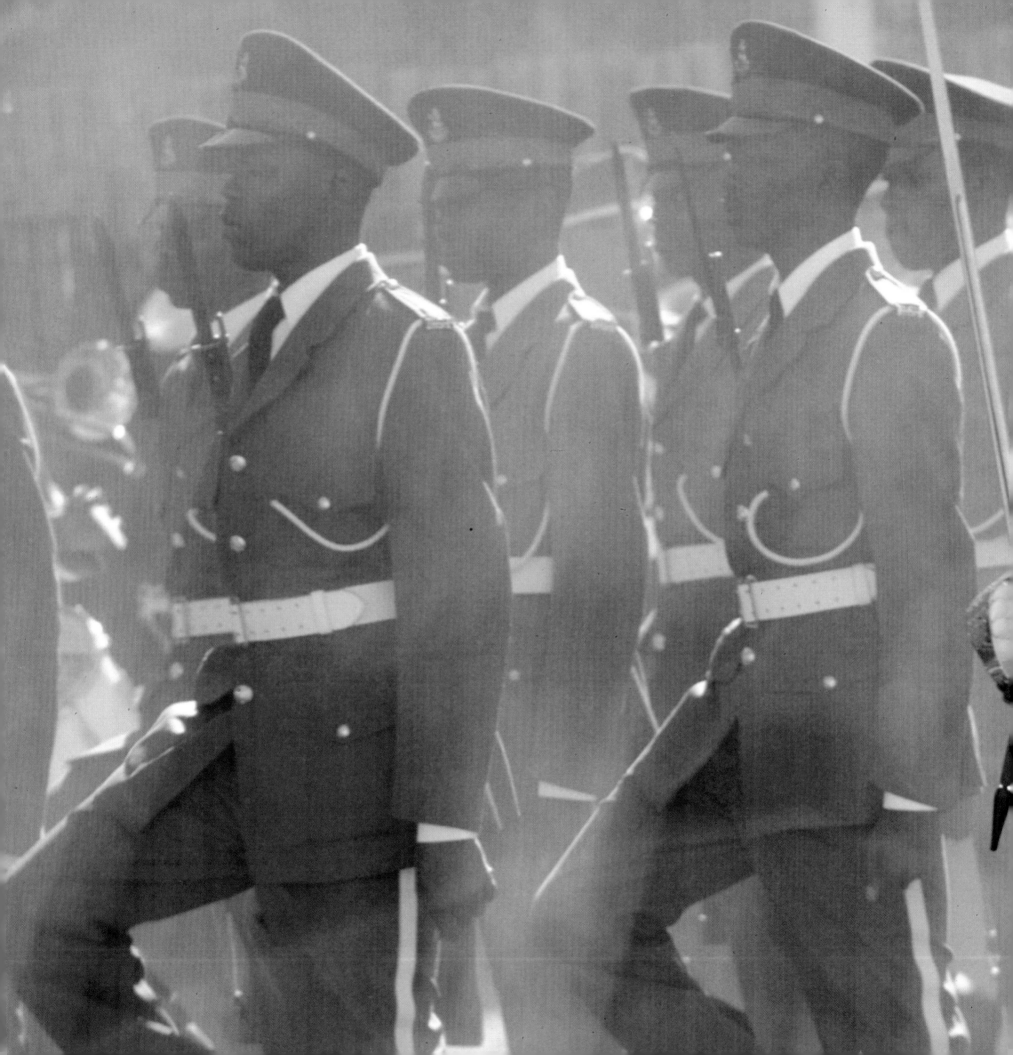

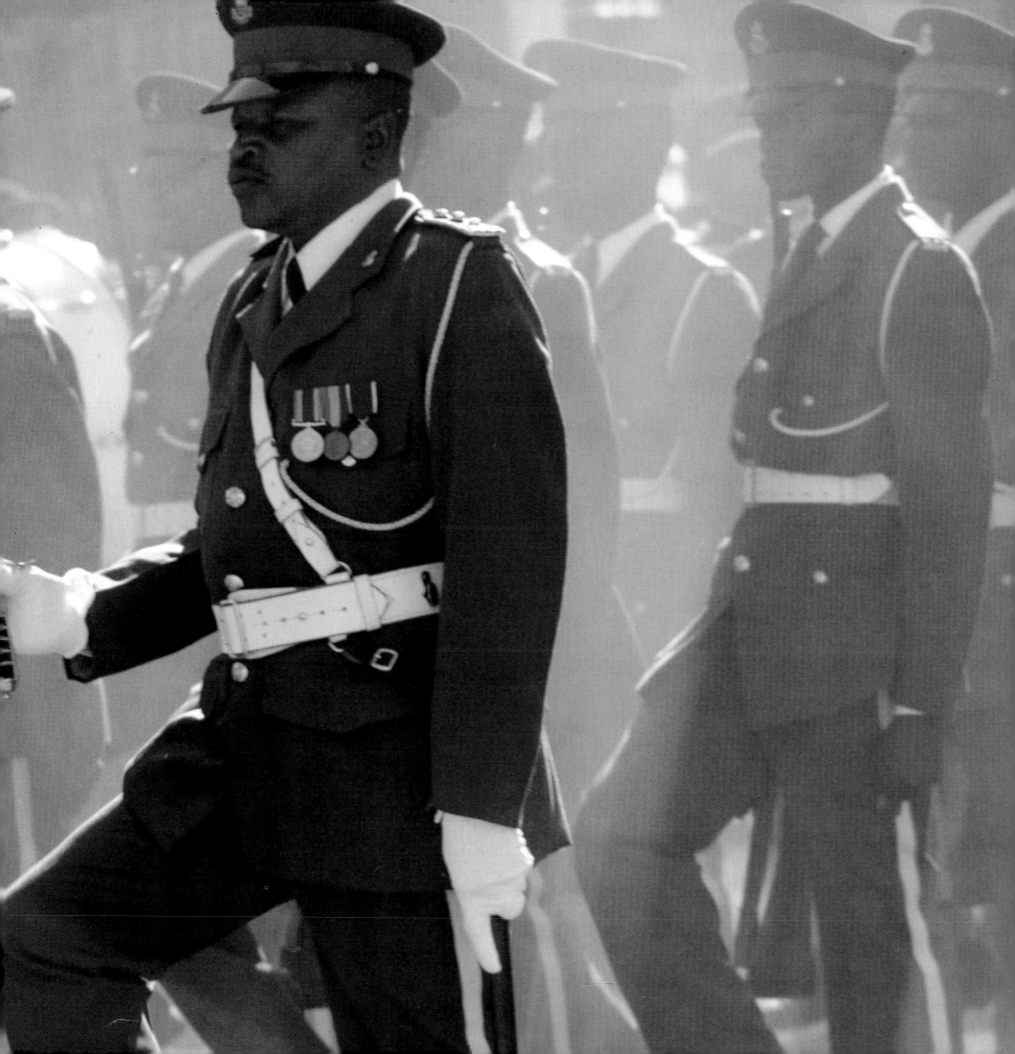

GOODWILL ZWELETHINI, King of the Zulu. King Goodwill Zwelethini is the descendant of Shaka, the famous

founder of the Zulu kingdom, now a homeland to eight million inhabitants. In the early nineteenth century, Shaka was the chief of a small Zulu clan of little significance among the other Bantu peoples. Convinced that the survival of the Zulu people depended on the subjugation of other clans, Shaka put the Natal region to the torch and wreaked bloody havoc. Between 1815 and 1828, he annihilated every ethnic group that opposed him. This period of turmoil, known as the *Mfecane* (great upheaval, terror), was accompanied by famine and the exodus of a large proportion of the Bantu peoples. Shaka's cruelty was legendary. Suffering from numerous complexes (his comrades ridiculed his tiny organ), he ordered his wives executed when they became pregnant. When his mother died, the grief-stricken ruler had a member of each family put to death to make sure the whole kingdom was in a proper state of mourning. But more than anything else, Shaka was a brilliant war chief. His military genius has often been compared to Napoleon's. He gave his soldiers the short spear for hand-to-hand combat and imposed Spartan discipline on his troops. Homosexuality was practically obligatory and he banned, under pain of death, sexual relations between his male regiments and his female regiments. Frustrated beyond endurance, the soldiers were ferocious in battle. Shaka's half-brothers assassinated him in September 1828, but the *Mfecane* that he had unleashed continued until about 1835. The immense flight of the Bantu populations changed the course of history in South Africa.

Previous pages:
A parade of the royal
army of Swaziland during
the national holiday

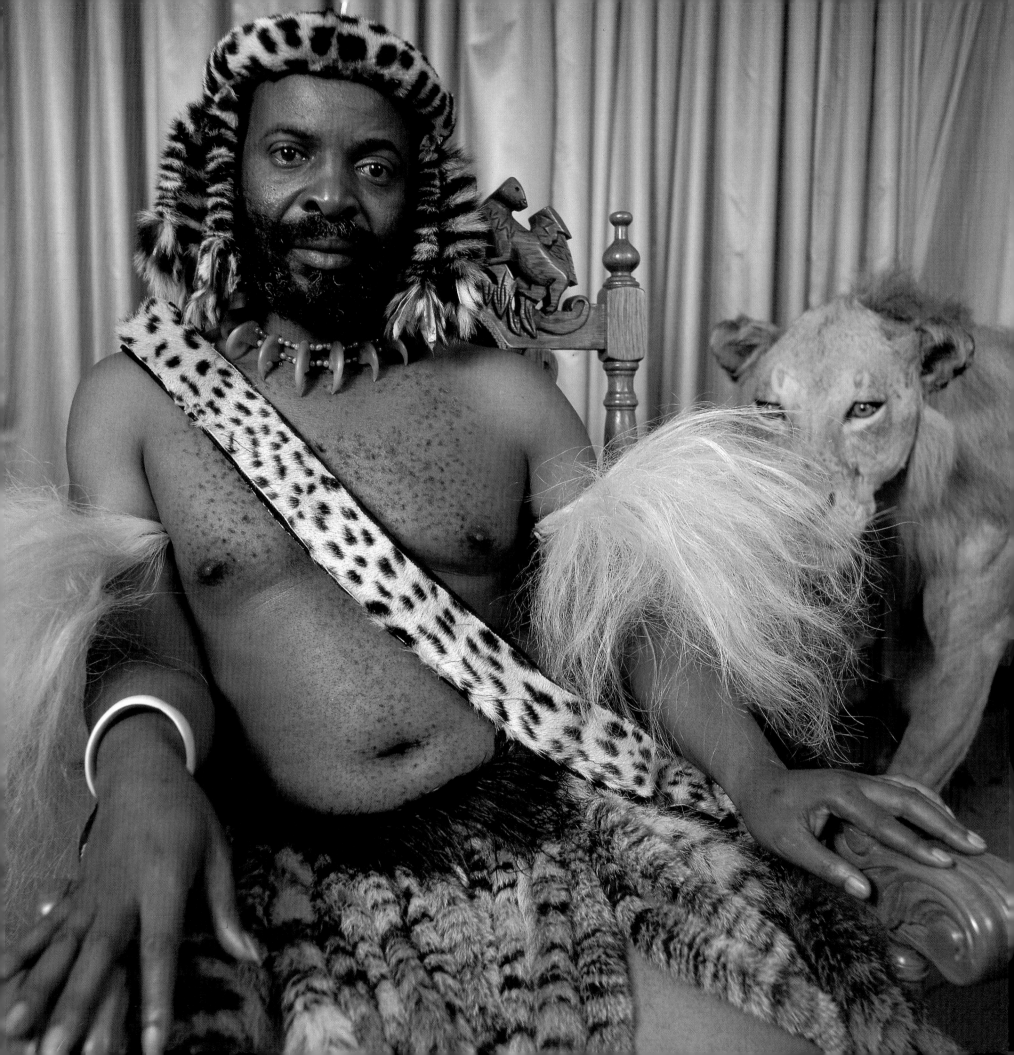

ENOK MAKHOSOKE MABENA II, Manala clan, King of the Ndebele. In the early nineteenth century, the Boers (white Afrikaners) embarked on a long march (the "Great Trek"), in quest of new lands. They arrived in the Transkei and annihilated the famous King Mzilikazi's Ndebele army. Some of his people crossed the Limpopo River and took refuge in the ancient kingdom of *Monomotapa* (Zimbabwe) where eighty percent of the Ndebele live today. The others set up *kraals* (farms) in an area near Pretoria, which became Kwandebele, a Bantustan, in 1981. King Enok is a genial man who belongs to the Manala clan. According to custom, he is the only king of the Ndebele. There is another claimant to Mzilikazi's throne, a descendant of the

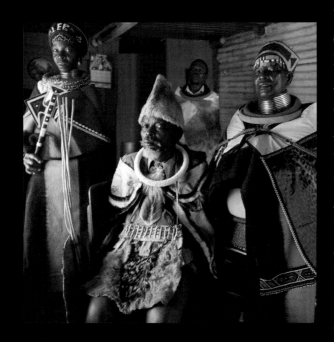

usurper described in the legend. "Once upon a time, there were two feuding brothers— Ndzundza and Manala. Their blind father, Musi, the king of the Ndebele, knew he was dying, so he summoned his favorite son, Manala, and said, "Come and see me early tomorrow morning and I'll give you my throne." But the queen preferred Ndzundza and ordered him to get up earlier than his brother and steal the royal power. The next day Ndzundza knocked on the king's door, but his father refused to see him. Ndzundza returned a little later, pretending to be Manala. The blind king reached out to touch his son's arm to make sure it was Manala's hairy limb, but the crafty Ndzundza had wrapped his arm in animal skin to trick his father. Then Ndzundza ran off with the symbol of power, which was a bag from which you could hear a child's cry. When Manala learned of the treachery, he raced after Ndzundza, fully intending to kill him. But when Manala caught up with him, Ndzundza offered his brother a girl to wed in exchange for his life, and Manala recovered the throne.

CHIEF JOHN SUYAPHI NDALA. John Ndala is the Ndebele chief of the Ndala clan and lives in Tweefontein, one of the largest townships in the Pretoria region. He is illiterate and unemployed.

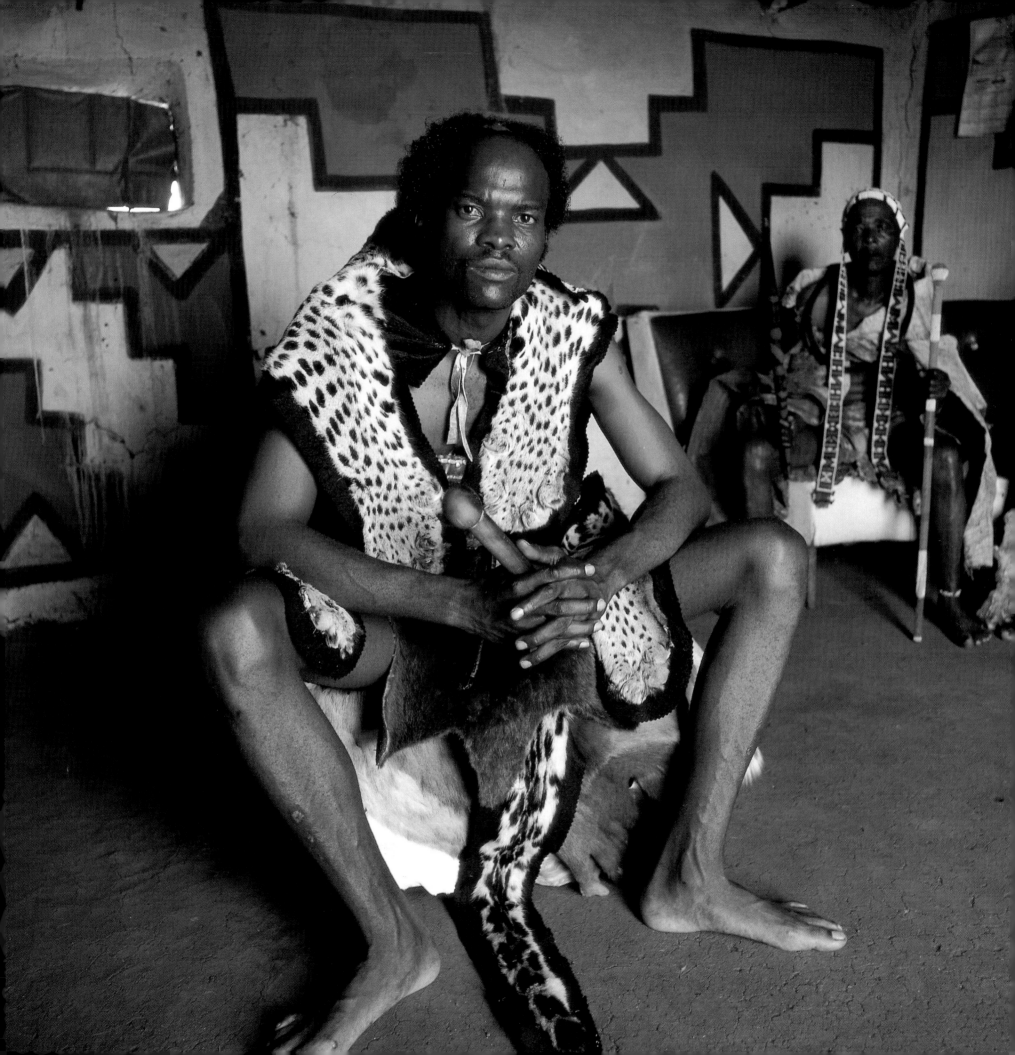

MODJADJI V, RAIN QUEEN. Queen Modjadji V has thirty-three wives. She is not allowed to marry men, but must choose her "wives" among the eldest daughters of the Lovedu people, which her dynasty has ruled for two centuries. Modjadji V the Rain Queen has mystical rainmaking powers. The Zulu have always feared these queens, who live in the mountains of the Transvaal. They believed they were four-lunged witches, who haunted ponds and marshes. When the ruler died, the empire of the Monomotapa was divided between her two sons. One of them was the sacred king of Mambo. His daughter, Dzuguzini, and her lover had a son out of wedlock. Since she refused to reveal her lover's name to her father, he expelled her from the kingdom. Before leaving, she stole the sacred beads and the secret of the rain, which she gave to her son as a gift. Later, she admitted that she had committed incest with her brother the prince. Thus Dzuguzini's son became the new king of Mambo. Born of incest, the dynasty perpetuated itself by incest. Mugodo, the fifth king in the dynasty, was paranoid. He saw plots everywhere. He murdered his sons, and as his madness worsened, he became convinced that all men wanted to assassinate him. Mugodo had a vision that only a woman born of royal incest could govern the people. Since his eldest daughter refused to commit incest, King Mogodo convinced his second daughter, who was more naïve, to do so. She gave him a son whom he immediately strangled with his bare hands. Her second child was a daughter who became Modjadji II, the Rain Queen.

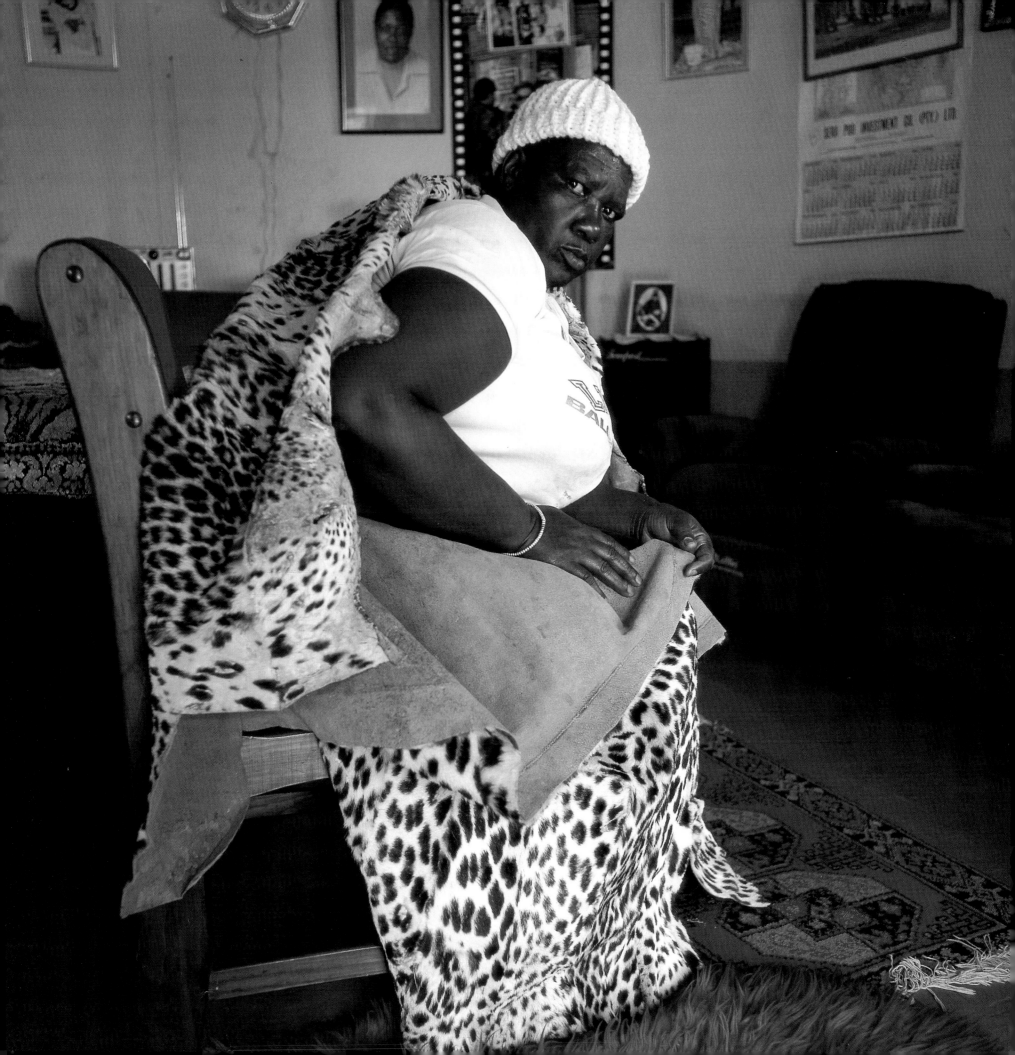

XOLILIZWE SIGCAWU, King of the Xhosa.

Xolilizwe Sigcawu has proclaimed himself king of all the Xhosa peoples, including the Thembu, the ethnic group to which Nelson Mandela belongs. Like the four million other Xhosa of the Transkei, the king lives in poverty on a *kraal* (farm) in the Umtata area. His authority and prestige have not survived the Xhosa people's tragic history. In the early nineteenth century, Nguika, a Xhosa chief, committed the terrible blunder of appealing to the English to defeat his rival, Ndamble. The English made him pay dearly for their support. For over fifty years, they harassed the Xhosa. Not content with defeating them, they humiliated them. Sir Harry Smith, an English high commissioner, had a peculiar sense of decorum; he imprisoned Chief Sandile and his Xhosa warriors when they came to sue for peace, and forced the chief to kiss his boots. In 1854, when the Crimean war erupted between Russia and England, the Xhosa believed that the Russians were blacks come to free them. They acted on the prophetic vision of Nongqawase, a sixteen-year-old Xhosa girl, who had seen her dead ancestors emerge from a river in carriages and order her people to slaughter the livestock and stop cultivating the land. On the day of deliverance, two red suns would appear. Then an army of the dead would arise, hordes of livestock would invade the hills, and the Russians would sweep the English from the surface of the earth. Those who refused to follow the prophecy would perish in a terrible hurricane. Some Xhosa believed in this formidable vision. In the years that followed, more than twenty million Xhosa would die of hunger.

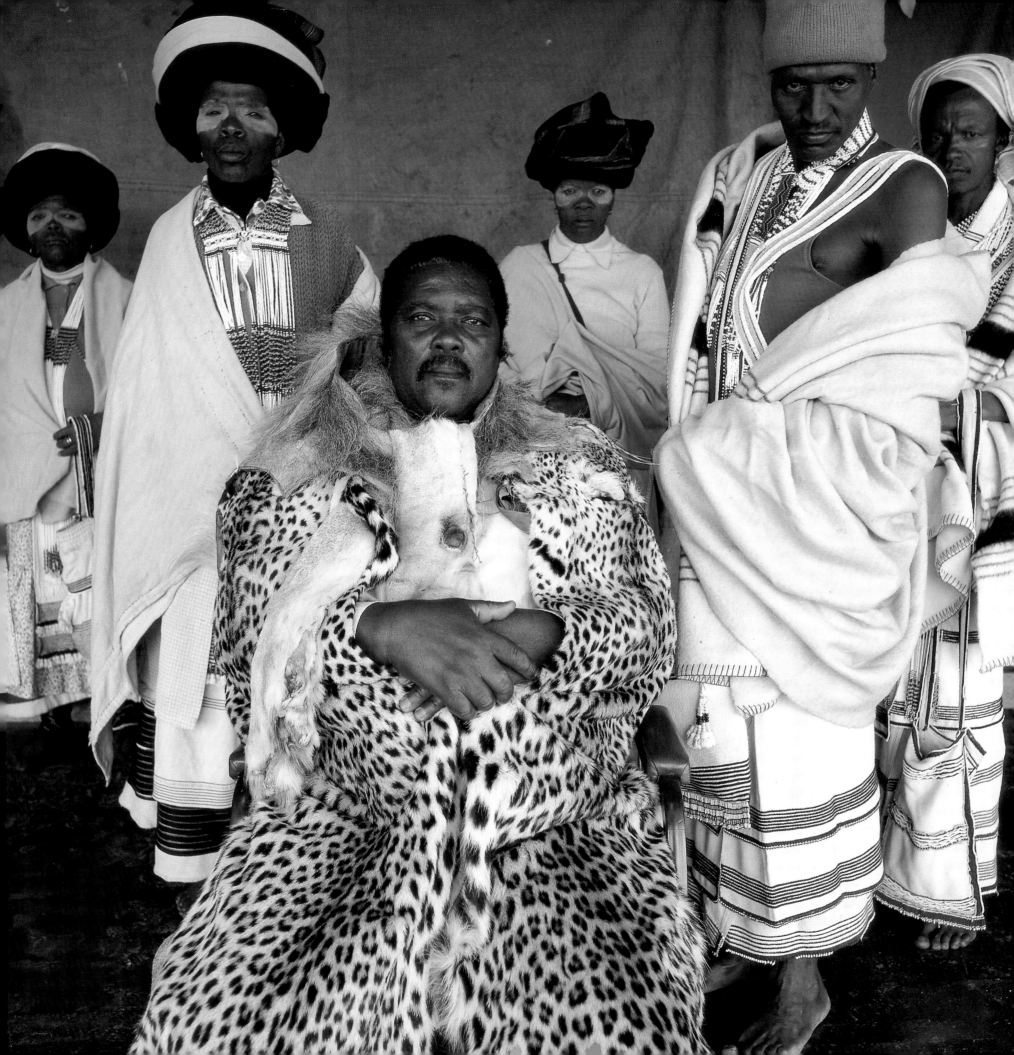

MOGHO NABA BAONGHO, Emperor of the Mossi, King of the Universe. Water is the source of life,

and the thirty-sixth *Mogho Naba* is named *Baongho* meaning "water." It is strictly forbidden to address him by his birth name. At one time, the Mossi believed themselves to be the only inhabitants on the earth. After his enthronement, the monarch was obliged to send his eldest son far from the palace to another province. He will never see him again. In the eleventh century, the King of Gambaga's daughter was returning from an expedition in northern Ghana when she lost control of the horse she was riding and they plunged into the forest. There she met Rialé, a Malian hunter, and they had four sons who divided the Mossi nation among them. The eldest son, Ouidraogo, became the first *mogho naba*. One of Ouidraogo's brothers ran off with his wife and his fetishes to the kingdom of Yatenga. Enraged, Ouidraogo ordered his horse saddled so he could go after his brother, but his retinue talked him out of it. Since then, a ceremony recalling the event has been held every Friday outside the palace in Ouagadougou. A steed awaits the *mogho naba*, who is all dressed in red, but the drums urge him not to leave for Yatenga. The *mogho naba* is a demigod who must never touch the ground with his bare feet. People must have their head uncovered in his presence, and he is forbidden to shake hands with a stranger. A *mogho naba* named *Wobogo* (the elephant) preferred to die in exile in Ghana rather than to shake hands with a white man. The recent death of the present sovereign's father proved these injunctions are more than just popular fantasy. The late monarch was named *Kougri* (the rock) because a rock is difficult to move. In the early 1980s, the president of the Republic, Captain Thomas Sankara, set up revolutionary tribunals to put corrupt members of the old regime on trial before the public. In the colonial era, the governments had maintained the Mossi emperors, whom they considered to be people of high stature. But Sankara threatened to drag the *Mogho Naba* Kougri before the courts if he failed to pay his overdue water, electricity, and telephone bills—an unbearable humiliation! The Mossi prefer death to dishonor. The *Banaba* (minister of the interior) sent a poisoned arrow and a rope to the *mogho naba*, a choice between poisoning or hanging. The emperor pricked himself in the thigh. Death was instantaneous. Officially, the *Mogho Naba* Kougri died of natural causes, but the Mossi know better; they say "his strength had left him."

Previous pages:
Akan chiefs from Ivory Coast
wearing solid gold ceremonial glasses
during traditional ceremonies in Dabou

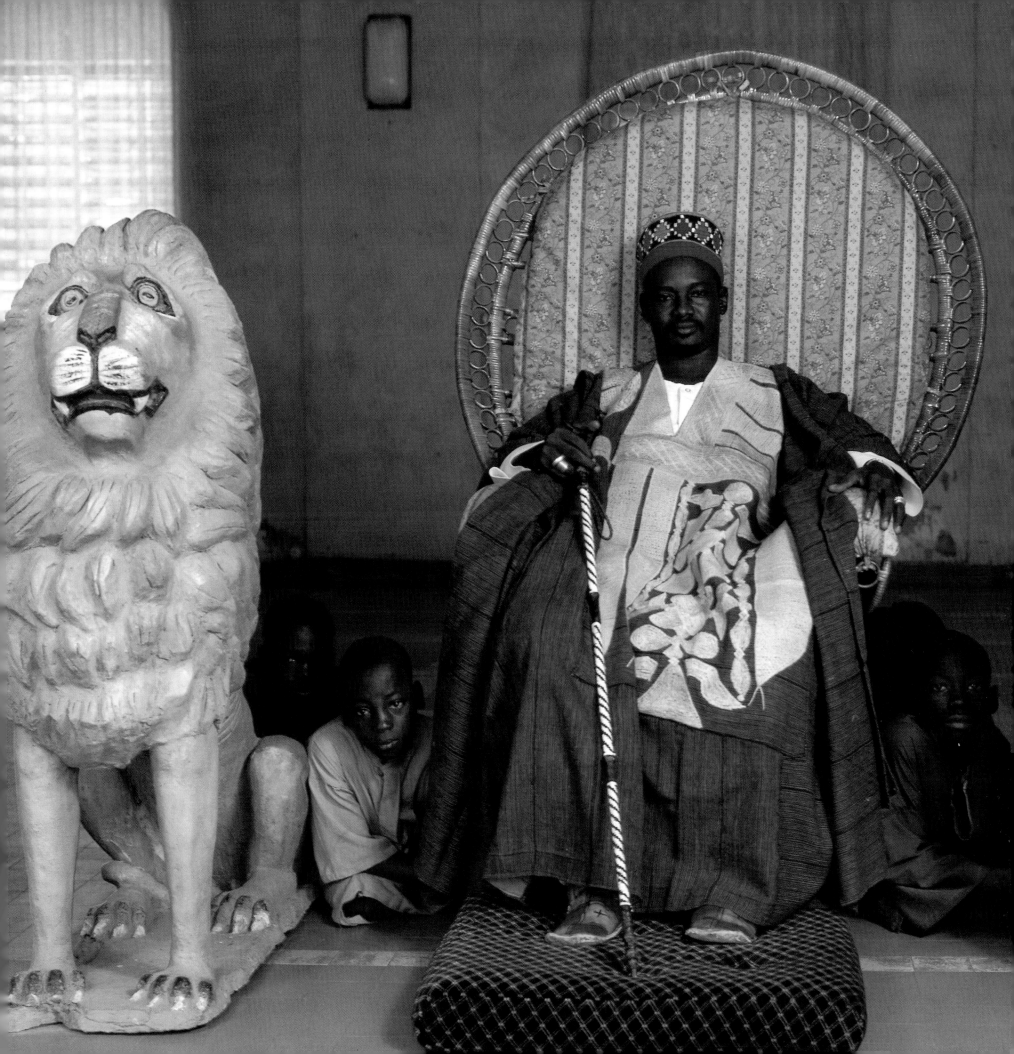

JEAN-BAPTISTE NDAHINDURWA, Kigeri V, Mwami of

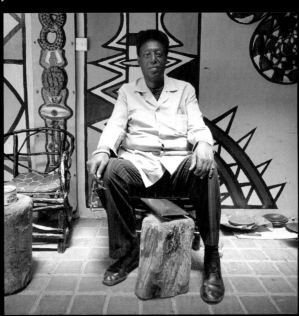

Rwanda. *Mwami* (king) Kigeri V is the only African king who has remained a bachelor. The 6'6" monarch has lived in exile in Kenya since Rwanda declared independence. Rwanda has two very different ethnic groups: the Tutsi, who account for fifteen percent of the population, and the Hutu majority, who account for eighty-five percent of the population. In July 1959, *Mwami* Mutara III died mysteriously. Three days later, the Tutsi installed his brother on the Rwandan throne. Jean-Baptiste Ndahindurwa became Kigeri V, *Mwami* of Rwanda. Fearing a new Tutsi dictatorship, the Hutu rebelled. The *Mwami* was forced to seek asylum in Kenya and Belgium. Two years later, the Hutu declared the country the Republic of Rwanda.

RONALD MUWENDA MUTEBI II, King of Buganda. On May 26, 1966, Milton Obote, then prime minister

of Uganda, ordered an attack on the royal palace of Buganda. Despite the guards' fierce resistance, Idi Amin's tanks destroyed the palace. The chief of state, the *Kabaka* (king) of Buganda, managed to escape to Burundi. In a few hours, Milton Obote destroyed one of the most prestigious kingdoms in Africa and ended four years of constitutional monarchy. At the same time, the kingdoms of Ankole, Bunyoro, and Busoga suffered the same fate. The abolition of the monarchies marked the beginning of sinister dictatorships under Obote and Idi Amin. The previous *Kabaka* died, but his ten-year-old son, Prince Mutebi, waits for the time when the government will restore the monarchy. Meanwhile, in the streets of Kampala, Baganda (or Ganda) kneel before him. To them, a little cannon fire cannot erase a thousand years of royal history.

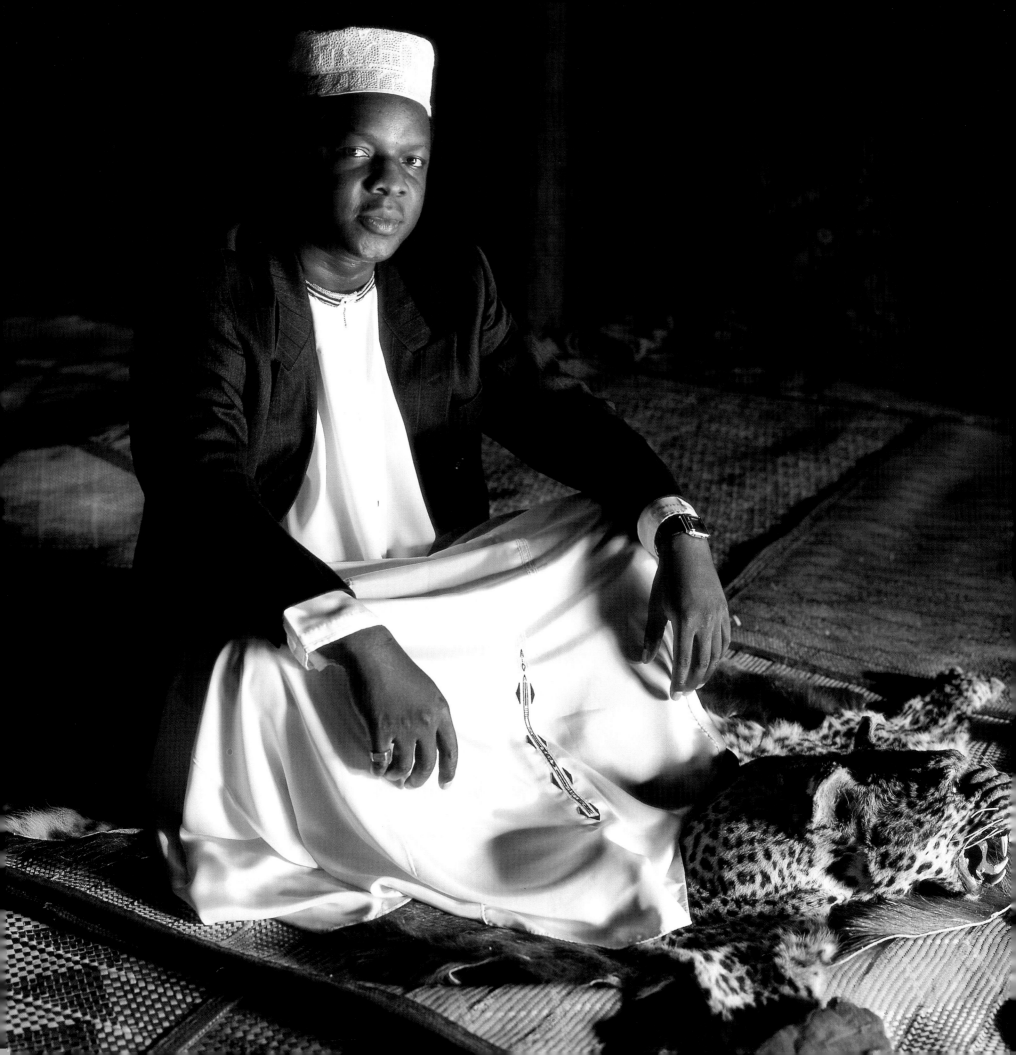

Photography Credits:
Pages 13, 14, and 18: Archives Basel Mission, Bâle, Suisse
Pages 16 and 21: Collection of E. Deroo, Paris
Pages 7 and 25: Collection Shoeffler-Deroo, Paris
Pages 9, 10, and 22: Royal Museum of Central Africa, Tervuren

The award of the "Villa Médicis Hors Les Murs,"
which was given by the ministry of foreign affairs in 1988 and the help of Claudine Maugendre of the
magazine *Actuel* were a key part of the creation of this book. I thank them.

I also thank:

Actuel Production
The ministry of culture, communication, and great works, who patronized my work
Kodak-Pathe and Publimod
Jean Francois Bizot, of the magazine *Actuel*
Michel Guy, former minister
Serge Francois, minister of foreign affairs
Agnès de Gouvion Saint-Cyr, R.I.P. of Arles
Jacques Thibau, who was the ambassador of France to Nigeria
Francois Bellorgey, former director of the C.C.F. of Lumumbashi
Jean-Michel Rousset, the French Cultural Center of Lagos
Belepe Bope Mabintch, University of Lumumbashi
Joseph Novadomsky, University of Benin
De Souza Ayiri, Museum of Monuments and Sites of the Republic of Benin
Grégoire Sotchoua, C.R.E.S. of Yaoundé
Owusu Sarpong, University of Kumasi
Amon d'Aby, Sociologist, Abidjan
Claude Hélène Perrot, Center for African Research, Paris
Gilbert Rouget, director of research at C.N.R.S., Paris
Murielle Laroche, Doctors of the World
Cismondi, director of Endipress, Abidjan
Pierre Alexandre, Fabrice Pernisco, and Muriel Jeancard
Thank you also to the African kings and in particular:

In Cameroon, the King Hapi IV of Bana and the Chief of Bandjum; in Nigeria, the Eze of Oguta, the King of Nnewi, the Obong of Calabar, and the Oba of Ogba;
in Ghana, the Asantehene, the Denkyerahene, and Jimmy Moxon; in the Democratic Republic of the Congo (formerly Zaire), the Nyimi of Kuba, the Mwaant-
Yaav of the Msiri; in the Ivory Coast, the King of Sanwi and the King of Agnibilekrou who unfortunately do not appear in this book; in Benin, the King Agboli-
Agbo and the representative of the dynasty of King Toffa I; in South Africa, the King Manala of Ndebele and Goodwill Zwelethini, King of Zulu;
in Kenya, the Mwami of Rwanda in exile in Uganda, Prince Mutebi.

Sadly, since this book was first published, the following kings have died: the king of the Ashanti, Ghana; the sultan of Sokoto, Nigeria;
the king of the Gen, Togo; the king of the Ndenye, Ivory Coast; and the king of the Abron, Ivory Coast.
All the kings from the Democratic Republic of Congo (formerly Zaire) disappeared during the war.

All the photos in this book were taken with Kodachrome film.

Ten Speed Press
P.O. Box 7123
Berkeley, California 94707
www.tenspeed.com

Distributed in Australia by Simon and Schuster Australia,
in Canada by Ten Speed Press Canada,
in New Zealand by Southern Publishers Group,
in South Africa by Real Books,
in Southeast Asia by Berkeley Books,
and in the United Kingdom
and Europe by Airlift Book Company.

Library of Congress Cataloging-in-Publication Data is on file with the publisher.

ISBN 1-58008-224-6 (cloth)
ISBN 1-58008-272-6 (paper)

First printing, 2000
Printed in Italy

1 2 3 4 5 6 7 8 9 10 — 04 03 02 01 00